WISCONSIN
FOLK
ART

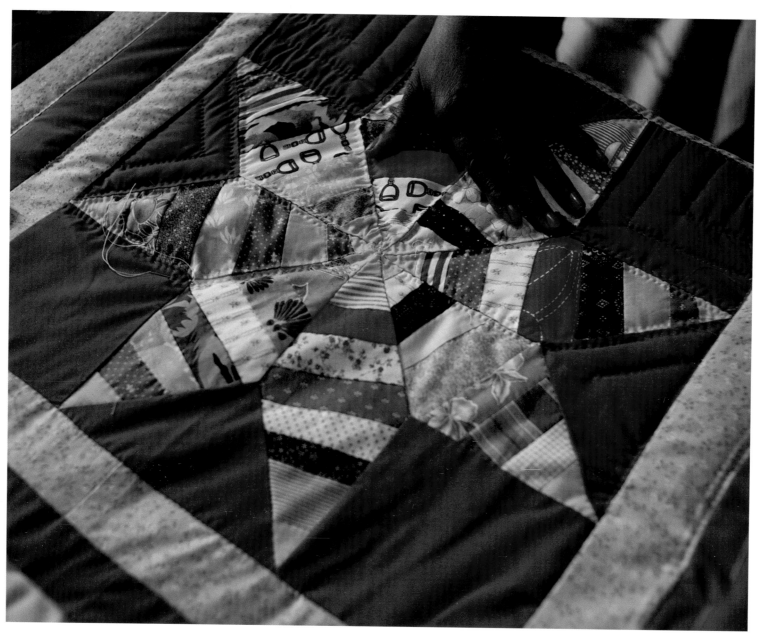

Eight-pointed
string star quilt
by Ivory Pitchford,
Milwaukee.

WISCONSIN
FOLK
ART

A SESQUICENTENNIAL
CELEBRATION

Edited by Robert T. Teske

Field Research and Catalogue Essays
by Janet C. Gilmore
James P. Leary
and Ruth Olson

Principal Photography by Lewis Koch

Published in conjunction with the
Wisconsin Folklife Festival
and a
Traveling Exhibition
organized by the
CEDARBURG CULTURAL CENTER
Cedarburg, Wisconsin

Funded in part by grants from the
National Endowment for the Arts and the
Wisconsin Sesquicentennial Commission

WISCONSIN FOLK ART:
A SESQUICENTENNIAL CELEBRATION

EXHIBITION TOUR

December 14, 1997 - March 15, 1998	Cedarburg Cultural Center
April 5 - May 31, 1998	Neville Public Museum of Brown County, Green Bay
June 23 - November 8, 1998	State Historical Museum, Madison
December 4, 1998 - February 15, 1999	Chippewa Valley Museum, Eau Claire

Designed by Victor DiCristo,
Braun Creative Group, Mequon.

Printed by The Fox Company, Milwaukee.
Printed in the United States of America.

CONTENTS

ACKNOWLEDGMENTS

Grandma used to tell me a custom practiced in Slovakia: When people moved to a new house, they always planted an apple or a fruit tree on the lot line. That way when the tree blossomed or fruited, there was fruit to share with the new neighbors. Grandma was like that apple tree. She came here to America and planted her roots. If my grandmas were alive today, they would thank you, as I am, for allowing this little tree to share its fruit with all the neighbors here in Wisconsin.

Sidonka Wadina Lee
Lyons
February 7, 1994

Only the generous assistance and collegial cooperation of a number of dedicated individuals and collaborating institutions made possible the Cedarburg Cultural Center's organization and presentation of **Wisconsin Folk Art: A Sesquicentennial Celebration**. On behalf of the Cultural Center's Board of Directors and members, I would like to thank the many people who assisted our organization in carrying out this complex and challenging project.

First of all, I wish to thank the National Endowment for the Arts, the Wisconsin Sesquicentennial Commission, and the Wisconsin Folklife Festival for the generous financial support they provided for **Wisconsin Folk Art**. In particular, I would like to acknowledge Dan Sheehy and Barry Bergey of the Endowment, Dean Amhaus of the Sesquicentennial Commission, and Richard March of the Folklife Festival for their personal assistance.

Secondly, I wish to recognize the exceptional staff of folklorists, photographers, and design professionals who contributed their special expertise to the development of **Wisconsin Folk Art: A Sesquicentennial Celebration**. Folklorists James P. Leary, Janet C. Gilmore, Ruth Olson and Anne Pryor identified and documented a fascinating group of traditional artists from throughout the state. Photographer Lewis Koch introduced us to these artists through his portraits and brought us their work through a selection of exceptional images. Exhibition Designer Dan Mayer transported Wisconsin's folk arts from the field to the museum gallery, and Publication Designer Victor DiCristo transferred them to the printed page.

Thirdly, I would like to thank the many organizations and institutions throughout Wisconsin which have assisted in various ways with the planning and presentation of **Wisconsin Folk Art**. Doug Kendall, David Mandel, and Debbie Kmetz of the State Historical Society of Wisconsin graciously assisted in identifying artifacts and photographs from their collections for inclusion in the exhibition, as did Larry Donoval and Eric Johnson of the John Michael Kohler Arts Center. The Chippewa Valley Museum, the Mert Cowley Collection, the Douglas County Historical Society, the *Hocak Wazijaci* Language and Culture Preservation Program, the Michigan Traditional Arts Program, the Lyle Oberwise Collection, and the Wisconsin Folk Museum also allowed the Cultural Center to utilize photographs from their collections, while the University of Wisconsin Press and the University of Wisconsin Cartography Laboratory furnished maps for the exhibition and for this publication. Thanks are also due the Neville Public Museum in Green Bay, the State Historical Museum in Madison, and the Chippewa Valley Museum in Eau Claire for agreeing to present the traveling exhibition to their audiences.

Fourthly, I wish to extend special thanks to the dedicated staff of the Cedarburg Cultural Center for their unflagging commitment to this project. To Jill Bault and Maria Gadzichowski who never objected to preparing countless revisions of label copy, and to Dick Ellefson, Whit Lehnberg, and Bill Beyer who worked long and hard to install and travel the exhibition, my heartfelt thanks.

Finally, on behalf of the Cedarburg Cultural Center and all the people of Wisconsin, I would like to express my sincere appreciation to the traditional artists of the Badger State whose truly exceptional work is the reason for this publication and the exhibition it accompanies. For over one hundred and fifty years, they have contributed richness and diversity to life here in Wisconsin, and for this they deserve thanks from us all.

Robert T. Teske
Executive Director
Cedarburg Cultural Center

F O R E W O R D S

F O R E W O R D S

F O R E W O R D S

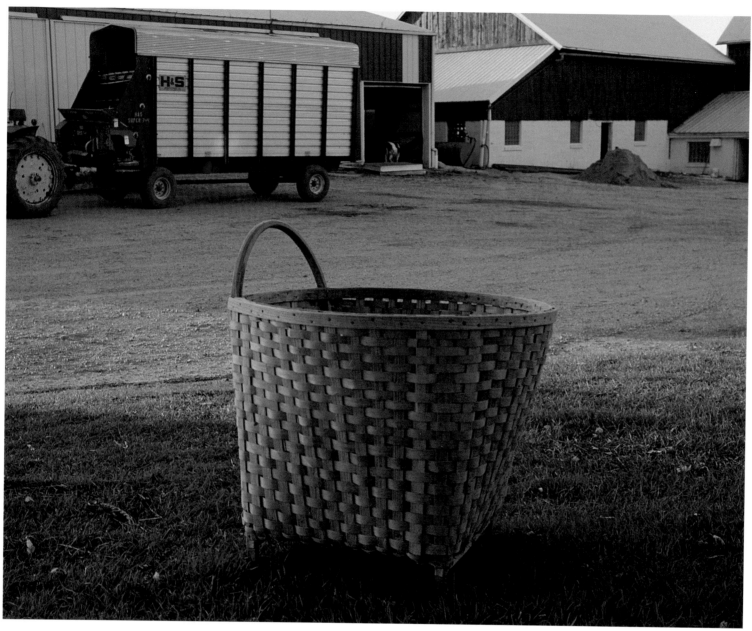

Bohemian cattle
feed basket
by Joe Buresh,
Luxemburg.

FOREWORDS

TOMMY G. THOMPSON

Governor
State of Wisconsin

GREETINGS!!!

As part of the ongoing festivities marking Wisconsin's 150th birthday, I am especially pleased to recognize the exhibit "*Wisconsin Folk Art: A Sesquicentennial Celebration*". It is most appropriate to acknowledge the role that traditional arts have played and continue to play in the lives of our State's citizens. This exhibit, through its focus on the occupations, recreational activities, communities and ethnic groups of Wisconsin, truly demonstrates the range of talents and skill present within our State.

Even before 1848, Wisconsin relied on many different people to insure its strength and health. An appreciation of quality, a pragmatism that combines beauty with usefulness and an affinity with the land and its features—all are concerns of ordinary people, the ones who made Wisconsin a great State.

The past remains with us, marking our present and influencing our future. "*Wisconsin Folk Art: A Sesquicentennial Celebration*" rejoices in the fact that our skilled artisans can carry forward traditionally valued skills and ideas. This fine exhibit reminds us both of who we are and where we came from.

Sincerely,

TOMMY G. THOMPSON
Governor

TGT/jlw

December 1, 1997

Mr. Robert Teske
Cedarburg Cultural Center
P.O. Box 84
Cedarburg, WI 53012

Dear Bob:

The Wisconsin Sesquicentennial Commission is pleased to offer our support and congratulations to "Wisconsin Folk Art: A Sesquicentennial Celebration." Of the many fine projects we have helped support and encouraged during this celebratory year, this exhibit stands out as truly representative of the entire state. The people represented here come from all parts of Wisconsin, and practice a number of different types of skills and art forms valued in the region. The objects you see here show what life in Wisconsin is about, not just in the past but now.

It's been exciting, planning this major celebration. The Wisconsin Sesquicentennial Commission feels privileged to have witnessed so close to hand the variety of ways that Wisconsinites choose to commemorate their past. Among these, this pulling together of traditional arts serves as a lasting monument to our ingenuity and our respect for tradition, as worthy of maintaining as is Wisconsin itself.

Sincerely,

Dean Amhaus
Executive Director

WISCONSIN SESQUICENTENNIAL COMMISSION

8 South Carroll Street ✦ P.O. Box 1848 ✦ Madison, Wisconsin 53701-1848 ✦ Phone: (608) 264-7990 ✦ Fax: (608) 264-7994
Co-chaired by Governor Tommy G. Thompson ✦ Governor Lee Sherman Dreyfus ✦ Governor Patrick J. Lucey

Printed on recycled paper ✦ Printing donated by Marathon Communications, Wausau, Wisconsin ✦ Paper donated by Gilbert Paper, Menasha, Wisconsin ✦ © 1997

December 1, 1997

Dear Bob,

We are pleased that the Wisconsin Arts Board has had the opportunity to work with you in playing a leading role in making traditional culture and folklife central to the observance of Wisconsin Sesquicentennial. Arts that have been passed on in families and communities are important markers of identity and embodiments of the values we are celebrating on this occasion.

As you know very well, one can find extraordinary beauty and insight in the traditional artistic expressions of ordinary people. This statement is a basic underlying precept both of the Wisconsin Folklife Festival and your affiliated exhibit, "Wisconsin Folk Art: A Sesquicentennial Celebration."

Many of the artists featured in the exhibit also will have the chance to participate in the Wisconsin Folklife Festival, a living cultural exhibit. As it moves from museum to museum around Wisconsin throughout 1998, your traveling art exhibit extends the reach of the festival both temporally and spatially.

Heartfelt congratulations to Cedarburg Cultural Center, to you as curator and to all the folk artists, folklorists and exhibit specialists who contributed to this outstanding display.

Sincerely,

Rick March

Richard March, Director
Wisconsin Folklife Festival

First Floor, 101 East Wilson Street, Madison, Wisconsin 53702

WISCONSIN FOLK ART ESSAYS

WISCONSIN FOLK ART ESSAYS

WISCONSIN FOLK ART ESSAYS

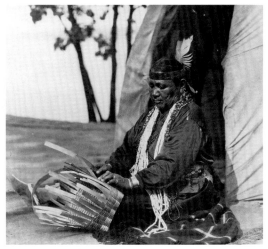

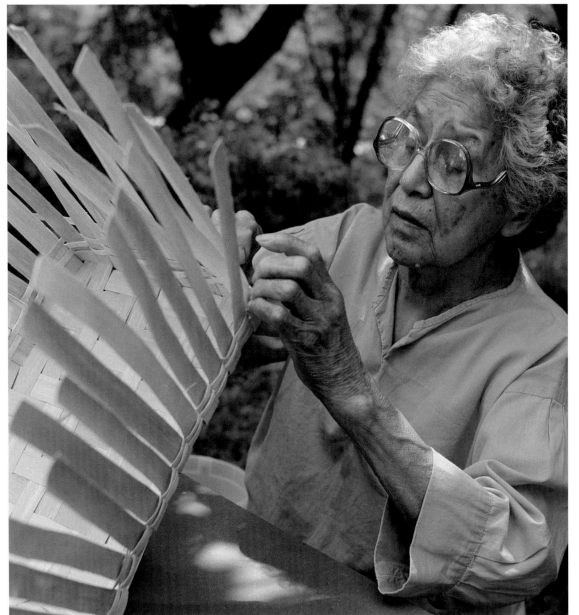

Bertha Blackdeer weaves a Ho-Chunk black ash basket in much the same manner as the "Winnebago Basket Maker" photographed by the H.H. Bennett Studio years earlier.

TRADITIONS THROUGH TIME:
WISCONSIN FOLK ART
AT THE SESQUICENTENNIAL

BY ROBERT T. TESKE

INTRODUCTION

For more than 150 years, from well before Wisconsin became the thirtieth state in 1848 until the present, its people have transformed everyday objects into works of art through a combination of craftsmanship and creativity.

During the early days, the Ho-Chunk made sturdy baskets of black ash native to the region for storing and transporting their belongings. The Oneida fashioned cornhusk dolls for their children following the tribe's relocation from New York to Wisconsin in 1838. And the Menominee created moccasins both for everyday use and for special occasions such as births and deaths.

From the mid-nineteenth until the early twentieth century, European immigrants who settled along the Lake Michigan shoreline fashioned homes, barns, articles of clothing, and household furnishings according to patterns learned in the Old Country. German settlers constructed *Fachwerk,* or "half-timbered," dwellings on their farms around Freistadt, while Luxembourgers used the abundant stone around Port Washington to build barns with distinctive arched doorways. Similarly, Dutch settlers in Cedar Grove and Oostburg followed Old World precedent by making wooden shoes for use in the garden and the fields. And in Milwaukee and Racine, Polish and Danish immigrants transformed sheets of paper into a variety of household decorations.

During this same period, lumbermen and hunters, fishers and farmers transformed the tools of their trades into things of beauty. Czech basketmakers in Kewaunee County utilized the same black ash employed by the Ho-Chunk to create large cattle feed baskets for hauling hay and silage to animals in the barnyard. Ojibwa fishermen crafted trout and musky decoys to lure their prey within spearing range below the ice on northern Wisconsin's frozen lakes. And duck hunters near Green Bay carved decoys and built hunting skiffs for use on Lake Michigan and on the many marshes and sloughs which surrounded the city.

More recently, African-Americans from the Deep South and immigrants from Laos, Mexico and Puerto Rico have added their distinctive music and dance, crafts and customs to the rich and diverse mix which has come to characterize Wisconsin. Quilters from throughout the American South brought distinctive "string" and "strip" quilting techniques, clearly reflective of their African heritage, north to Wisconsin. Similarly, Hmong immigrants who came to the state from their native Laos following the Vietnam War introduced their colorful needlework and elaborate traditional clothing into Wisconsin's multicultural mosaic, much as Danish and Norwegian settlers did years earlier. In addition, recent arrivals from Mexico, Puerto Rico and the Hispanic Southwest brought Carnival masks, piñatas, and paper flowers to enrich the state's many community celebrations.

Though times have changed and technology has evolved enormously over the 150 years since Wisconsin became a state, many of the folk arts once required to meet daily needs continue to be practiced to this day. Rather than fulfilling everyday functions, Wisconsin's folk arts now provide practitioners ways of acknowledging their heritages,

Norwegian mangle boards

by Norman Seamonson,

Stoughton.

celebrating their communities, and expressing their ethnic, regional and occupational identities.

Thus, contemporary Wisconsin folk artists do not fashion Potawatomi cradleboards and Norwegian mangle boards because there are no modern baby carriers or electric irons available to them. Rather, they continue to create these time-honored objects because of their importance as symbols — symbols of ethnic identity, religious faith, and commitment to the "old ways."

Similarly, many of Wisconsin's retired loggers, farmers and fishers use their newly-won leisure to recall the central experiences of their lives in wood, metal, or paint. A few former lumberjacks, for example, depict life in the woods by carving scenes of horses skidding logs over ice-covered winter roads. Some fishers and farmers fashion models of their tugs and tractors, their nets and wagons, from wood or bits of scrap metal, while others use paint to remind themselves of plowing and sewing, harvesting and threshing.

This publication, like the exhibition and festival which it accompanies, celebrates Wisconsin's many accomplished folk artists and the extraordinary range of traditional art forms they continue to practice at the time of the state's Sesquicentennial. Through the essays included in this volume, the professional folklorists who have had the privilege of working with these artists over the years at festivals and workshops, in exhibitions and performances, seek to share just a bit of what they have learned from and about these masters of tradition.

As an introduction to the topic, Robert T. Teske considers the traditional nature of folk art and the ways in which tradition ties the folk arts to history and heritage. Janet C. Gilmore then looks at the place of traditional arts within community celebrations and as vehicles for celebrating community. James P. Leary examines Wisconsin's folk arts as expressions of ethnicity "in exile," as tools consciously employed by folk artists to recreate their homelands and to reaffirm their own ethnic identities. Finally, Ruth Olson considers the

ways in which Wisconsin's folk arts reflect the lifestyles of many rural residents of the state, especially those who make considerable sacrifices to remain "living on and off the land" in Wisconsin's Northwoods.

While the varied forms of folk art discussed here represent a wide range of the traditions still practiced in Wisconsin, the selection included in this publication is far from comprehensive. Many other forms have been practiced historically, and many others continue to be practiced today. However, these recent examples of the state's long-established folk art forms, because of their traditional nature, often tell tales as old as Wisconsin.

KEEPING TRADITION

"...tradition is the creation of the future out of the past."
— *Henry Glassie, Folklorist*

Like the bark of Wisconsin's birch trees, the hides of its deer, and the scrap metal of its factories, tradition is a **resource** which the state's folk artists have employed in their creations for over 150 years. Drawing upon the artistic precedents offered by family members and friends, neighbors and co-workers, Wisconsin folk artists have found models for their own work and for the creations of subsequent generations.

At the same time, tradition is a **process,** a particular way of doing things learned over time through exposure to informal instruction. Embodied in any one artist at the time of artistic creation, the process reflects **continuity** with what has come before and a consciousness of **community** standards. It also displays the folk artist's tendency toward **consistency** with the established norm, while allowing some degree of individual **variation** to satisfy the need for personal expression and meet the demands of a constantly changing cultural context.

Each work of Wisconsin folk art is a direct result of this complex process, of this balancing act between the past and the present, the individual and the group. And each work is

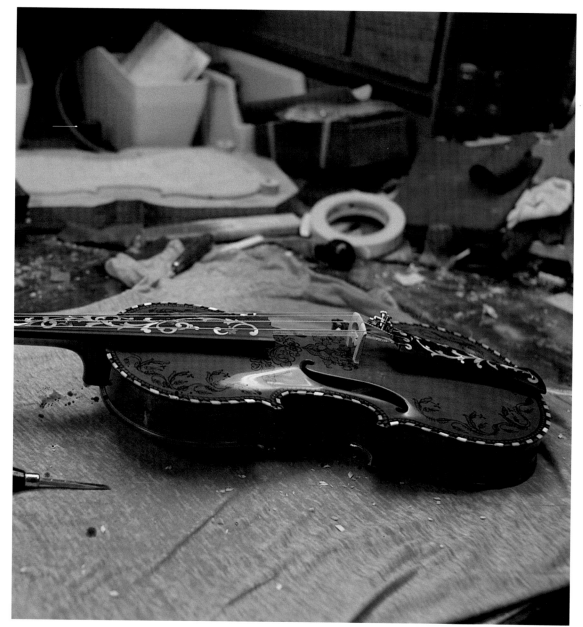

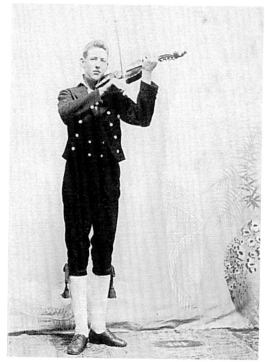

Ron Poast's contemporary Hardanger fiddle closely resembles the instrument played by fiddler and fiddle-maker Anton Rundhaug of LaCrosse during the early 1890s.

Three generations of the Dufeck family of Denmark, Wisconsin, continue to make cheese boxes much like those displayed by early employees of the Dufeck Manufacturing Company.

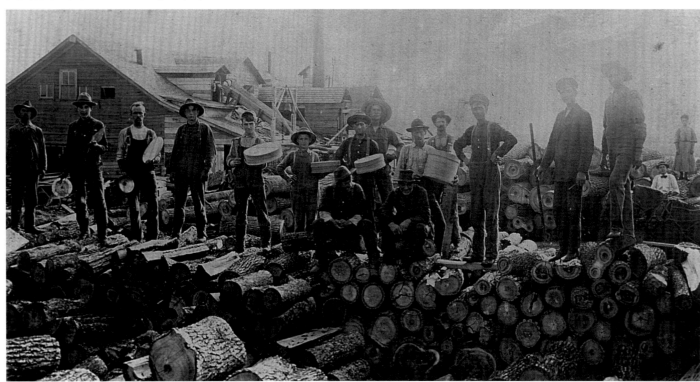

so richly symbolic and so deeply meaningful because it carries the authority of successive generations of artists and the approval of the contemporary community. On the occasion of Wisconsin's Sesquicentennial, no other works better reflect the state's abiding appreciation of continuity and community than these.

CONSISTENCY

Many of the folk arts currently practiced in Wisconsin represent long-standing traditions which have remained relatively stable over time and space. Ruth Greengrass Cloud's description of the pervasiveness of ash basketry among the Ho-Chunk provides a good example:

> *Most of our people that I knew, they all made baskets, because that's how they lived. They had to make a living. I was raised in Black River Falls, but they had baskets in Tomah, Wittenberg, Wisconsin Rapids. (Cloud 1994)*

The artists who, like Ruth Cloud, continue to practice these traditional arts have not sought to make major changes in designs or patterns, in materials or construction techniques. Backed by the generally conservative communities which have helped to shape the art forms, they rarely seek change as an end in itself. Unlike contemporary artists who place a premium on the new and innovative, they are comfortable with those characteristics which are customary.

Thus, the black ash kettle baskets still made by Ruth Cloud and the market baskets woven by her sister, Bertha Blackdeer, closely resemble those crafted by their mother and earlier Ho-Chunk basketmakers in their materials and design. The heart-shaped baskets which Albert Larsen still weaves from red and white paper as decorations for his tree at Christmas time clearly recall those his father made in Denmark and in the Larsen home in Kenosha's Danish-American community. And the drum-shaped cheese boxes manufactured by the Dufeck family in Kewaunee County for three generations still meet the same requirements for storing and aging cheddar as they did over one hundred years ago.

The consistency and familiarity of these folk arts must have been comforting to the peoples of Wisconsin as massive changes swept over the state and through their lives. These readily recognizable art forms offered islands of stability amidst a sea of change, a way to impose a known order on the chaos of existence, a means of perpetuating communities' spiritual and cultural perspectives. The continued creation of many of these folk arts today, when other alternatives are less expensive and more convenient, suggests that this need for stability and identification still remains strong in communities around the state.

CONTINUITY

Not just a resource, tradition is also a process, a particular way of doing things which folk artists learn over time through informal instruction. Anna Vejins, for example, learned how to knit Latvian mittens from her mother, Alma Upesleja, who had in turn learned the art from her grandmother, Ieva Lacis. Pat Farrell of Green Bay learned to build hunting skiffs from two local hunters, John Basteyns and Ted Thyrion, who also built duck hunting boats, carved decoys, and made paddles and other waterfowling accouterments.

Similarly, Allie Crumble of Milwaukee learned to make African-American quilts from her mother as a child in Sardis, Mississippi. Just as her mother taught her to quilt, so too has Allie Crumble taught her own daughter, Ivory Pitchford, the techniques of African-American quilting. Pitchford's first quilt was a "string" quilt that her mother showed her how to assemble. She started it at about the age of sixteen, constructing blocks about the size of a napkin from small strips of fabric sewn to a paper backing. She then quilted it herself, in "shares" or sections, just as her mother did. Now an accomplished quilter herself, Ivory Pitchford would like

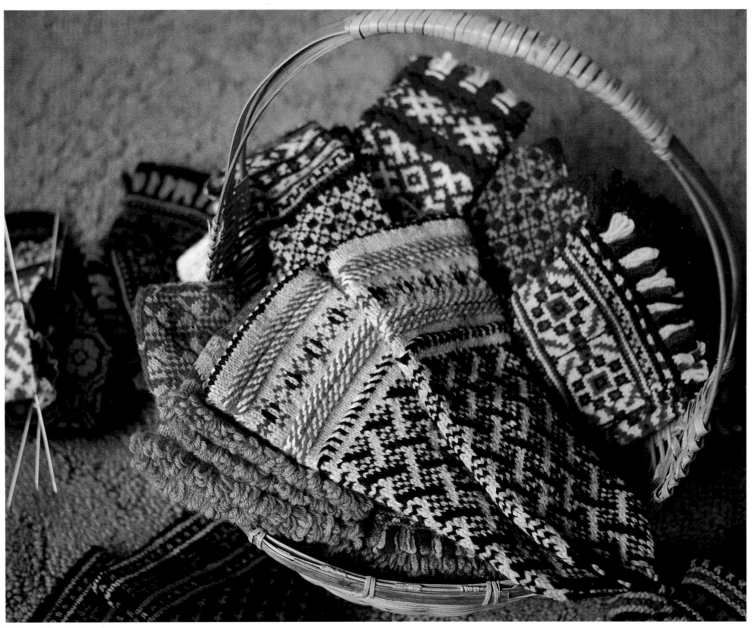

Latvian mittens by Anna Vejins,

her mother Alma Upesleja, and her

great-grandmother Ieva Lacis.

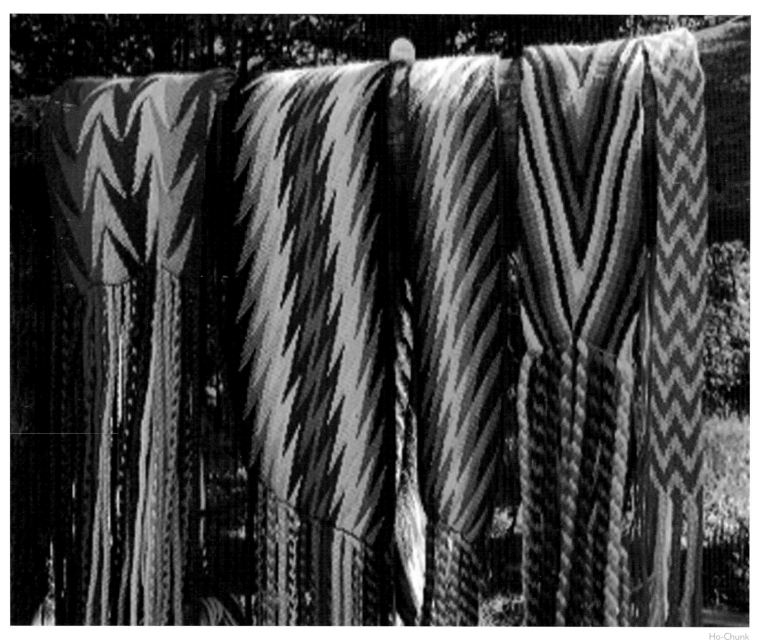

Ho-Chunk
finger-woven sashes
by Willa Red Cloud,
Neillsville.

to start her own quilting club, and like her mother before her, she would use a "string" quilt to introduce her students to the African-American quilting tradition.

As a result of this process of informal instruction, frequently passing from one generation to the next, the creations of Wisconsin's folk artists are like links in a long chain of transmission. They are the most recent versions of many similar artifacts which artists have fashioned over the years using common materials and techniques learned from others. At once old and new, these artistic expressions sustain continuity with the folk artists who have gone before, establish communication with contemporaries, and show the way to those who will follow.

Perhaps Willa Red Cloud, who learned to make Ho-Chunk finger-woven sashes from her mother, Priscilla Mike, best expressed the deeply felt sense of continuity experienced by many Wisconsin folk artists:

> The way that I look at it, when people pass away, they don't really pass away. They are gone physically, but they still are with us. When I do my weaving, I still see my mom's hands working on it even though they are my hands. My brother picked up working on the hides, which she taught us. She also taught us to do beadwork; my sister does that. My younger sister does the sewing. Those are parts of my mother that we took on. (Red Cloud 1994)

CREATIVITY AND CHANGE

Wisconsin's traditional artists and the communities of which they are a part may value continuity and stability. However, their appreciation for consistency and commonality does not preclude various types of change within folk art forms or the exercise of individual creativity on the part of the folk artist.

Material folk arts, like folktales and folksongs, are stored in the memories of masters and students and are communicated orally or by example. Some variation from artist to artist is inevitable. Consequently, Elena Greendeer's beadwork *pah-keh,* or hair tie, may employ the same colors and replicate the same basic design as an earlier Ho-Chunk example made by her grandmother, but it is not identical, not a deliberate reproduction of the earlier piece of dance regalia. These small, "passive" changes, rather than being regarded negatively, are valued in most communities as signs of the individual artist's presence within the larger tradition.

Folk artists may also introduce other, more "active" kinds of change into their traditional art forms. Artists who are masters of a particular tradition may seek to improve, modify or simply vary their designs and patterns just to demonstrate their creativity and skills. Sidonka Wadina Lee, for example, finds the combining and re-combining of various forms of braided and woven wheat into new designs among the more challenging aspects of her Slovak wheat weaving. Similarly, Betty Piso Christenson demonstrates the virtuosity which won her a National Heritage Fellowship from the National Endowment for the Arts by constantly varying the designs and patterns on her Ukrainian Easter eggs.

Other Wisconsin traditional artists have chosen to modify the materials used in creating their work in response to their current situation. Bernie Jendrzejczak, for example, has taken to using wrapping paper or origami paper for her Polish papercutting as opposed to the flimsier paper used in Europe, and she has also substituted Elmer's Glue for the paste of flour and water used in Poland. Similarly, Hmong instrument maker Wang Chou Vang has substituted gourds and animal hides for the materials he would typically have used in Laos in making soundboxes for his two-stringed violins.

With regard to adapting new technologies to the creation of folk art, several Wisconsin artists demonstrate different levels of involvement. On the most basic level, John Arendt has begun drilling holes in the members and rims of his large Czech cattle feed baskets and attaching them with small nuts and bolts in order to avoid splitting the black ash

splints. This seems to him a preferable alternative to the earlier process of using small nails which often broke the splints during the attachment process. On a slightly different level, Carroll Gottschlich and Christina Cronin began making solo dance costumes for students at the Cashel - Dennehy School of Irish Dance by using hand embroidery techniques. When they became more heavily involved in designing and creating the dresses, they moved to machine embroidery as a work-saving alternative. On yet another plane, Jeff Prust's use of chainsaws in carving large-scale bears and other figures suggests how a new power tool can itself generate a new form of expression, related to earlier whittling and hand carving in some ways, but dependent in style upon the advantages and limitations of the tool itself.

Cross-cultural exchanges and marketing of traditional artifacts to broader audiences are two other factors which have brought change to certain forms of Wisconsin folk art. With such a diversity of cultural communities living in close proximity and with so many cultural traditions closely related to one another, Wisconsin has fostered numerous examples of "creolization" or blending of various folk arts into new hybrid forms. In northern Wisconsin, for example, Ho-Chunk basketmakers have adapted their products to Euro-American tastes in the creation of "bingo baskets" and collectible miniatures for an expanded audience.

The many "active" and "passive" changes introduced by Wisconsin folk artists into the creation of their work are surely significant, but they seem to pale by comparison with larger variations resulting from cultural and social changes imposed upon the artists and their art forms by contemporary American life. Although, as many of the preceding examples suggest, certain folk art forms continue to be practiced continuously over long periods of time, the uninterrupted flow of any one folk art form from generation to generation is becoming increasingly the exception instead of the rule. Rather than there being several members of a community skilled in carving or basketmaking, needlework or weaving,

increasingly the tendency seems to be toward a few individuals preserving their art forms, keeping them alive as part of their heritage and as a resource for others who might take an interest.

The reasons for this are many. Necessity no longer requires the degree of self-reliance which once compelled Native American and immigrant populations to turn to the models offered by their cultures and communities in creating clothing and shelter, tools and toys. Time no longer permits the dedication of long hours to painstaking needlework or intricate carving. And technology offers endless alternatives in terms of new production techniques as well as alternative products to those once fabricated by the state's folk artists.

When interruptions of this type have occurred in the traditional transmission process, Wisconsin's folk artists have found varying ways to respond. Some have sought to "revitalize" traditions still firmly situated within living memory of the artist and the community. Julia Nyholm, for example, had watched her aunt, a head woman on the Bad River Ojibwa Reservation, twine rabbit fur blankets when she was younger. However, she did not take up the art form actively until the late 1980s at the request of her son.

I really hadn't thought too much about the rabbit blankets, because I was doing finger weaving and the [yarn] bags So when [my son] asked me, I thought, 'Gee, I wonder if I'll be able to remember?' But the funniest thing, when Earl asked me that, I went out in the car and I went to the cemetery. I went and stood by my mother's grave. I said, 'Well, Ma, Earl wants me to make a rabbit blanket. I wonder if I can. Would you please help me?' So I stood there for the longest time. So then I went to the car and I started coming back. I was coming back over the bridge and, all of a sudden, I said, 'I know how to do it.' (Nyholm 1994)

Julia Nyholm displays her

Ojibwa rabbit fur blanket.

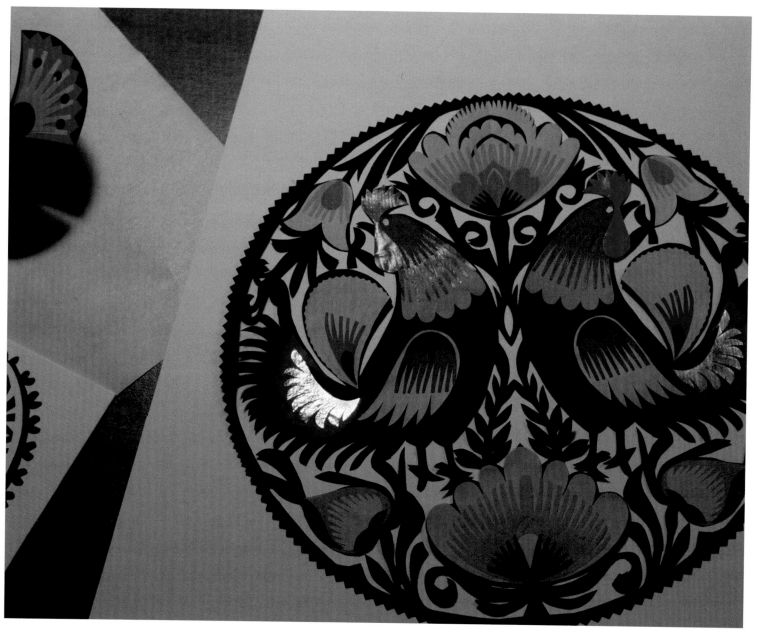

Polish *wycinanki* in the style
of the Lowicz Region
by Bernie Jendrzejczak,
Hales Corners.

Ron Poast of Black Earth followed a somewhat less spiritual path, though one which was frought with mystery for some time, in his efforts not just to revitalize, but to revive, the making of Norwegian Hardanger fiddles in Wisconsin. For years, Poast listened to his mother describe a mysterious eight-stringed Norwegian fiddle beautifully inlaid with mother-of-pearl. When he finally saw one in a storefront display in Mount Horeb, he turned to museum collections in Iowa and Wisconsin to supplement a Norwegian publication on Hardanger fiddles which he had found. Shortly thereafter, he began building his own beautifully detailed versions of the instruments which had last been popular around the turn of the century. Poast's commitment to reviving the tradition of Hardanger fiddle making in Wisconsin has contributed substantially to a similar revival among musicians interested in playing it.

CONCLUSION

As a result of their traditional nature, Wisconsin's folk arts combine elements of continuity and consistency, which link them to the past, with aspects of creativity and change, which join them to the present and the future. As a result of their grounding in ethnic, regional, occupational and religious groups which share systems of belief and aesthetics, Wisconsin's folk arts reflect a sense of community despite their creation by single individuals.

Rooted in the past yet responsive to the present, reflective of both communal values and individual creativity, Wisconsin's folk arts have served as symbols central to the lives of many residents since before the time of statehood. Their beauty and meaning, their resiliency and richness argue strongly for their continuing presence for years to come.

Cedarburg Cultural Center
Cedarburg, Wisconsin

SOURCES

Cloud, Ruth Greengrass. 1994. Tape recorded interview by James P. Leary at the Cloud home, Baraboo, Wisconsin, for the *Hocak Wazijaci* Language and Culture Preservation Program.

Crumble, Allie M. 1990. Tape recorded interview by Janet C. Gilmore at the Crumble home, Milwaukee, Wisconsin, for the Wisconsin Folk Museum.

Glassie, Henry. 1995. "Tradition," in "Common Ground: Keywords for the Study of Expressive Culture." *Journal of American Folklore*, 108:430, Pp. 395-412.

Nyholm, Julia Eckerberg. 1994. Taped recorded interview by James P. Leary at the Nyholm home, Crystal Falls, Michigan, for the Wisconsin Folk Museum.

Red Cloud, Willa. 1994. Tape recorded interview by Michelle Greendeer at the Red Cloud home, Dells Dam, Wisconsin, for the *Hocak Wazijaci* Language and Culture Preservation Program.

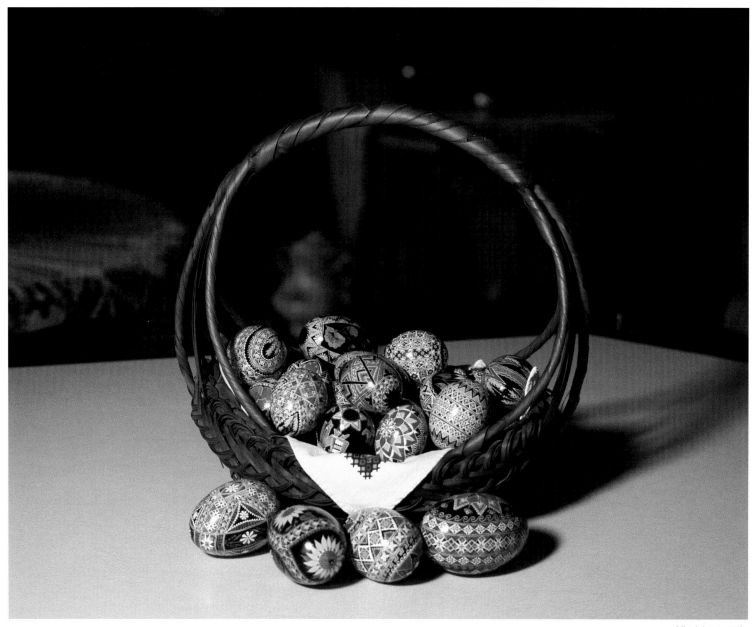

Ukrainian *pysanky*

by Betty Piso Christenson,

Suring.

28

MARKING TIME, HONORING CONNECTIONS, RECORDING MEANING

BY JANET C. GILMORE

Ebenezer Scrooge, the well known figure from Charles Dickens's *A Christmas Carol*, scorns merriment and denies celebration, refusing to cultivate "the kindnesses of life for his own happiness." Dickens describes him as one untouched by the seasons, so dedicated is he to the routine of his life and the narrow world of money-lending. Scrooge is not only unaffected by the seasons of the year, he is also unaffected by the seasons of life. Scolded as fearing the world too much, he prefers books to boisterous play with schoolmates in his youth; he remains loyal to his work over his fiancee; he does not marry and thus avoids the jolly companionship of children, "spring-time in the haggard winter of his life." In his portended death, he is stripped of worldly possessions and promised a funeral devoid of pomp—which therefore no one will attend—and a headstone that no one will tend. In the end, he is to be denied words and the immortality bestowed upon the person who shares bonds joyfully with others. Shocked by the bleak record and miserable prospects revealed by the Ghost of Jacob Marley and the Spirits of Past, Present, and Future Christmases, Scrooge reforms, reborn through the gaiety, foolishness, and playful inversion characteristic of celebration:

> *His hands...busy with his garments...turning them inside out, putting them on upside down, tearing them, mislaying them, making them parties to every kind of extravagance.*

Scrooge bestows a prize turkey upon the Cratchit family for their Christmas dinner, then joins his nephew for a Christmas dinner party. The next day he raises clerk Cratchit's salary, and thereafter assists him and his struggling family, forever dwelling in mutual gratitude.

Dickens completed *A Christmas Carol* in 1843, a time of extreme disparity between the fortunate and the unfortunate, enhanced by the dispassionate mechanization of the Industrial Revolution. He pilloried the Scrooge character to disparage the smug lack of compassion of people who had achieved comfort and routine, often at the expense of others, and more generally to point out the forces that undercut the fabric of society. The "Ghost of an Idea" that he suggested as a remedy was reaching out to others with a sense of shared humanity, joining with them in celebration, enjoying companionship, food, play, the seasons of the year, the seasons of life, experiencing "the power...in things so slight and insignificant that it is impossible to add and count 'em up...." Through the extraordinary behaviors practiced while celebrating, individuals and humanity could experience rebirth and, through regular celebration with others, immortality.

A Christmas Carol struck a universal chord, and remains a popular work in the United States, re-enacted annually in school plays and a variety of film versions aired over television during the winter solstice season. Dickens keenly understood the nature of celebration and its importance in our lives.

Unlike Scrooge, most of us appreciate celebration. We enjoy the opportunity to take a break from the routine to indulge in out-of-the-ordinary activities like savoring special foods, dancing to live music, playing games, or dressing up in disguises. Most of us need the more somber ceremonial aspects of many celebrations to help us reflect and cope with existence. Through celebration, we join with others to acknowledge and re-establish our place and participation in the universe and the social order, as "fellow passengers

instead of separate races of creatures bound on separate journeys," explains Scrooge's nephew. During these moments, we shape our identities, linking them to people present and invoked; we state and recreate the communities we share with others. "You're just wholesome when you're together," says Ho-Chunk Elena Greendeer of Oneida.

Unlike Scrooge, most of us pay attention to the seasons of the year—especially in Wisconsin, a state with an ideology of four distinct seasons, even though northerners complain that there are only two (winter and a pitiful attempt at summer, or winter and road construction), and some add a fifth, "mud time," between winter and spring. Many of the most important, most widely-shared, and most public celebrations we enjoy are based on marking seasonal changes and the passage of time during the year. The interrelated rhythms of old agrarian and religious calendars follow the movements of earth and celestial bodies in the heavens, and harness the symbolism inherent in the year's cycle of beginnings, endings, and transitions in between. Spring represents a time of rebirth, growth of the light, planting of seeds, symbolized by the egg at Easter, full of potential, and by muck and snow melt in northern

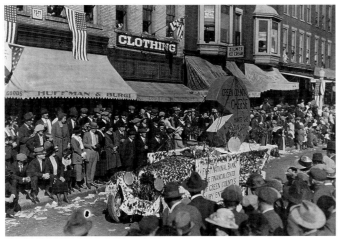

A float featuring a wheel of cheese in the annual Cheese Day Parade in Monroe, October 10, 1916.

Wisconsin. Summer-fall is the season of light, a time of growing, comfort, and plenty, fairs and festivals showing off and sharing the bounty: from catfish in Potosi and cheese in Monroe to morel mushrooms in Muscoda, from sweet corn in Sun Prairie and potatoes in Stevens Point to cranberries in Warrens, from cherries in Jacksonport to wild rice in St. Croix and lake trout in Bayfield. During the fall-winter period, the light darkens, and Wisconsin folks prepare for the dark time by fattening the larder with sauerkraut, dried mushrooms, canned fish from the lakes and produce from the garden. They fatten the body with sweets at Halloween and Christmas and with feasts at *lutefisk* dinners, Ghost Suppers, and Thanksgiving. And they bolster their souls through trick-or-treat at Halloween or *julebukking* during the winter solstice season with disguises and trickery to fool the dark spirits. Winter is a time of darkness and death, transformation and preparation for rebirth through light and the lightness of festivities surrounding the winter solstice, Christmas and New Year's. The fattening of the fall and sobriety of the winter are replayed in Lent customs in late winter, in preparation for Easter and the rebirth of spring and another year.

Adding counterpoint to the celebration of the annual round and the earth's position in the universe are celebratory activities that recognize the seasons of human life, another birth-through-death cycle which, unlike Scrooge, most of us respect. Generally more personal and private, these formal acknowledgments follow the individual's life cycle, marking key events and the passage of time in a person's life, and often designating the person's cultural matrix, a web of connections to other individuals.

Even before the birth of a new person, celebratory activities take place. Friends, relatives, or office mates shower a new mother-to-be with gifts to prepare for a new baby. Some traditional practices require that particular members of the baby's family provide specific gifts. In Xao Yang Lee's White Hmong family in Sheboygan, it is proper for a mother or mother-in-law to express her love for her daughter's or daughter-in-law's first born by furnishing a baby carrier.

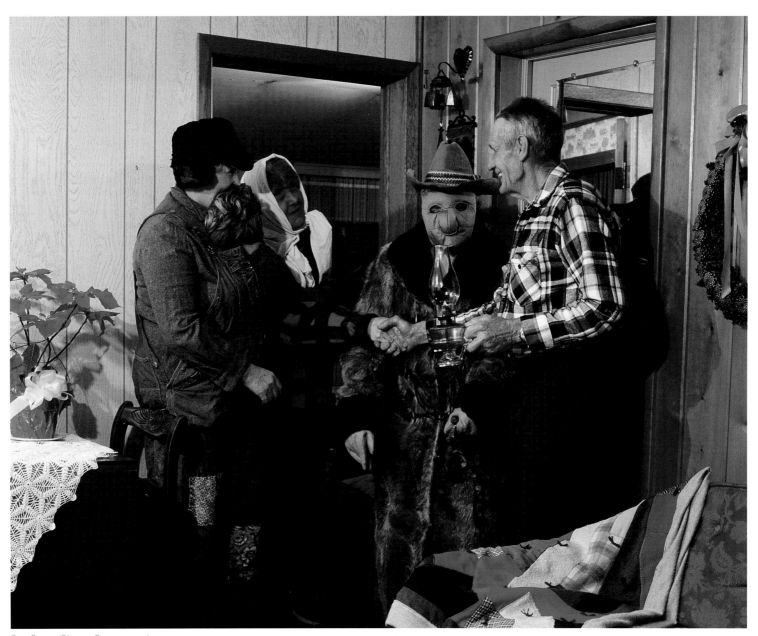

Fern Frame, Oljanna Cunneen, and

Beulah Knudson greet Obert Berge while

julebukkiing in the Blue Mounds area

during the 1982 winter solstice season.

31

According to Ned Daniels' Forest Potawatomi tradition up around Crandon, "A grandfather is proud and happy that he's got grandchildren. He feels real good about it, so he makes cradleboards."

Annual birthday parties mark the individual's progress in life. In this state that so loves a party, many schoolchildren celebrate an annual birthday more than once, with special treats at school, with a private, family celebration on the actual anniversary of the birth day, and again with a party for special friends during a weekend event—thus acknowledging much of the child's social network at that time of life. Growing up in Texas, Berta Mendez of Waukesha celebrated birthdays with friends at school by exchanging handmade paper flowers. Later in life while bringing up her children in Wisconsin, she remembered the piñatas of celebrations in her youth and began making them for her children's birthdays.

Bar and *bat mitzvahs,* confirmations, senior proms, graduation parties, and even gang initiation rites signal the passage of a child to adulthood and associate the person with a particular social circle that adheres to a distinctive set of beliefs. Many traditional quilters bestow one of their handmade creations upon a grandchild at graduation, honoring the passage, demonstrating the grandmother's approval, and giving concrete expression to the grandmother and grandchild's connection.

Marriage, the joining of two individuals into a new social unit, is perhaps the most universally important of life cycle celebrations. Especially for women, it traditionally marks a significant change of identity through name, and in some groups, through a new family allegiance and clan association. And according to most traditions, the bride's family takes financial and organizational responsibility for the event, with months of arrangements and preparations for the site, event structure, food, music, dress, and decorations. In the old days, Polish weddings in Wisconsin were legendary for their length and extravagance, and even today they can be complex events:

> *Many couples in heavily Polish Portage County, for example, set their date in accordance with the availability of a contingent of older Polish ladies who prepare a wedding feast that must include such ethnic delicacies as kielbasa (Polish sausage), kapusta (sauerkraut), and pierogi (a stuffed dough, akin to ravioli, that is parboiled then fried). Couples also hire bands, like Norm Dombrowski and the Happy Notes, that can play Polish dance tunes as well as orchestrate the grand march and the bride's dance. Enormous guest lists include much of the surrounding community. Those invited give cash as often as any other gift and are recompensed with music, food, and plenty of beer, shots of brandy, and pop (Leary 1998).*

Perhaps in return for the huge concessions the bride must make in agreeing to the arrangement, the traditional Jewish marriage certificate, a *ketubah,* records the groom's promises to the bride and is regarded as a legal document. Diane Glaser Simmons of Glendale creates both the traditional document, as well as a more modern version with pledges from both the bride and groom.

Some families regularly mark the progress of a pairing with anniversary celebrations, especially of milestones like the 25th or 50th. Berta Mendez and her husband feted their 40th with a family reunion. Almost all of their nine children were able to attend with their families, each bearing a piñata they had made in honor of their mother's long dedication to producing them for special events in the children's, family's, church's, and Latino community's lives.

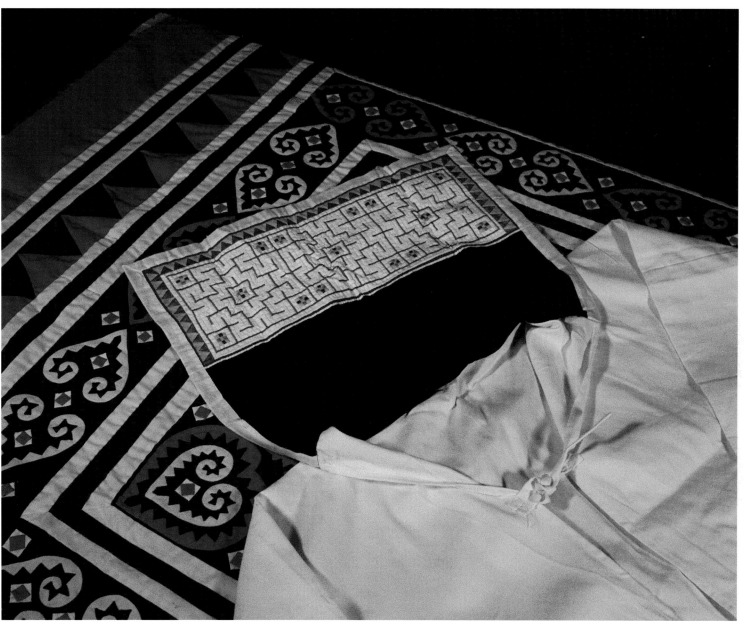

Hmong burial robe

with embroidered collar

by Xao Yang Lee,

Sheboygan.

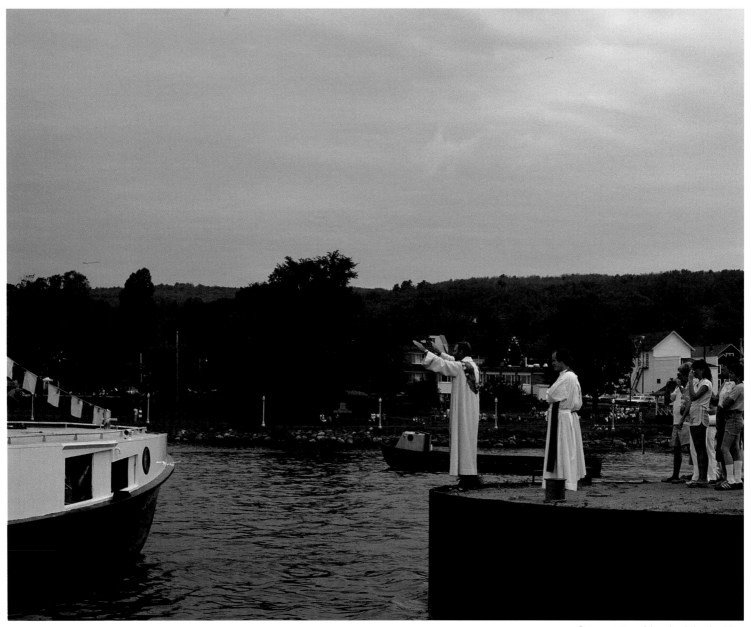

Representatives of three local churches bless
Bayfield's fleet of commercial fishing
boats during the commercial fishermen's
association festival in July, 1981.

Finally, funeral "celebrations," and perhaps annual commemorations thereafter, give closure to a life and aid the transition to a new social order for the dead as well as those who must adjust to life without the deceased. According to Xao Yang Lee's White Hmong family practice, it is the role of the daughter-in-law, a person least familiar with her husband's ancestry, to make funeral squares for her husband's parents. She embroiders the cloth with a maze of vegetable and flower designs and clan symbols to remind the deceased of the ancestral line and the proper path back to the homelands, to bar bad spirits from entering the path and luring the deceased from it—and to ensure that the needleworker knows the family's lineage. In other traditions, it is common to place items in the deceased's casket to symbolize the person's dedication to a particular interest in life and thus the influence the person has had in shaping the destinies of younger generations. Betty Piso Christenson of Suring placed two of her elaborately decorated Ukrainian eggs in her mother's hands "before she went to meet our Lord," in recognition of her mother's:

> *...enthusiasm, love, and patience, just being Mama and being proud of who she was, that made me stay with it [egg decorating] over the years until I have conquered.*

Similarly, commercial fisher Andy La Fond of Algoma honored his chub fisherman father's interests and influence by decorating his coffin with fish netting, a net needle, a chub dressing knife, and his chub sticker, a custom-made device for easing chubs from gillnets.

Overlapping, intertwining, but not necessarily related to these cycles of seasonal and life celebrations, are yet more celebratory cycles, events, and acts. They acknowledge the existence, beginnings, ends, transitions, and special moments of various types of associations, formal and informal, based on shared heritage, special interests, avocations, and vocations. Workhorse owners and old-time farming buffs gather at annual thresherees for horse pulls and demonstrations of full-size and miniature working models of old farming equipment, reliving the days that the late Lavern Kammerude of Blanchardville recorded in several dozen oil paintings. Jack Swedburg of Webster and his fishing buddies celebrate their mutual obsession with an annual fishing trip to a secret lake in Canada. Ben Goebler of Mt. Vernon and the teams of the Sugar River Euchre league celebrate their passion most Thursday nights, fall through spring, reveling in the occasional "skunk," and polishing off each evening's competition with home-cooked foods. Allie Crumble of Milwaukee created her celebratory "Necktie Quilt" to capture a moment in the life of her Metropolitan Baptist Church community. She identified and arranged the 36 ties she solicited from the pastors, deacons, ushers, family, and friends in her church to show the church male hierarchy, her menfolks' positions within it, and a circle of friends within the membership.

In Wisconsin, a culturally pluralistic state with well over 100 ethnic groups, an equally broad array of religious groups, with four seasons and a vast range of outdoor activities and indoor pastimes, there are so many celebratory cycles in which an individual may participate at once, it is no wonder that Wisconsin is sometimes called a party state. While Wisconsin natives may just possibly have more opportunities, and more varied ways, to celebrate than folks in other parts of the country, each individual participates in only a selection of celebratory cycles, or grids, as Jack Santino calls them (Santino 1994: 1-8). For as Scrooge discerned very clearly, serious involvement in key celebratory cycles, events, and activities requires a substantial commitment of time, effort, and resources, as well as a strong desire to participate.

One of the most vexing aspects of celebrations for Scrooge was the break from the routine, and the conscious decision to engage in what appeared to be unproductive behavior. Indeed celebration and ceremony require that people depart from the activities they would ordinarily pursue, to participate in a range of absorbing, apparently frivolous, out-of-the-ordinary activities,

making merry through theater—pageantry, parades, masks, costumes, adornments of homes and gathering places—music, dance, games, food. These common celebratory activities often exaggerate those of everyday life, frequently emphasizing orderliness or its opposite, disorder. Games, parades, and pageants offer precise procedure, definite roles, and rules of behavior. Music presents a highly ordered sequence of sounds, and its opposite, noise, an intensification of random sounds. Dance orders body movements and makes it possible for individuals to move together in synchronization, while its opposite, wild abandon, features unpatterned, individuated gyrations. To a wedding, powwow, or Hmong New Year's celebration, one might wear best clothes of the finest, newest fabrics in the most fashionable, "orderly" cuts and colors—according to the aesthetics of the particular group. Worst clothes—outmoded styles, rags, clashing colors and combinations of garments—and "otherly clothes"—masks and outfits projecting a completely different identity—are important for some celebrations, for fooling Pookas at Halloween, or neighbors while *julebukking*. Excess in food and drink is common to most celebration: "disorderly" acts of gorging (eating too much, as at Thanksgiving) or fasting (eating too little, or forgoing certain foods as during Lent), and more orderly acts of consuming distinctive foods (that involve a complex, orderly process to produce, require special ingredients, or bear special significance to the celebrants or activity) or symbolic foods meant to represent something else, like wine for the blood of Christ and bread for his body at Christian communion services.

Whether orderly or disorderly, celebratory activities exist within a specific festive order. What Scrooge saw as a break from the routine actually represents a departure from one routine based on the ordinary and adherence to another festive one, time "out of time," where extraordinary behaviors are ordinary and the apparent wildness is in fact controlled within the bounds of the event. Different events combine a variety of celebratory activities, but emphasize some over others. For example, the St. Francis Society of the Town of Holland in the extreme southwestern corner of

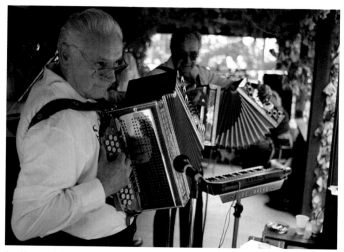

Joe Krev and the "Echoes of Slovenia" perform at *Vinska Trgatav*, the Slovenian wine harvest celebration in Racine County, 1993.

Brown County (just east of Kaukauna and Appleton), hosts a *Schut* ("shoot") one Sunday of the year, a celebration that consists of a prescribed sequence of activities and clearly defined roles for participants. Now held in early August, the event has occurred annually since 1849, and it continues a tradition still found in Germany, Belgium, and the Netherlands that dates back to the Crusades. The martial and benevolent religious society was originally composed only of men with Dutch Catholic heritage, but over the years the group has opened its membership to men and women of other backgrounds. The *Schut* often draws 100 shooters and 1,000 onlookers. While the day's routine has been adjusted to the times over the years, participants have followed the same basic structure year after year. The event begins in the morning with a mass at St. Francis Catholic Church, followed by registration of the shooters at Van Abel's Hall, a local supper club in business since 1850. Participants and onlookers then march in a procession from the hall to the shooting grounds, a quarter mile away. Heading the procession—which these days has become a parade representing local organizations, youth and cultural groups—is a bearer of the American flag, the

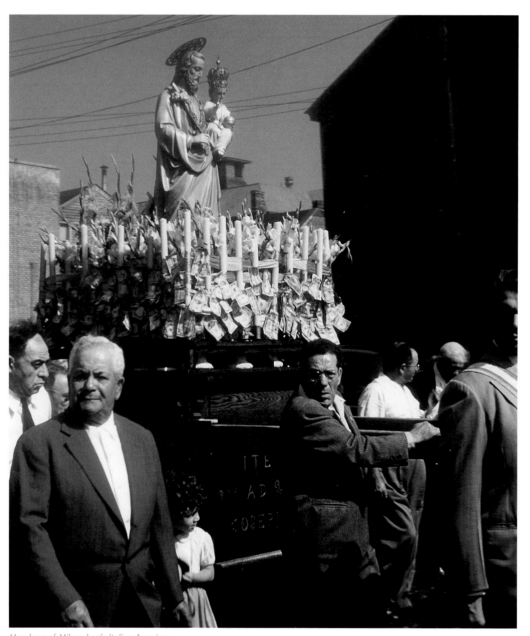

Members of Milwaukee's Italian-American
community carry a statue of St. Joseph bedecked
with offerings of money through the city's
Third Ward during a 1950 festival procession.

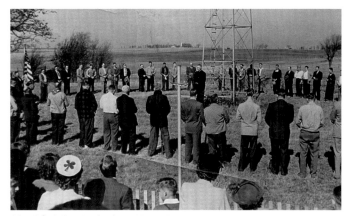

A local Catholic priest leads participants in prayer prior to the Hollandtown *Schut* in the early 1960s.

boisterous Wisconsin Catholic wedding, the *Schut* proceeds from serious and orderly ritual—ceremony—to a celebration within a celebration, exuberance and a more playful structure—food and drink for hundreds, followed by dancing to a live polka band.

While most of the common celebratory behaviors are present in the *Schut,* the key categories emphasized are a kind of theatrical game, where roles are adopted and played, and where players respectfully follow proper procedures, compete in marksmanship, and display dignified, sportsmanlike behavior. The event integrates oppositions of order and chaos. It emphasizes the importance of order in human affairs, and resonates with the ultimate duty of the society to help fellow human beings, by ritually using a tool and skill that have the potential to harm fellow humans and blast the social order to pieces.

priest, the King shooter of the past year's *Schut,* and the officers of the St. Francis Society. Once the procession reaches the grounds, local musical groups may play a few numbers, and the priest says prayers for deceased members of the Society. Then the shooters circle around what is now a 100-foot steel tower topped with a large bird now composed of rubber belting, built annually by the same family, and purchased by the past year's King shooter. The pastor takes the first shot, the past year's King the next, and then the rest of the shooting is done in rotation as each shooter's name is called. The shooters continue shooting in rotation, until the bird is brought down; it may take 10 to 20 rounds, as few as 150 and as many as 930 shots, to shoot the bird to bits (which these days must be cleared afterwards from the roof and swimming pool of an adjacent house!). Monies from registration fees support five awards, one to each person who brings down a wing, the head, or the tail, and the person who brings down the rest of the bird becomes King. The King must use part of the award to purchase the bird for the next year's *Schut,* and part for a round of drinks for fellow participants; he or she receives a silver parrot pin (that recalls the Crusades), and a cape made by local women to wear during the event. After the shooting, participants retire to Van Abel's Hall for dinner, cardplaying, and dancing to a local polka band. Like a

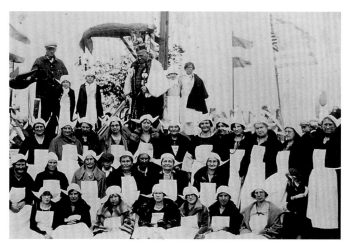

John Coppes, King of Hollandtown's 75th Anniversary *Schut* in 1925, surrounded by women in Dutch traditional costume.

In contrast to the *Schut,* a traditional Wisconsin Hmong funeral follows a more flexible format. Lasting at least 24 hours and up to three days, it might involve food, card-playing, story-telling, and ritual garments for the deceased,

but the key activity is the music of the *qeej* players. A "free reed instrument" with a bamboo sound cavity and bamboo tubes fitted with copper reeds, the *qeej* can make special, penetrating sounds that mimic the tonal qualities of the Hmong language. Throughout the duration of the funeral, *qeej* players make their instruments sing songs to guide the spirit of the dead person step-by-step back to:

> ...*every village or town or province where he lived before—we take his spirit back to appreciate the town where he lived, the wood he burned, the water he used, to appreciate all those things before he can go to another village. We go from village to village, until we get to the village where he was born. (Xiong 1992)*

Thence the *qeej* players guide the spirit back to his great-grandparents and ancestral homelands, over the mountains in Laos, to China. Ritual garments reaffirm the message of the music, with decorations in the funeral square delineating the proper path, and special shoes protecting against the bugs and cold experienced during the trip through the mountains.

At a minimum the *qeej* players play the required ceremonial exhortations. But the longer the funeral service, the more likely they may add lighter songs as background to activities that help the mourners take their minds off the deceased and their sorrow. Whether lighter and optional, or more solemn and obligatory, the music is constantly in the background, persistently reminding, persuading the spirit of the deceased to stay on the proper course.

Qeej player Joe Bee Xiong of Eau Claire has a repertoire of other, "fun" songs he may play at other events, like New Year's celebrations, to send away the old year and welcome the new, and another of songs-without-words for dance competitions, where he jumps, leaps, and executes difficult steps while playing the *qeej*, but the funeral songs—music beyond music—can only be played during the funeral service (else they can bring misfortune). Xiong learned to play the *qeej* to be of help to his community. Indeed besides giving a

Joe Bee Xiong of Eau Claire plays the Hmong *qeej*.

proper closure to a life—for the living and the deceased—the funeral songs serve to perpetuate Hmong distinctiveness by reminding the living as well as the deceased of their ancestry, their history, and their identity. Xiong believes that "the *qeej* is a symbol of the Hmong people."

A set menu of foods, offered in an orderly fashion, is central to the *lutefisk* dinners that many Wisconsin Norwegian Lutheran church groups have held for decades in the fall. With the primary aim of raising money for the particular church group, the event is focused on the well-being of the greater community. In exchange for cash that will help the specific group, the community at large is invited to celebrate and remember aspects of its heritage, by partaking of foods that participants don't mind consuming ritually at least once a year (indeed some attend as many of the suppers as they can during the season). The best of these dinners are elaborately orchestrated, including weeks of carefully coordinated food preparation in advance, and during the dinner, well-organized kitchen duty and ticketing, seating, and serving of guests. Served family style,

Lutefisk Dinner, Burke Lutheran Church,
Town of Burke, November 2, 1996.

and all-you-can-eat, the menu of simple and modest
Norwegian "comfort foods" includes the challenging
lutefisk—dried cod cut to pieces with a saw, reconstituted
by soaking in lye and rinsing in many baths of water, then
boiled—and *lefse,* a potato-based, dampish flat bread
sometimes slathered with butter and brown sugar and used
in various ways to help eat the meal. Meatballs and ham
might be offered, which require less bravado to consume,
as well as a variety of well-cooked vegetables like green
beans, potatoes, maybe rutabagas, and perhaps pickled
beets and cranberry relish. Finishing off the meal is
rømmegrøt—a warm, thick cream sauce oozing with
melted butter, sprinkled with cinnamon, sugar, and more
butter—and the thin, economical coffee for which
Midwestern Scandinavians are famous. Conversation,
indeed all other activities, at these events are definitely
secondary to the immersion in the food. Amazingly most
consumers submit to second and third helpings of the
distinctively smelly, slippery *lutefisk,* which is much
improved by drenchings of melted butter. As the fish eaters
become satiated, conversation picks up with nostalgic
reminiscences of first experiences with the delicacy and the
best of past *lutefisk* dinners, both public and private.

Just as different celebratory events may emphasize specific
festive activities over others, and just as an individual may
emphasize particular celebrations over others, so each
person may emphasize one kind of celebratory participation
or activity over others in a particular event. Lovers of *lutefisk*
act chiefly as consumers at a church supper for only a couple
of hours during a fall weekend. But several dozen people work
behind the scenes, and a number devote weeks ahead to
preparation, especially of food, with some specializing in
lefse-making, others in cooking *rømmegrøt* or baking
traditional cookies, and a few in handling the daunting
lutefisk. These dedicated workers are people who enjoy
gathering with others to sustain their church community, to
produce the food, and to contribute expertise in a specialty
that they may have cultivated over many years.

As children, spectators, and consumers, we all have
benefited throughout our lives from the dedication and
hard work of others involved in producing an event. As we
mature and become abler—and most often once we have
our own children—we may become fuller participants,
more responsible in engineering celebrations and
maintaining traditions. After years of enjoying her mother's
Danish-style Christmas Eve festivities, Inga Hermansen's
daughter now hosts the event in her home in Racine. She
cooks the goose and her mother the rice pudding for the
traditional dinner. The families walk around the Christmas
tree and sing songs, exchange gifts and make ornaments for
the tree. Adults who shoot during the *Schut* have often
been "spectators since birth," learning by attending the
event and watching, fascinated by the prospect of one day
being able to participate as shooters themselves.

Just as Joe Bee Xiong trained for years in order to play the
qeej for Hmong funerals, most active contributors to
celebratory events devote a tremendous amount of time
during the year and throughout their lives to preparations.
(Imagine Scrooge's indignation!) In her youth in Laos, Xao
Yang Lee learned needlework from her mother to make
clothing for her family and soldiers. Every year she and her

mother and sisters made new everyday garments to debut at the annual New Year's celebration. In this country, her family dons handmade Hmong garments less frequently and only for festivities, mainly at New Year's, Christmas, and Sheboygan's 4th of July parade. While no longer as relentlessly involved in sewing everyday garments for her family, Lee has still produced them as celebratory ones for her children, as they have outgrown the old and needed new ones.

Similarly Ho-Chunk Elena Greendeer has been routinely involved in keeping her children outfitted in traditional garb for powwows and dance competitions:

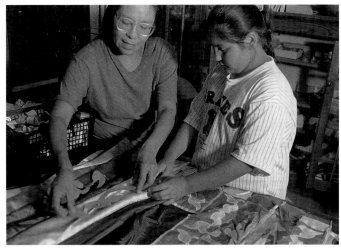
Elena Greendeer works with her daughter Verna to make a Ho-Chunk ribbon skirt, Oneida, 1994.

Fancy dance dresses for my older daughters. They belong to two different categories when they perform, which keeps mother busy. And also we do the variety of dresses and men's dance articles for other people besides our own.

Earlier in life, Greendeer herself benefited from her paternal grandmother's work: "when we were leaving for a powwow...she would make two or three pairs of moccasins so all of us children wouldn't have an excuse not to dance."

Greendeer's impetus for learning the beadwork and ribbon appliqué of traditional Ho-Chunk regalia was watching others dance in their regalia: "I always thought it was awesome." Then when she started dancing:

...in my teenage years...I used to dance at the Stand Rock Indian Ceremonial....And I became one of the performers and I also desired more varieties of dress to wear....And the only way to get it is to make it....So I learned from watching my mother work, and also some of the other elderly women in dance outfits with appliqué—ribbon work—skirts and blouses. I learned how to make my own, and it wasn't very long that I had a large variety.

The training of a youngster in celebratory practices might follow its own life cycle with an elder marking points of passage. African-American Allie Crumble of Milwaukee learned the arts of the quilter in a ritual progression. Her mother, Minnie Lofton, presided over the process, taking care that Allie would learn the techniques properly and in the proper order, and respect the skills she was learning. First, she determined when her daughter would begin to learn:

My mother started me piecing a little four-patch, sitting on an orange crate. I was seven years old, and I had started to school and everything. And in the evening when I come home, I'd go over my lesson and then Mama said, 'Get your quilt.' I said, 'Quilt? Mama.' And then you see, my other sister then, she was a little girl running around and when I got about eight years old, she was outside playing, she was playing, and I'm sitting up in the house sewing on a quilt and I thought that was too old for me, just sitting up there sewing. Oh I didn't like that. But Mama would just make me sew anyway.

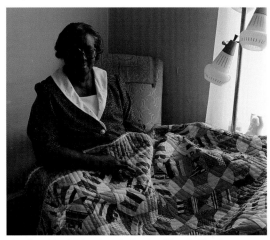

Allie Crumble of Milwaukee displays her "Snowball" quilt.

As Allie completed her work properly, her mother assigned increasingly more complex tasks:

> *And then, when I got through, got enough blocks to make a quilt, she made me a little four-patch quilt. She put it together for me. And then I started on a nine-patch. Then I was going on pretty good then. And then after that...it was a string quilt.*

When she was about eleven, Allie continues:

> *I remember Mama was in the kitchen one day and she was cooking and she had up a quilt, and I said, 'I believe I could quilt just like her'. And I went to quilting, I had some long stitches. But Mama come in there, she said, 'Did you do that?' I said, 'Yes, ma'am.' She said, 'Child, I'm going to get you a thimble and some thread and you can help Mama.' I was so happy. I was so happy to help her. I couldn't hardly, you know, get up in the morning time, go to school, come back and get on that quilt. I said, 'Mama said I could quilt!' And I did. And then she was telling me how ...to make my stitches short.*

With the granting of the thimble, Allie had made an important passage in learning to quilt, but her mother had more plans, and Allie more struggles. Her mother:

> *...started me to sewing with a thimble. And I would tell my mother, 'I don't know how to sew with this thing.' She said 'You have to sew with a thimble, you will never be able to quilt,' and I said to myself—I wouldn't let her hear it—I said, 'I won't quilt no way.' But I can sew with that thimble now and I can't do without it for nothing. I have to have a thimble, and I got so many thimbles...And when I pass away, I want them to put a thimble on my finger, I do, in my casket. I want that thimble on my finger.*

Through the ceremony of becoming a quilter, Allie became a producer of objects of ritual significance, awarded at celebrations of life passages, to express bonds between family members. Through a ritual process, she was deemed competent to represent and perpetuate a celebratory tradition. Her wish to go to her grave with a thimble on her finger is a fitting closing ritual, and a symbolic tribute to her dedication in life to quilting and family well-being.

Besides the ritual progression and rites of passage that might accompany the learning of a celebratory tradition, elders may instruct their students to follow further ritual while engaged in certain celebratory preparations. When Forest Potawatomi Josie Daniels of Crandon became involved in funeral preparations for her sister, her grandmother specified the proper procedure for making moccasins for the dead:

> *In our Native American ways, people that die have to have brand new moccasins to travel the spirit road....She used to tell me, 'Now when you make moccasins for somebody going into the*

spirit world, that's a different kind of moccasin. You have a different mind when you're making them. Don't put real shiny beads on there.' In the old days, they didn't have no beads on them, just plain moccasins. 'But nowadays,' she said, 'they like to put a little decoration on them.' Then she says, 'Just cut out your moccasin. If there're any trimmings, don't throw them away. Put them aside. And if there're any strings, put them aside. And don't be sticking that thread in your mouth when you thread your needle. Dip it in a little saucer of water.' So I had to put all my scraps aside. Even the cotton material that you put behind the vamps. And then, she said they have to be sewn at night. During the wake you could be sewing these moccasins. Takes about four days for that soul to get where it's going. Any time during that time you can dress her up in the moccasins. And her little pouch, where she's going to put her tobacco and four matches for the journey, for the four fire places—plus the things she liked to eat. Maybe a little candy, maybe she liked a certain kind of bread. That's what she told us to do. 'Why do I have to use water?' I would ask her....'Oh,' she says, 'the dead spirit makes everything dead. So when you're sewing for the dead, and you put that in your mouth—later in life he can come back and catch that. Maybe your mouth will hang down, or get numb, or you'll get shaky. He could come visit you.'

These steps would not only ensure the proper passage of the deceased into the spirit world, but would protect the person who, while preparing the dead for the journey, entered into a kind of borderland between the living and the spirit worlds.

During the process of creating celebratory objects, many artists find themselves transported into a reflective, meditative state like the "different mind" that Daniels and her grandmother required to make the moccasins for the dead. In this state, the artist may recall forebears, elders who taught the skill, lessons learned, and the prospective recipients of the artifacts. In private celebration, they link the past with the present and future, the spirit world with the world of the living. Elena Greendeer remembers how:

> *My mother asked one elder woman to show me how to make my first appliqué....By watching her appliqué work, well, I learned very quick. I still think of that off and on. Now tonight, I'm starting my own daughter's third or fourth dress, so those memories always come back to me.*

While deftly weaving traditional Ho-Chunk yarn sashes, Willa Red Cloud of Dells Dam sees her "mom's hands working on it even though they are my hands." When she is creating a sash as a gift, she continues:

> *I think about the person while setting it up. I ask them the design and I think about that too. If they don't tell me, I just think about the person. Somehow everything ends up being the same colors, matching, going together really well.*

As Albert Larsen of Bayview engineers Danish heart baskets for his Christmas tree each year, he thinks of the precision and detail that his father achieved in making them. In striving to match his father's model, he hopes that recipients will be able to see that "these things were from the Larsens' Christmas tree." Betty Piso Christenson of Suring remembers, as she inscribes eggs with exquisitely detailed Ukrainian symbols, how her mother told her about the beauty of the eggs in Europe, and "how her mother and grandmother would do them, how every egg would tell a little story....You just didn't make an egg just to make an egg." And for makers of models of equipment and scenes from their pasts—modelers like George Ellefson, John Henkelman, Bill Malone, Carl Vogt, and Ivan Bambic—the creative process is a way of remembering, re-experiencing, and conveying holistically, their lives as commercial fishers, loggers, farmers, or Slovenian villagers.

The process of creating celebratory objects and preparing for celebratory events can also enhance the artist's connection to the year's seasons and celebratory cycle. During the fall, Willa Red cloud tends to weave into her sashes the "colors of the ground" that she associates with that time of year. The tireless, productive Sidonka Wadina Lee of Lyons practices her Slovak egg decorating in advance of Easter in the spring, and her wheat weaving in the fall prior to the holidays. The manufacture of the cornhusk dolls so symbolic to the Oneida people is imbued with the growing cycle of the long-husked white corn distinctive to the Nation. Kim Cornelius Nishimoto's family of De Pere plants the corn at the end of May or early June. They weed it usually once during the growing season. On the weekend following Labor Day, when the corn is fully ripe and dried on the cobs, they pick it. Then they husk the corn, leaving on some husk so they can braid the cobs together and hang them to dry. Nishimoto's maternal grandmother, the late Priscilla Manders, reported that into the 1950s the family used to gather for a husking party in the barn. But these days, with everyone so busy, Nishimoto, her sister and mother husk and braid the corn sporadically as they have time, in her mother's garage, visiting as they have the opportunity. They save the inner husk for doll-making, since it is longer, softer, and easier to work. The corn is turned into white corn soup and cornbread for celebratory consumption, and some is saved as seed for the next year's corn.

Besides learning or creating in a proper celebratory sequence, and celebrating connections with others and the universe during the creative process, artists may follow additional ritual in caring for their creations. Once created, some objects must be treated as animate beings with their own lives and consciousness, deserving of celebrations held in their honor. Like the *qeej* for the Hmong, the drum is deeply symbolic to Sakaogon Ojibwa of Mole Lake. Joe Ackley has heard elders say, "When the drum stops, then our race will be extinct." In this tradition, drums may only be created by people in families where the tradition has been cultivated. Following after his father and grandfather, Ackley makes "social" drums for powwows. After he produces one, an elder speaks for it, and a feast is held for it. Everyone is invited, guests sing honor songs and songs for the drum, and traditional foods offered include deer meat, wild rice, fry bread, and corn. Generally Joe tries not to leave the drum alone. But whenever he leaves it at home, he covers it, and when his group of drummers, called a "drum," must abandon it to dance during powwows, he ties sweetgrass to the drum to show it is being respected. When the drum is not in use, it must be stored on its side.

Not all objects created for celebratory purposes require such formal sanctions, but Oneida-Menominee-Potawatomi Louis Webster could be speaking for all objects created with celebratory intent as he discusses a particularly "spirited" flute he once made: "It becomes a part of you, a part of your spirit that bonds you to the earth, the spirit world, that link to the other side—the spirit world." He adds:

> *People can take inanimate objects and make them an instrument of power if they know how to use it. They can do it with almost anything. It's your will and your belief that gives something power....Like that one flute, a medicine man told me I shouldn't use it for just playing, for demos and things like that. I should have my tobacco and my sage and I should smudge it before and after I use it....If you don't take care of it, what happens to it happens to you. I've got to take better care of it. In return it will take care of me.*

The creative process involved in preparing for celebrations is a celebratory act. An item created through this process, in this borderland state, is invested with the power to speak and act for the person who created it, to speak and act beyond the person who created it. Concretely expressed in symbolic "writing," celebratory objects provide historical

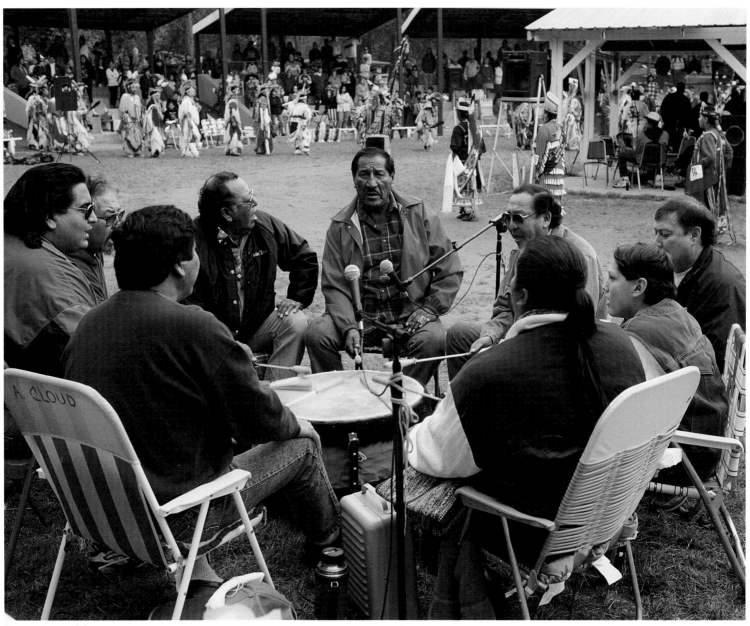

Powwow drum and dancers at

Black River Falls, in September, 1994.

records of connections and meanings. Coddled and protected, ceremoniously produced, they contribute in no small measure to the practice and perpetuation of the greater celebratory tradition, the linking of generations through time, and a kind of immortality. Kim Cornelius Nishimoto surely had these tenets in mind when she spoke about her plans to make cornhusk dolls for her offspring:

> *I'd like to make a set for each of my sons, for when they get older. Then they can have something from me that I've made....as the generations go down, it will be something that they have to pass on of our culture....it's a way of preserving the culture through future generations....Somebody in future generations, my grandchildren or my great-grandchildren, will know they had a grandmother that was Oneida. And this is what she did, she made cornhusk dolls. And that was something that was passed to me, from my mother, and from her grandmother.*

Nishimoto decorates the dolls' clothes with the fitting motif of the mythological Sky Dome that separates the earth from the Creator's realm, with scrolls symbolizing life in balance above the domes. Carefully placing the beads on the cloth, the artist depicts the borderland, the state in which she creates, the place that joins her to past, future, and the universe, a moment of celebration, time "out of time."

And so, dear Scrooge, we are glad that you came to see "the power...in things so slight and insignificant that it is impossible to add and count 'em up...." Through distinctive actions, words, and objects, through celebratory moments, we can achieve a different reality and a different state of mind that encourage the contemplation of the greater forces and truths in our lives.

Mt. Horeb, Wisconsin
November 1997

SOURCES

Ackley, Joseph. 1989. Tape-recorded interview by James P. Leary, Lac du Flambeau, WI. "In Tune with Tradition" Project, Cedarburg Cultural Center, Cedarburg, WI.

Allen, Terese. 1995. *Wisconsin Food Festivals: A Resource Guide with Recipes.* Amherst, WI: Amherst Press.

————. 1996. "Traditional Foodways of Wisconsin." Unpublished report, Wisconsin Sesquicentennial Celebration Folklife Survey, Wisconsin Arts Board, Madison.

Camp, Charles. 1989. *American Foodways: What, When, Why and How We Eat in America.* Little Rock, AR: August House.

Christenson, Betty Piso. 1993. Tape-recorded interview by James P. Leary, Suring, WI. "Passed to the Present" Project, Cedarburg Cultural Center, Cedarburg, WI.

Crumble, Allie. 1992. Tape-recorded interview by Janet C. Gilmore, Milwaukee, WI. Wisconsin Folk Museum, Mt. Horeb.

Cubbs, Joanne, ed. 1986. *Hmong Art: Tradition and Change.* Sheboygan: John Michael Kohler Arts Center.

Daniels, Josephine. 1994. Tape-recorded interview by James P. Leary, Crandon, WI. Traditional Woodland Indian Master Artist Project, Wisconsin Folk Museum, Mt. Horeb.

Daniels, Ned. 1994. Tape-recorded interview by James P. Leary, Crandon, WI. Traditional Woodland Indian Master Artist Project, Wisconsin Folk Museum, Mt. Horeb.

Dickens, Charles. 1915. *A Christmas Carol.* Philadelphia and New York: J. B. Lippincott Co. Reprint Edition, 1966. Ms. completed, December 1843.

Goebler, Ben. 1997. "Sugar River Euchre League" weekly column, Mt. Horeb *Mail,* Mt. Horeb, WI.

Greendeer, Elena. 1994. Tape-recorded interview by James P. Leary, Oneida, WI. Traditional Woodland Indian Master Artist Project, Wisconsin Folk Museum, Mt. Horeb.

Grumke, Gina. 1996. Documentation on the Sugar River Euchre League, Mt. Vernon, WI. Wisconsin Sesquicentennial Celebration Folklife Survey, Wisconsin Arts Board, Madison.

Hermansen, Inga. 1993. Tape-recorded interview by Mary Zwolinski, Racine, WI. "Passed to the Present" Project, Cedarburg Cultural Center, Cedarburg, WI.

Holmes, Fred. 1944. *Old World Wisconsin: Around Europe in the Badger State.* Eau Claire, WI: E. M. Hale and Company.

Kammerude, Lavern, and Chester Garthwaite. 1990. *Threshing Days: The Farm Paintings of Lavern Kammerude.* Mt. Horeb: Wisconsin Folk Museum.

Kronewiter, Uwe. 1997. "Ethnic Folk Festivals in Wisconsin." Unpublished M. A. thesis, Department of American Cultural History, Ludwig-Maximilians-Universität, München.

La Fond, Andy. 1990. Interview by Janet C. Gilmore, Algoma, WI. "Harvesting the Inland Seas" Commercial Fishing Exhibit Project, Wisconsin Maritime Museum, Manitowoc.

Larsen, Albert. 1993. Tape-recorded interview by Mary Zwolinski, Milwaukee, WI. "Passed to the Present" Project, Cedarburg Cultural Center, Cedarburg, WI.

Leary, James P. 1993. "Report on the Hollandtown *Schut*" for the "Passed to the Present" Project, Cedarburg Cultural Center, Cedarburg, WI. Includes photocopies of nine articles from area newspapers: "Hollandtown," De Pere *Journal-Democrat,* 1941; "Hollandtown Completes Century of Schuts," Appleton *Post-Crescent,* 1949; "Schut," fragment, source unknown, 1956; "Gene Wall, 25, Crowned Hollandtown Schut King," possibly Appleton *Post-Crescent,* June 10, 1956; Ed Van Berkel, "Hollandtown Claims Oldest Continuous Schut in Nation," Appleton *Post-Crescent,* November 29, 1964; "125th King of Schut Acclaimed in Holland," Appleton *Post-Crescent,* 1974; Mike Hinant, "Oldest Schut King Did It Twice," Appleton *Post-Crescent,* 1978; Kathy Bagnall, "It's Schut Time," Heart of the Valley *Current,* August 5, 1992; and "Dedication: Van Abel's," Kaukauna High School *Alumni News,* 1993.

—————. 1998. Comments for Rena J. Grubb, "'Jecz Cha Nacha!': You Are Invited to a Polish Wedding in Wisconsin." In James P. Leary, ed., *Wisconsin Folklore: A Reader.* Madison: University of Wisconsin Press.

Lee, Sidonka Wadina. 1993. Tape-recorded interview by James P. Leary, Lyons, WI. "Passed to the Present" Project, Cedarburg Cultural Center, Cedarburg, WI.

Lee, Xao Yang. 1993. Tape-recorded interview by James P. Leary, Sheboygan, WI. "Passed to the Present" Project, Cedarburg Cultural Center, Cedarburg, WI.

Lubansky, Andrew. 1996. "Lutefisk!" Unpublished paper, Folklore 320 class, University of Wisconsin—Madison. Includes photocopy of "Another Fish Story," by Dave Wood, Wisconsin Life Trip (Whitehall, WI: Dan Kamp Press), pp. 45-47.

Manders, Priscilla Jordan. 1993. Tape-recorded interview by James P. Leary, De Pere, WI. "Passed to the Present" Project, Cedarburg Cultural Center, Cedarburg, WI.

Mendez, Berta. 1993. Tape-recorded interview by James P. Leary, Waukesha, WI. "Passed to the Present" Project, Cedarburg Cultural Center, Cedarburg, WI.

Nishimoto, Kim Cornelius. 1995. Tape-recorded interview by James P. Leary, De Pere, WI. Traditional Woodland Indian Master Artist Project, Wisconsin Folk Museum, Mt. Horeb.

Olson, Ruth. 1996. Fieldwork report. Wisconsin Sesquicentennial Celebration Folklife Survey, Wisconsin Arts Board, Madison.

Pryor, Anne. 1996. Documentation of the Lakeview Lutheran Church *lutefisk* dinner, Madison, WI. Wisconsin Sesquicentennial Celebration Folklife Survey, Wisconsin Arts Board, Madison.

Red Cloud, Willa. 1994. Tape-recorded interview by Michelle Greendeer, Dells Dam, WI. Master Artists Project, *Hocak Wazijaci* Language and Culture Preservation Committee, Mauston, WI.

Santino, Jack. 1994. *All Around the Year: Holidays and Celebrations in American Life.* Urbana and Chicago: University of Illinois Press.

Swedburg, Jack. 1996. Tape-recorded interview by Ruth Olson, Webster, WI. Wisconsin Sesquicentennial Celebration Folklife Survey, Wisconsin Arts Board, Madison.

Teske, Robert T., ed. 1987. *From Hardanger to Harleys: A Survey of Wisconsin Folk Art.* Sheboygan: John Michael Kohler Arts Center.

Webster, Louis. 1995. Tape-recorded interview by James P. Leary at the Wisconsin Folk Museum. Traditional Woodland Indian Master Artist Project, Wisconsin Folk Museum, Mt. Horeb.

Xiong, Joe Bee. 1992. Tape-recorded interview by James P. Leary, Eau Claire, WI. "Hmong in America" Project, Chippewa Valley Museum, Eau Claire. Edited version of interview to appear in Leary 1998.

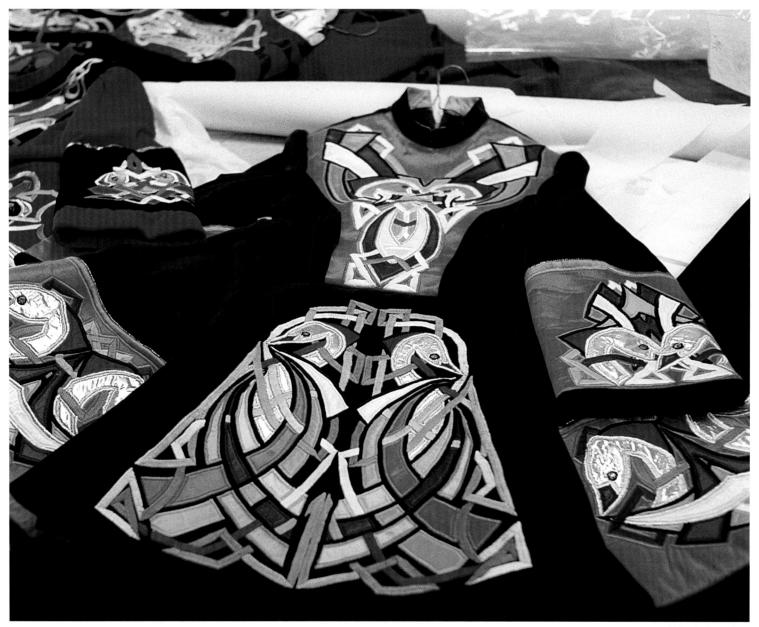

Irish solo dance dress
by Carroll Gottschlich
and Christina Cronin,
Shorewood.

LEAVING SKIBBEREEN:
EXILE AND ETHNICITY IN WISCONSIN FOLKLORE

BY JAMES P. LEARY

*"Oh, Father, I often heard you talk of Erin's
lovely isle;
You said it was a handsome place, so rich
and rare the soil.
You said it was a lovely place wherein a
prince might dwell.
Oh why then did you abandon it?
The reason to me tell."*

 —"Skibbereen" or "The Famine Song"

SKIBBEREEN Co.CORK.10240.W.L.

The ballad "Skibbereen" evokes conditions in southern Ireland's County Cork amidst the "potato famines" of the 1840s and 1850s. Sung in many versions throughout Irish-America, it tells, through dialogue between a son and his father, of starvation wrought by crop failure, high rent from a British landlord, and eviction.

*"They set our roof a-blazing with scornful
bitter spleen,
And when it fell, the crash was heard all
over Skibbereen."*

The father goes on to recall his wife's collapse and death amidst this onslaught, and his flight to join rebels in the hills. Their pikes and rusting blunderbusses prove no match for imperial troops. The defeated parent wraps his baby son in an old coat to set out for America "in the dead of night, unseen." In the final verse the now-grown son vows to return to Ireland to fight for that nation's freedom with "the cry of dear old Skibbereen" (Sommers 1996:74-75; Wright 1975).

Many such songs of homes abandoned, in many tongues, have been sung by Wisconsin's many peoples. I have heard all these and more in kitchens, ethnic halls, taverns, churches, funeral parlors, and via field recordings: the Croatian *Ja Sam Sirota* (I am an Orphan), the Finnish *Kulkurin Valssi* (Vagabond Waltz), the German *Sehnsucht nach der Heimat* (Longing for the Homeland), countless improvised Hmong laments, Ho-Chunk *Hay Lush Ka* or warrior songs, the Hollander *Lief Vaterland Vaarwel* (Dear Fatherland Farewell), the Italian *Torna a Sorrento* (Return to

Sorrento), the Norwegian *Farvel Norrig* (Farewell Norway), the Polish *Jescze Polska Nie Zgniela* (Our Poland Shall Not Perish), the Slovak *Kde Domov Moj* (Where Is My Home?), the Swedish *Helsa dem Darhemma* (Greet the Folks at Home), and the Welsh *Enwaith Etto Cumrie Ahnwul* (Once Again in Dear Old Wales). (See Leary 1985 and 1987.) Known superficially or not at all to outsiders, these songs burn with meaning for their singers, connecting them with a lost ancestral world they remember and imagine.

So it is with me, James Patrick Leary, and "Skibbereen." In 1938 folklorist Alan Lomax recorded its singing from J.W. Greene on Lake Michigan's Beaver Island. Greene had learned the song from Irish immigrants whose performance made "the hair stand up" on his head, a reaction not unlike my own. A photograph of Skibbereen hangs on the wall in my childhood home in Rice Lake. My paternal great-great-grandparents, Fenton Leary and Margaret Connolly, left Skibbereen in the 1850s for America. My maternal great-great-grandparents, Abraham Berigan and Bridget Hogan from the Irish counties Carlow and Tipperary, emigrated about the same time. Laborers, farmers, and homemakers, they were followed by successive generations of builders, farmers, cattle brokers, domestic workers, clerks, teachers, lawyers, public servants, and writers who, through six generations, have sustained a sense of Irish-American identity.

On March 17, St. Patrick's Day, my mom, Patricia Berigan Leary, would bring out heirloom ribbons, shamrocks, and medals for us to wear to school. When school was over, we'd come home to the scent of corned beef and cabbage and the sound of Morton Downey's "It's the Same Old Shillelagh" spinning at 78 rpms. Although she could barely carry a tune, mom still sang "The Wearin' o' the Green," an old "rebel song" acquired from her jig-dancing grandfather, John Berigan. From both parents we learned that *Erin Go Bragh* meant "Ireland Forever," the differences between "lace curtain" and "shanty" Irish, that bricks were "Irish confetti," that "blarney" was bewitching banter. From both

we came to recognize Irish names and to remark facetiously that we'd dropped the "O'" in our surname after Mrs. O'Leary's cow supposedly tipped a lantern to ignite the Chicago Fire. We grew to determine who was "as Irish as Paddy's pig," who had "the map of Ireland written all over their face," who was "a fine broth" of a boy or girl, and why our messy rooms were likened to "a pig in a parlor."

Sunday outings often involved visits to the Russell family, a quartet of elderly Irish-American brothers and sisters who lived on a farm down the road. There we chased chickens in the yard, petted sheep in the barn, ate homemade bread, and drank spring water. Sometimes I'd hang my ear out to catch fragments of brogue-laced stories concerning Ireland's neverending "troubles" with England, the experiences of Irish-American immigrants, the bygone local house parties where fiddling Red Donnelly entertained, and the fictitious adventures of the wandering bumpkins "Pat and Mike."

When I was ten I traveled with my parents, my brother Mike, and my sister Kathleen back to Ireland where, inspired by another song of immigrant remembrance, we "watched the sun go down on Galway Bay," then kissed the bardic stone in Blarney Castle, and walked the streets of "old Skibbereen." In later years I would go to school in Dublin and join the Irish-American Shamrock Club. Like my parents and siblings, I treasured an assortment of Irish tweed hats, linen cloths, woolen sweaters, glassware, and blackthorn shillelaghs. And my dad once smuggled a lump of peat from an Irish bog past customs, encased it in wood and glass, then hung it on the wall in the family home: an authentic fragment of "the old sod" positioned nearby the poet A.E.'s observation that "we hold Ireland in our hearts more than the land our eyes have seen."

I thought of "Skibbereen" and my own ethnicity especially in the early 1990s while assisting Ken Funmaker or *Wamaniga* (Walks on Snow) in his efforts to establish the Ho-Chunk Nation's "Language and Culture Preservation Program." A native speaker, an elder in the Bear Clan and Medicine Lodge, a singer with an enormous repertoire of traditional songs extending back generations, and an accomplished silversmith, Ken was ever-mindful of his people's forced removal by the federal government to successive reservations in Minnesota, South Dakota, and Nebraska, as well as of their persistent efforts to reclaim portions of a lost Wisconsin homeland. Language, ceremony, song, and material arts have sustained the Ho-Chunk, just as they have sustained my own Irish-American sensibility, just as they have sustained so many more of Wisconsin's peoples who seek connections across time and space with worlds that are paradoxically gone but still their own.

A sense of exile suffuses our folk expressions of ethnicity. Indeed the distinctly ethnic productions of Wisconsin's folk artists are—like my dad's juxtaposed poetry and peat— shards of heart and old sod, of memory and material. As nearby parts that conjure a faraway whole, they are enshrined in exile. Imperiled by dislocation, loss, oppression, adaptation, and assimilation, we necessarily let some old ways slip into oblivion. Yet we continue, modify, and create other traditions. Through them we assert our past heritage and present identity with an often fierce determination.

Consider Jim Razer, an Ojibwa wrenched from his family and placed in government schools, whose stubborn reclamation of traditional arts defies cultural genocide; or Jerry Hawpetoss, a Menominee, whose dreams of a landscape he has never seen—woodland clearings strewn with domed wigwams—are stitched on regalia and danced into existence; or the late Priscilla Manders, an Oneida, who

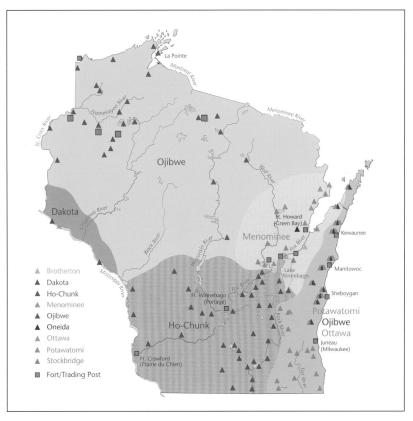

NATIVE-AMERICAN SETTLEMENT
IN WISCONSIN, C. 1830.

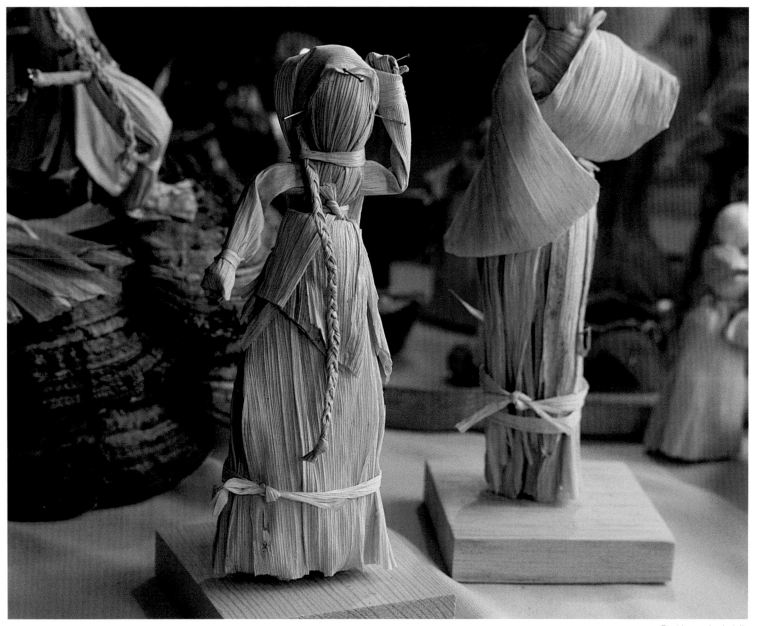

Oneida cornhusk dolls
by Priscilla Jordan Manders,
Oneida.

fashioned corn husks into figures and settings reminiscent of the old ways practiced by her elders. Consider the contemporary heirs of nineteenth century European immigrants: Elda Schiesser, whose delicate *scherrenschnitte* commemorates in paper the 1840s exodus of Swiss ancestors from Glarus to Wisconsin's New Glarus; Bernie Jendrzejczak whose *wycinanki,* executed in diverse regional styles, symbolically unifies a Poland long partitioned by Austrian, German, and Russian empires; and the multitude of Wisconsin Norwegians whose organization of ethnic lodges, celebration of their homeland's independence each *Syttende Mai,* support of museums like Vesterheim and Little Norway, and practice of chip carving, Hardanger lace-making, and *rosemaling* idealize the old world in the new. Consider too the kindred folk artistic impulses of Wisconsin's twentieth century refugees and economic migrants: Elizabeth Keosian whose Armenian needle lace bespeaks the village life obliterated under the Ottoman Empire; Vita Kakulis and Konstantins Dravnieks, whose respective production of Latvian clothing and musical instruments counter from afar the "Russification" imposed on their Baltic homeland; Xao Yang Lee whose "story cloths" alternately chronicle peaceful Hmong village life, the disruptions of war, and the journey to America; and Berta Mendez, whose making and use of piñatas links her Wisconsin-raised children with their mother's West Texas chicana upbringing.

Unified in their exile's reliance on ethnic traditions, these and other Wisconsin folk artists are divided in the means and strategies by which they express their experiences. Their folk arts have variously **survived**, or been **creolized**, or **invented**, or **revived**.

In the first instance, some are practitioners of continuous traditions, of artistic skills that have **survived** despite radical cultural changes. Illustrative of popular notions that folklore is transmitted simply "from generation to generation" without

end, some folk artists have indeed learned to do what they do from family members and neighbors while growing up. In the mid-1960s, for example, Willa Red Cloud of Dells Dam sought help from her mother, Priscilla Mike, regarding the techniques for finger-weaving Ho-Chunk yarn belts.

> *It was back in eighth grade when I had a crush on one of my first boyfriends. I wanted to make him a really nice gift, so I asked my mom—she was working on a belt—and I asked her if she would teach me how to do it. She brought out the arrowhead [pattern] and said, 'If you learn this one, you'll know how to do the rest of them.' I made a thin belt that would fit in his pants, regular blue jeans . . . That is when I first started doing it (Red Cloud 1994).*

When Willa Red Cloud was twenty-four her mother died, leaving a large sash unfinished. Willa braided the ends and wears the sash at powwows, along with another one made by her great-grandmother, Stella Mike: "They are still with us. When I do my weaving, I still see my mom's hands working on it . . . "

As a Rusk County farm boy during the Depression, Leo Hoeft similarly saw his immigrant father, John Hoeft, fashion a potato basket from oak just as he had done in Kashubia along the Baltic Sea's south shore.

> *It was built like a seashell, oblong. When he filled it and dumped it into a [potato] sack, it just filled a 100# sack. He made it here . . . They were farmers over there [in Kashubia]. A very poor country. But they had the traditions of those people (Hoeft 1996).*

Leo too dug potatoes and tried his hand at oaken baskets, but trapping and working with the woodlot's black and white ash trees were more to his liking. Instead of Kashubian potato baskets, Leo Hoeft made snowshoes and trapper's pack baskets in patterns derived from American Indians but widely adopted by many peoples since the fur trade's establishment in northern Wisconsin during the eighteenth century. In other words, Leo Hoeft blended woodworking skills and practical inclinations derived from "the traditions of those [Kashubian] people" with materials, forms, and functions peculiar not so much to America in general but to the particular corner that is northern Wisconsin.

Hardly a direct survival, Hoeft's handwork is decidedly **creolized**—an amalgam of several distinct but interrelated cultural traditions—as is the work of many more of Wisconsin's folk artists. When Wang Chou Vang settled in Eau Claire in the mid-1980s, he could no longer find the sorts of gourds and hides he once used in northern Laos to make the Hmong *nkauj nrog ncas* or two-stringed violin. Rather than abandon instrument-making, Vang adapted metal patio lamps for soundboxes, then covered them with the hides of deer and raccoon hunted in Wisconsin's woods. He seldom uses the instrument to perform the courting songs of his southeast Asian youth, improvising laments instead:

> *I left my mother and father behind,*
> *And I'm lonely in this country*
> *And nobody helps (Leary, Koch, and Teske 1990:64).*

The next generation of American-raised Hmong have gone further, all but abandoning handmade violins and flutes for electric guitars. Yet their rock-inflected music sustains lyrics in Hmong that chronicle the links and gaps between old and new world existence.

Eight decades earlier Waldemar Ager, the prophetic editor of Eau Claire's Norwegian newspaper, *Reform,* recognized the significance of this combinatory, creolized aspect of cultural life in ethnically diverse Wisconsin. He admonished his readers that:

> *What has been accomplished among us has not*
> *been brought about either by the Americanized*
> *Norwegians or by the Norwegian Norwegians,*
> *who just go around and criticize everything, but*
> *by Norwegian Americans.*

It is such people, Ager suggested, who embrace the new and sustain the old, who are in exile yet at home, who "build this country on the basis of the best in both nations" (quoted in Pfaff 1997:1-2).

Waldemar Ager's creolized vision was the pragmatic derivative of a far more ambitious notion advanced by utopian thinkers in the nineteenth century, including those Wisconsin German and Polish intellectuals who spoke, respectively, of establishing *Deutschtum* and *Polonia* in America (Bohlman 1982; Kubiak 1962). Painfully aware of their homelands' political divisions, economic turmoil, class restraints, religious conflicts, and constraints on free expression, they imagined ideal ethnic American societies that combined "the best of both" Old World customs and American democracy. Their utopias, nobly attempted, were never fully realized. Yet they did find a degree of permanent substance in the diminutive creations of folk artists.

Hmong storycloth by Xao Yang Lee
of Sheboygan reflects the
disruption in village life caused by
the Southeast Asian conflict.

Butcher shop whirligig by
Slovenian carver John Bambic,
Milwaukee.

In the early 1940s, while the Nazis occupied much of Europe, Wisconsin journalist Fred Holmes began gathering material for what would become his finest work, *Old World Wisconsin: Around Europe in the Badger State.* On one of his trips, Holmes visited Dr. C.O. Lindberg, a Swedish immigrant, in Grantsberg to confer about Swedish culture in northwestern Wisconsin. After coffee and rusks, Holmes tells us:

> *The doctor took me into his back yard to show me a rock garden in the construction of which he had spent years. It is a microcosm of the Javla community in Sweden where he was born and confirmed and where he grew to manhood. The Swedish countryside for five miles around has been landscaped to exact scale—the birthplace, church, blacksmith shop, railroad tunnel, and all unusual features in the terrain. 'When I grow tired I come out here,' observed the doctor . . . 'It makes me feel young to vision familiar scenes where many of my people and friends still dwell.' The Swedes made of their Wisconsin homes a paradise where the good things of life beyond the sea are still cherished (Holmes 1944:246).*

Unlike "Skibbereen," which counters "talk of Erin's lovely isle" with grim reality, here is paradise not lost but won. Lindberg did not memorialize his reasons for leaving, nor did he imaginatively render his village under its then presentday Nazi dominion. Rather he **invented** an enduring "golden age" by forging fleeting blissful moments into a miniature composition as lovely, whole, and lasting as the figures, "forever panting and forever new," that grace Keats' "Grecian Urn" (see Hobsbawm 1983; Stewart 1984; Boyes 1993).

Nor have Wisconsin immigrants from war-torn countries ceased to invent tiny villages, places in the heart made visible, where peace and stability reign. Born in Slovenia in 1922, Ivan "John" Bambic emigrated to Milwaukee in 1950 after having spent five years in an Austrian "D.P." (displaced persons) camp. He soon found work in the Pfister Vogel Tannery and joined with fellow Slovenians to purchase land

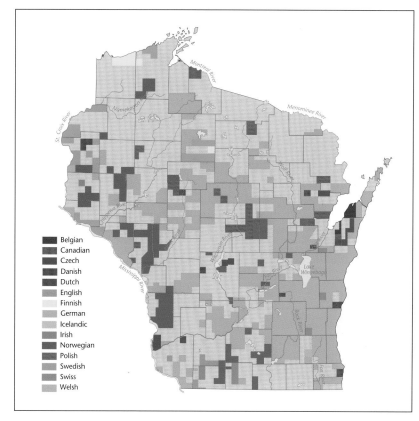

THE ETHNIC PATTERN
IN WISCONSIN, C. EARLY 1900s.

Belgian
Canadian
Czech
Danish
Dutch
English
Finnish
German
Icelandic
Irish
Norwegian
Polish
Swedish
Swiss
Welsh

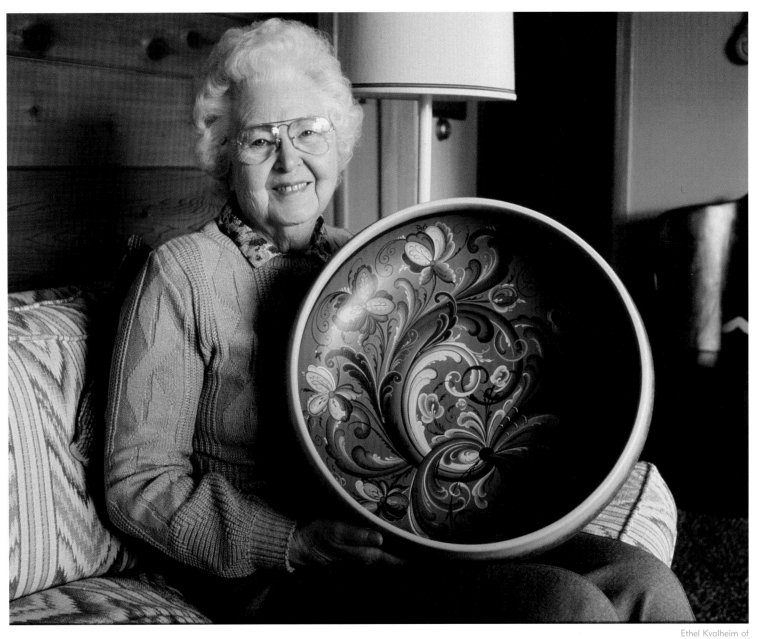

Ethel Kvalheim of
Stoughton displays one of
her *rosemaled* bowls.

in Racine County for what would eventually become Trgatav Park. Outfitted with cottages, grape arbors, and a pavilion for dining and dancing, the Park is a sort of camp. Yet for its builders it does not recall the displaced persons camps so many endured, but rather the Slovenian villages of their childhoods. And in this imagined village they reenact the *Vinska Trgatav* or wine harvest—the culminating moment in a bygone agrarian year (Zwolinski 1994:24-25). An active participant in such nostalgic festivities, John Bambic began in 1980 to fashion his memories into whirligigs—wind animated sculptures—that collectively represent the people and occupations of his home village. A blacksmith pumps bellows, a cobbler nails down a heel, a butcher cuts meat, a carpenter splits wood. All is intact and no bombs fall.

Nikola Milunovich hid with his family in the mountains of Yugoslavia during World War II, then settled briefly in northern Italy before coming to Milwaukee in 1950. Eventually an overhead crane operator for Harnischfeger's and member of the Steelworkers' Local 1114, this now American industrial urban worker took up woodcarving in 1979 to render figures reminiscent of his boyhood in a Serbian agrarian village. And like Lindberg and Bambic, he sought to invent a miniature village, with people gathered around a communal well, a place where harmony prevailed and time stood still.

Still other practitioners of ethnic folk arts are the children, grandchildren, and even more distant descendants of immigrants. Regarding succeeding generations, the immigration historian Marcus Hansen generalized in 1938 that newcomers may retain many elements of Old World culture, yet their children often reject this legacy to embrace America's mainstream. Lacking direct connections with their respective old countries, raised in families where distinctive folk arts have not survived, many members of the third and subsequent generations have **revived** an array of ethnic traditions, have sought their folk cultural "roots" through commited experimentation, study, and travel. Certainly this has been true of Wisconsin's Norwegian-Americans.

In the late 1990s Ethel Nelson Kvalheim, a third generation Norwegian-American from Stoughton, is the nation's most honored living practitioner of the ethnic art of *rosemaling*. Yet Kvalheim, born in 1912, neither fully encountered nor attempted *rosemaling* until the 1940s. She was a farm girl interested in but unable to study art. After marriage in 1933 and an extended stint in a dry cleaning plant, she found herself a homemaker in 1941 with small children and a yen to paint. She began making sketches of her old rural neighborhood near West Koshkonong Church, and her promising landscapes were eventually recognized by the Rural Art Committee of the University of Wisconsin (Barton 1948:89-92).

There was nothing particularly Norwegian about Ethel Kvalheim's initial work, yet she was increasingly fascinated by the paintings of Per Lysne, the founder of America's *rosemaling* revival, whose workshop was located fortuitously just down the block. Soon Kvalheim was studying local *rosemaled* pieces and attempting her own renditions on woodenware. Although she never studied with Lysne, she talked with him often and, in the late 1940s, she enrolled in a workshop conducted by Norwegian *rosemaler* Sigmund Aarseth at Vesterheim, The Norwegian-American Museum in Decorah, Iowa. A dedicated practitioner thereafter, Ethel Kvalheim was recognized in 1969 when she earned the National Rosemaling Association's first Gold Medal. She received a National Heritage Fellowship from the National Endowment for the Arts in 1989, having already won the St. Olav's Medal from the King of Norway in 1971 (Gilmore 1986; Martin 1989:28).

Ethel Kvalheim's aknowledgment by the King of Norway and her prior instruction by a visiting Norwegian testify to the status and the strength of revived ethnic folklore in the Old Country, and to that revival's affect on Norwegian-America. For more than five centuries Norway chafed under the successive domination of Denmark and Sweden, winning its independence only in 1905, then enduring Nazi occupation during World War II. Norwegian political nationalists, not surprisingly, have long championed the

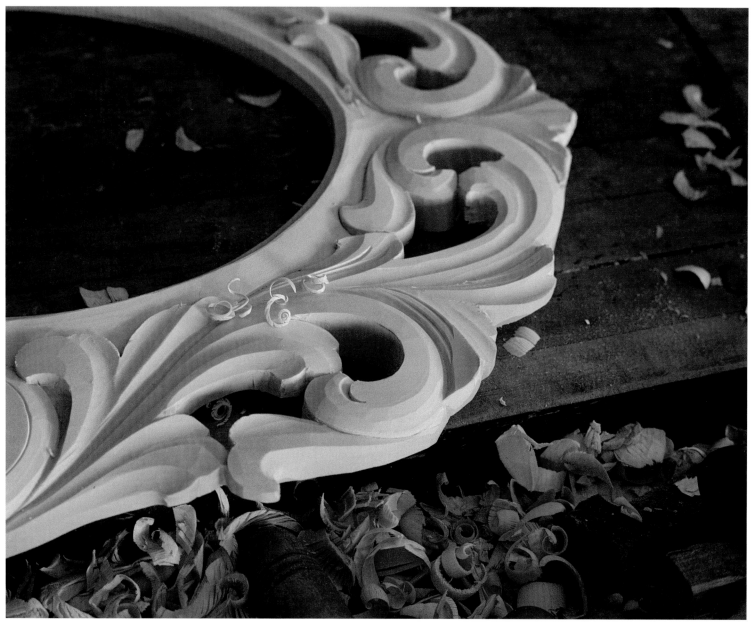

Intricately carved frame
by Phillip Odden,
Barronett.

cultural practices of Norwegian peasants: for their indigenous origins, their intrinsic worth, and their capacity to instill ethnic pride. In the late nineteenth century Norwegian folk arts were incorporated into school curricula generally, while a few specific schools, like the *Hjerleids Husflid Skole,* trained students to become masters of traditional arts.

Phillip Odden of rural Barronett, Wisconsin, learned of the century old *Husflid Skole* in 1976 while visiting relatives in Norway. At the time Odden had been dividing his year between Forest Service labor in Montana and fighting fires in Alaska. Inspired by Eskimo and American Indian carvings, he had begun working on bone, horn, and soapstone in his spare time. The visit to Norway shifted Odden's artistic stance toward his own ethnicity. Enrolling at the *Husflid Skole,* he learned various regional and historical styles of traditional Norwegian woodcarving. There he also met a Norwegian fellow student, Else Bigton, who would become his wife. The couple settled in northwestern Wisconsin and began Norsk Wood Works in 1979. Nowadays their partnership continues to produce new furniture in ancient forms for a grateful clientele, comprised chiefly of Upper Midwestern Norwegian-Americans, whose homes are in some measure temples to the land their forebearers left.

Indeed Wisconsin's ethnic folk arts—whether they have stubbornly survived, or been creolized, or invented, or revived—are as essential to many of their patrons as they are to their makers. Through such arts kindred exiles commune with ancestral worlds that, like "Amazing Grace," are lost yet found in the traditional alchemy of memory and material.

Ethnic folk arts are likewise widely appreciated by cultural outsiders in contemporary Wisconsin. On a given day anyone might encounter any of the aforementioned artists and their work amidst a festival, a craft show, an organization's program; or through a gift shop, a media production, a newspaper article, a museum exhibit. Schools, libraries, and other public institutions, meanwhile, have modified curricula, purchased materials, and allocated funds in recognition and support of ethnic folk arts, their makers, and their communities. It has not, however, always been so; nor, without effort, will it remain so.

During a century and a half of statehood, Wisconsin—its government and its citizenry—has both welcomed diverse peoples and attempted to irradicate their cultures. Hardly an American Indian in Wisconsin over fifty was not taken from his or her family to attend a government or parochial school that taught native cultures were, at best, "backward" and, at worst, "demonic." Throughout the nineteenth century, prominent Yankees deplored such customs of Germans, Slavs, and other European ethnics as the Sunday afternoon beer garden and a preference for education in the mother tongue. Wisconsin's Bennett Law of 1889 eventually made it illegal for any school to offer primary instruction in a language other than English (Rippley 1985:44-45).

In 1914 Edward Ross, a Professor of Sociolgy at the University of Wisconsin and a proponent of Anglo-Saxon supremacy, railed against the influx of Jews and Catholics from central, eastern, and southern Europe. His *The Old World in the New,* aptly characterized as "a scholarly counterpart to the Ku Klux Klan" (Abramson 1980:154), maligned Italians as mentally and morally deficient, characterized Jews as having "little feeling for the particular," and fretted most about "The Alarming Prospect of Slavic Immigration" (1914:106-119,160,139). Mindful of the fact "one-third of all the Polish farmers are in Wisconsin," Ross formulated an ethnic domino theory:

> *When a few Poles have come into a neighborhood, the other farmers become restless, sell out, and move away. Soon a parish is organized, church and parish school arise, the public school decays, and Slavdom has a new outpost (1914:127&136).*

Professor Ross's lurid fears seem almost comic from a late twentieth century perspective, yet his rhetoric continues to be applied to Wisconsin's more recent African-American, Amish, Hmong, and Mexican-American peoples.

Certainly in his own time, Edward Ross's xenophobic ranting was paralleled by considerable Ku Klux Klan activity in Wisconsin, particularly with the onset of prohibition and jingoism following World War I. Mustered against Slavs and Jews in the northern cutover, the Ku Klux Klan in Madison worked in coalition with several University of Wisconsin fraternities, the YMCA, and prominent religious and political leaders. United in their notion that "Americanization" meant conformity to Anglo-Protestantism, they vowed to "clean up" the "Greenbush" neighborhood clustered around Park and Regent streets.

> *The Greenbush was not the most lawless area of Madison, but it was the most culturally diverse. Along with Italians of Sicilian origin, the Bush was the home of most of Madison's Jews and a high proportion of its small African-American population (Messer-Kruse 1993:29).*

The Greenbush neighborhood was ultimately destroyed in the 1960s, like the tenant farmer's home in Skibbereen, by the wrecking balls of urban renewal. Its twice-exiled people, however, persist in gathering to honor their once whole and ongoing existence through the occasional, fragmentary, yet significant folk arts of music, story, festival, and food (Murray 1988).

In the late twentieth century, as we honor Wisconsin's folk arts and artists, we must remember just how hard it has been and still is to keep folk arts alive. At a historical moment when the arts are under attack, when official language legislation is proposed unnecessarily, and when welfare reforms disregard refugee peoples, we must realize that folk arts cannot exist apart from their communities. For surely the exile's "cry of dear old Skibbereen" sounds for us all.

Folklore Program
University of Wisconsin - Madison

SOURCES

Abramson, Harold J. 1980. "Assimilation and Pluralism," in *Harvard Encyclopedia of American Ethnic Groups,* ed. Stephan Thernstrom. Cambridge: Harvard University Press. Pp. 150-160.

Barton, John Rector. 1948. "Farm Girl Saga: Ethel Kvalheim, Stoughton," in *Rural Artists of Wisconsin.* Madison: The University of Wisconsin Press. Pp. 89-92.

Bohlman, Philip V. 1982. *"Viele Einwanderer aus der alten Welt":* German-American Rural Community Structure in Wisconsin," *Midwestern Journal of Language and Folklore* 8:1, pp. 8-33.

Boyes, Georgina. 1993. *The Imagined Village: Culture, Ideology, and the English Folk Revival.* Manchester, England: Manchester University Press.

Gilmore, Janet C. 1986. "Ethel Kvalheim," field report compiled for the John Michael Kohler Art Center's Survey of Wisconsin Folk Art.

Hansen, Marcus Lee. 1938. *The Problem of the Third Generation Immigrant.* Rock Island, Illinois.

Hobsbawm, Eric. 1983. "Inventing Traditions," in *The Invention of Tradition,* ed. Hobsbawm and Hugh Trevor-Roper. Cambridge, England: Cambridge University Press. Pp. 1-14.

Hoeft, Leo. 1996. Tape recorded interview by James P. Leary at Hoeft farm, Bruce, Wisconsin, for the Wisconsin Arts Board's Sesquicentennial Folklife Survey.

Holmes, Fred L. 1944. *Old World Wisconsin: Around Europe in the Badger State.* Eau Claire: E.M. Hale and Company.

Kubiak, Wanda Luzenska. 1962. *Polonaise Nevermore.* New York City: Vantage Press.

Leary, James P. 1985. *Accordions in the Cutover: Field Recordings of Ethnic Music from Lake Superior's South Shore.* Double LP record and booklet. Mount Horeb: Wisconsin Folklife Center.

_____. 1987. *The Wisconsin Patchwork: A Companion to the Radio Programs Based on the Field Recordings of Helene Stratman-Thomas.* Madison: Department of Continuing Education in the Arts, University of Wisconsin.

Leary, James P., Lewis Koch, and Robert T. Teske. 1990. *In Tune With Tradition: Wisconsin Folk Musical Instruments.* Cedarburg: Cedarburg Cultural Center.

Martin, Philip. 1989. *Rosemaling in the Upper Midwest: A Story of Region and Revival.* Mount Horeb: Wisconsin Folk Museum.

Messer-Kruse, Timothy. 1993. "The Campus Klan of the University of Wisconsin: Tacit and Active Support for the Ku Klux Klan in a Culture of Intolerance," in *Wisconsin Magazine of History* 77:1. Pp. 3-38.

Murray, Catherine Tripalin. 1988. *A Taste of Memories from the Old "Bush".* Madison: The Italian-American Women's Mutual Society.

Pfaff, Tim. 1997. "Everyone Brings a Dish to Pass: Gathering at the Community Table," preliminary draft of an exhibit script. Eau Claire: Chippewa Valley Museum.

Red Cloud, Willa. 1994. Tape recorded interview by Michelle Greendeer at the Red Cloud home, Dells Dam, Wisconsin, for the *Hocak Wazijaci* Language and Culture Preservation Program.

Rippley, LaVern J. 1985. *The Immigrant Experience in Wisconsin.* Boston: Twayne Publishers.

Ross, Edward. 1914. *The Old World in the New.* New York: The Century Company.

Sommers, Laurie Kay. 1996. *Beaver Island House Party.* East Lansing: Michigan State University Press.

Stewart, Susan. 1984. *On Longing: Narratives of the Miniature, the Gigantic, the Souvenir, the Collection.* Baltimore: Johns Hopkins University Press.

Wright, Robert L., ed. 1975. *Irish Emigrant Ballads and Songs.* Bowling Green, Ohio: Bowling Green University Popular Press.

"Junque Art"

by Dennis O'Donnell

of Frederic.

UP NORTH:
REGIONALISM, RESOURCES AND SELF-RELIANCE

BY RUTH OLSON

When I was ready to go to college, I moved south to Eau Claire. Where I come from, that's the way we thought of Eau Claire: "Down South." Since then, I've heard a number of people call as much as the top two-thirds of the state "Up North." We Northerners find it all too easy to believe that folks in Madison and Milwaukee consider everything above their cities "Up North," a place they've historically thought of as their playground and resource bank. Where I come from, we're as much a part of Minnesota as we are Wisconsin; we listen to Minnesota weather and we shop in Minnesota cities. Other parts of the North feel the same way about the Upper Peninsula of Michigan. Mention Madison "Up North," and you're as likely to get a sneer and a snort as you are to get an acknowledgement of a connection to our capitol. Only someone from Milwaukee—or worse, Illinois—would mistake the Fox Valley or LaCrosse as part of the real North. Sometimes in the winter we go down to the tropics, Eau Claire, where the temperature can be ten degrees higher than "Up North."

Somewhere among these attitudes lies a region. The boundaries are flexible, depending on the needs of its inhabitants. But like any region, it has its basis in a genuine physical distinctness, in this case through both geography and weather. And like other regions, it has a recognizable culture, one which has affected and influenced the landscape (although not the weather). The folk art you're apt to find in Northerners' homes, more likely to be found on their floors and counters than on their walls, expresses the major concerns of that culture—a dependence on local material, a love of the simple and useful, and a celebration of the woods, water and weather that distinguish Northern occupations and preoccupations from those of city dwellers.

UP NORTH: IN PLACE AND TIME

The North is marked by more than such artificial boundaries as the west-east traverses of Highway 29 or Highway 8. The glaciers that moved through Wisconsin helped to determine some of the differences in the North: its irregularity contrasts to the smoother, more uniform landscape of the South; moraines in northern Wisconsin are more severe than moraines in southern Wisconsin; and glacial activity has provided a noticeably larger number of lakes in the North.(Mickelson 1997) The chilling effect of Lake Superior and the significantly shorter growing season prevent the kind of productive agricultural enterprises common to the South. Instead, you're more likely to find large stands of birch, aspen and especially evergreens. Northern Wisconsin lies on the southern edge of the great boreal forest that extends north through Canada to the Arctic region, assuring that both the trees and the wildlife of the North are different from those in the South. There's an abundance of the more well known woodland creatures, like the white-tailed deer, the black bear and the bald eagle, and the presence of the more rare, like the pine marten and the loon. (Vale 1997) Reflecting the significance of this unique surrounding, northern artisans often create in wood their appreciation of nature, from oak leaf motifs on gun stocks, and chainsaw carvings of bear, to replications of fish and ducks for use in hunting.

The influence of the environment on northern residents' lives is pronounced in their art, but this influence doesn't only work one way. The evidence of the people who have lived here, from generations back to recent arrivals, is everywhere. The presence of towns—former mill towns—along northern rivers serves as a reminder of the region's

logging past. (Bawden 1997) Small farms and abandoned barns show more recent economic trends. Lakes burgeon with docks and vacation homes. The increasing number of aspen stands show the current legacy of logging pulpwood. And everywhere, as common to the North as the trees themselves, hunting shacks, rustic to fancy, dot the woodland landscape.

The distinctness of the region is evident in the number of names it has had even since European settlement. From the time the Wisconsin Territory was organized in 1836, including land in the northern part of the area ceded by the Ojibwa, Menominee and Ho-Chunk, the forests and waterways of the North have shaped the region's identity. After the resources of the "Pineries" were harvested by fur traders and loggers, the logged "Cutover" drew homesteaders. After the 1920s, as many farmers abandoned their struggle with short growing seasons and poor soil, tourism and recreational hunting and fishing began flourishing in the reforested "Northwoods." Drawn by the lakes, rivers, and wildlife, tourists have traveled up to play in "Indianhead Country." Even today, the naming of the region continues to point to its resources and its concerns: some have considered northern Wisconsin and the upper peninsula of Michigan as "the State of Superior," indicating the widespread feeling of separation northern residents feel from the wealthier, more populous south; others refer to the area as the "Ceded Territory," acknowledging the treaty rights of the Indian groups who lived there before the Wisconsin Territory was established.

The contemporary folk art produced by northern loggers, farmers, hunters and fishing enthusiasts demonstrates that the forms of occupation that originally drew people to the area still persist. Logging continues, as does trapping and dealing in furs. Agriculture, too, remains, but rather than the larger agribusiness-influenced dairy or meat production enterprises typical further south, there are more small farms and agricultural concerns distinctive to Wisconsin. Ginseng and cranberries, indigenous to the state and long ago gathered and cultivated by loggers, are most common in Wisconsin's northern counties. While cranberry bogs

tend to be operations excluding other forms of agriculture, ginseng has been mostly a sideline for part-time or small dairy farmers. In Marathon County, where most of the ginseng in the state is grown, family dairy farms are the norm. Farmers or people who work in town will have about two acres a year "under cover" (in ginseng). As one grower jokes: "Ideally, you don't want to plant any more than your wife can harvest."

Tourism, long a fact of life in the North, is recognized as a mixed blessing. Only the annual procession of tourists to the North's lakes and woods allows many Northerners to live up there year round. Because tourists are outsiders, they become one of the bonding forces for residents of the North. The presence of outsiders offers the opportunity for naming and signifying just who is who. Many residents of the Northwoods still refer to themselves as "Jackpine Savages," in reference to the scraggly, tough trees found everywhere in the region. They like pointing out their roughness and lack of civilizing influences, in strong contrast to the transitory population crowding the northern roads and lakes every summer. Developing names and acronyms for outsiders is one way to distinguish real residents. Calling someone a FIB, for example, uses an open secret to express what Northerners and other Wisconsinites often think of those pushy people from Illinois. Most importantly, calling someone a FIB means residents are sufficiently confident of shared attitudes to feel comfortable using that acronym. Drawing clear lines between insiders and outsiders is one way to promote a sense of community.

REGIONALISM

The word "community" gets slapped on with a pretty broad stroke these days, both by academic specialists and by the media. We speak of the "agricultural community" or the "Native American community" as if these were indeed unified groups. By doing so, we emphasize some elements that a large disparate group of people may share, and ignore for the moment the many different elements that in

reality separate people within the group. Because the term's stress on unity lends it positive force, it can readily be made into a metaphor for political purposes or boosterism. (Williams 1983)

Regionalism, on the other hand, incorporates both a sense of self and a sense of place. Where community implies a less graspable notion of grouping, regionalism is more apparent and thus less susceptible to boosterism. Folklorist Barbara Allen has listed several elements essential for a region to exist: first, *place,* since a region has to have a geographic reality; second, *people,* whose lives are in part determined by the conditions and resources where they live; next, *history,* both of the residents' lives and of their influence on the place; and finally, *distinctiveness,* from its surrounding environments and from the whole of which it is a part, either economically, historically, culturally, or in some combination of these three factors. (Allen, p.2) There needs to be a regional consciousness, a regional sense of self. A region is, after all, an idea, a subjective reality as well as an objective one. Its subjective reality is most palpable in the ways people express their sense of the place. In Northern Wisconsin, that expression takes place through a number of connections and shared concerns.

A Connection and Response to the Physical Conditions of the Area Many of the people who live in the North enjoy— or are at least used to—the challenge of living with a short growing season, a severe winter, and wooded and swampy areas sometimes difficult to travel through. Tom Nelson of Ashland found that surveying took him through a lot of country. As a boy, he had begun making snowshoes because he admired a pair he saw. As a surveyor, he wore the snowshoes he made because they were necessary to get around in the winter.

Naming the landscape is a common response to place among people, like those from Up North, who tend to spend a lot of time out-of-doors. Jack Swedberg of Burnett County explains how his hunting crew communicate with each other:

> *...we have pet names for different areas that we hunt, you know, 'Jim Ball's Field'.... Jim Ball was an old pioneer years ago up there who tried to farm in Swiss Township in the sand and almost starved to death. But the old section where he farmed, that's 'Jim Ball's field.' And his field is the tallest trees you've ever seen, you know.... And if you tell one of our 14 year olds, ...'Okay, you go on up and get on the north end of Jim Ball's field,' he'll know exactly what we're talking about.*

An historic photograph from the Mert Cowley Collection shows an Eskimobile Sno-Tank built by the Swanson Machine Co. of Almena, Wisconsin.

Such local names for familiar places are common in closely knit communities, and efficiently allow insiders to pinpoint precise locations. This familiarity with locations and conditions, this ability to cope with and communicate essential features of the environment, bonds residents to the land and to each other.

A Connection to the Resources of the Area Such is the case for Della Pleski, who makes many of her baskets from raffia she orders from a supplier, but accents them with materials she's gathered around her rural home in Foxboro. Her most special baskets, the ones she uses herself or makes for family, feature splints and trim harvested from local trees, like an old apple tree from her childhood home. A few years back, when the jumble of old antlers her husband had accumulated from previous years' hunts grabbed Pleski's attention, she decided to experiment with antler handles for her baskets, so that those old antlers wouldn't go to waste. Those baskets were snatched up. She has found that hunters order these baskets from her as a different way to display their trophy—some prefer a useful basket handle to a mounted rack. The value of these baskets isn't limited to hunters; Pleski has also made a basket for a woman who hit a deer with her car. "It's the most expensive basket I've ever gotten," the woman sighs, remembering the damage to her car, "but at least I got something out of the experience." And in typical Northwoods fashion, barter is often part of the process of Della's basketmaking; hunters frequently will trade a bag of old antlers in exchange for her labor.

A Connection to Time, Particularly Seasons of the Year One typical farmer in Douglas County describes his year in terms of the type of hunting and fishing he does. The year begins with fishing for suckers, which he likes to pickle or smoke. Early spring is marked by the smelt run; summer blossoms into a panorama of fish—panfish, bass, northerns, walleyes; fall is marked by hunting; and winter is the time for ice fishing. In this way, time moves from season to season as he fills his freezer with fish, grouse, duck, deer and sometimes bear. Even his work day shows the integration of hunting and fishing with the rest of his life. In the summer, this dairy farmer prefers fishing for walleye because they start biting just about the time he regularly finishes milking and can get out onto the lake—first star-rise. And in the early fall, he finishes his evening chores so that near twilight he can go out to his stand to bait and watch for bear and other wildlife.

A Connection Among the Members of the Community Indicative of the folk ways of Northern Wisconsin is the habitual adaptation of both European- and native-based traditional activities among residents. For example, one wild rice harvester of mixed heritage uses an old winnowing mill to fan his rice. A number of people of mixed blood dwell Up North, and the names they have for themselves explain their ancestry: Findians, Scandindians, Norwindians. Ethnicity remains a way for people to identify themselves. While there are still ethnic enclaves—places apparently ethnic in their town names and within their phone books—marking ethnicity has become a way to celebrate community heritage. Everyone in the community shares the heritage, whether or not they share the ethnicity. But there are still other ways in which residents of northern communities form bonds with each other.

Polk County dairy farmer Dennis O'Donnell is intricately connected to his community, not only because he was born, grew up, and has always worked there, but also because his community is interested in what he is doing. O'Donnell learned how to weld from an uncle who worked at the machine shop in Frederic. Now he uses his welding skills not only to repair his farm machinery, but also to create wacky sculptures out of old equipment parts. O'Donnell's "junque art" entertains his friends and neighbors; in fact, people from all over the community keep their eyes open for interesting scrap metal for him. Many of his sculptures end up as gifts to local people. O'Donnell's community appreciates his art because they understand the syntax of these pieces; they can identify the parts and see how they make sense as a new whole.

When the local sheriff indulged himself in the purchase of an old tractor, O'Donnell teased him, saying he'd make him one in better shape that would be less trouble. The miniature tractor he made has a moveable steering wheel, a spring seat, and even a P.T.O. All these things, especially the Power Take Off, are recognized and appreciated by people who know tractors because they use them every day. If O'Donnell had intended this tractor as something to sell to

city residents, he wouldn't need to include such features. These extra touches communicate that he knows the sheriff shares his detailed knowledge of tractors. Such shared understandings build connections in communities.

A Connection to History and a Sense of the Past Many Northerners involved in traditional occupations feel a real connection to the past through their work and speak of their occupational lives within the contexts of these ongoing traditions. For example, a fur trader from Burnett County reflected recently on the fur market's fluctuations. In the 1980s when fur prices were high, there were about 300 fur buyers active in Wisconsin; now he only knows of six. In spite of this sharp decline, he believes there will always be a market for fur. He points with satisfaction to nearby Fort Folles Avoine, a fur trading post from 150 years ago which sometimes features re-enacted rendezvous, while just down the road he carries on the still-viable tradition of fur trading.

Another person strongly connected with the past is Mert Cowley, deer hunter extraordinaire. Cowley is known regionally as a hunting poet—in fact, the "jackpine poet." Cowley likes to hunt with old hunting equipment. For a number of years he hunted deer with black powder; he also has re-built and driven an old Model A to his deer camp during hunting season. He collects old guns and his deer camp is about 100 years old. Cowley thinks a lot about the connection between himself and the land's past; he has mentioned places where he could just "feel" the presence of arrowheads. He claims he has the most archeological finds to his name of any amateur in the state. Cowley freely acknowledges his sentimentality and romantic tendencies. He worries that with divorces increasing, fewer fathers have the chance to teach their sons in the wild. He also worries about the decay of deer camp culture and has informally documented a number of deer camps that have fallen into disuse. His recent publication of a book on the history of hunting in Wisconsin furthers his mission; he believes that by keeping hunting's history alive, he will keep the tradition alive as well.

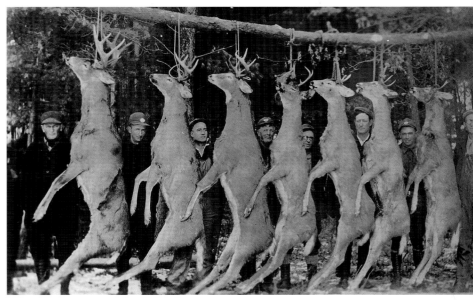

Another photo from the Cowley Collection documents a deer hunting party following a successful hunt.

A Playfulness with the Symbols and Materials of the Area Dennis O'Donnell is a good example of a folk artist who uses occupational skills in his leisure-time self-expression. His creations feature animals, tractors, cowboys—representations of what he sees and what reflects his own life. Besides welding and farming, he worked for a number of years as a farrier. He still uses left-over horseshoes to make cowboy figures, or as legs for his "farmacue" grill, a barbecue made entirely from farm equipment parts. O'Donnell's art emphasizes innovation, new ways of looking at things, and especially humor.

He pokes fun at city people, since they pay for things that are rusty. He's made a number of pieces of lawn furniture from old metal for people from the Twin Cities, who have then refused to pay for the pieces unless they were more rusted. He distinguishes between what city people value and what he values. "If it's useful, it won't sell," O'Donnell says, relating his experience of making a cookbook holder

that he thought was a particularly good idea. He has yet to sell one, although they've been popular gifts to his family. Because he treats his art as a hobby, he has a devil-may-care attitude about his work. When people stop buying, O'Donnell will just keep farming.

RESOURCES

The natural resources of the area are crucial for many residents. Local people hunt ducks, partridge, small game and more notably, bear and deer, more for food than for trophies. People also fish to eat: most popularly crappies, bluegill, bass, walleyes, northern pike and musky. While many need to harvest resources in order to eat, most Northerners also place a high priority on producing their own food because they have high standards for what they eat—what they put on the table is better and fresher than what they could get at the store. The combination of avocation and vocation—using sportsman skills, or what have come to be identified as recreational activities, for self-sustenance—is a distinct feature of the North. A high value is placed on what makes good use of these resources. Thus, most of the objects from the North in this exhibit feature the art of everyday life, of the useful. And objects whose functions aren't immediately clear are often recognizably made with everyday tools.

Everyday Objects One characteristic that distinguishes life in the North, and in Wisconsin's rural areas in general, is the value placed on homemade things and the ability to reuse materials. Within the home, beauty gets emphasized in the practical and the common, as in Lauretta Suhr Neubauer's corduroy quilt. Neubauer's quilts are made chiefly for bedding, from whatever materials are available. Yet her selection of fabrics and patterns results in a statement of Neubauer's aesthetic preference and values, and adds warmth and personality where an impersonal store-bought blanket or comforter would do. Similarly, Inez Robertson's rag rugs, made from rags collected and saved, add color and pattern to a kitchen's working spaces or other heavily used places in a home. Quilts and rugs made from scraps exemplify traditional "subsistence-style" fabric work, in that they use what is on hand to construct completely new products, of affordable beauty.

Many of the items that mark the material culture of the North relate to surviving cold winters. Ethel Wetterling Soviak of Ladysmith, for example, knitted her wool socks specifically for wearing in cold weather. While it might be more convenient to buy wool socks from a store, according to Soviak they were not guaranteed to wear as well as hers were. Tom Nelson, a surveyor who makes snowshoes for himself and other outdoorsmen, emphasizes that a major portion of the year can be spent on snowshoes; they are not only for sport, but actually necessary just for getting around. Nelson and Soviak, like Robertson and Neubauer, create aesthetic objects that rely not on their beauty but on sound construction, effectiveness and appropriateness in harsh environments—indoor or outdoor—that sometimes demand more than the generic.

Just as domestic space allows the everyday to reflect the maker's and user's values and aesthetics, beauty and value are emphasized in other places as well, such as the environments of hunters. Patrick Farrell, who builds skiffs for duck hunting, produces only one boat a year. His concentration on sturdiness and practicality makes his boats both simple and pleasing. In many ways, Farrell's boats are a community project. He works only with local wood, for example, and learned his skills from his neighbors and from family friends. As a hunter himself, and as part of a network of craftsmen and outdoorsmen who value the outdoor traditions of their region, the choices Farrell makes as he builds each boat reflect his community's values.

Duck decoy

by Patrick Farrell,

Green Bay.

Bear chainsaw

sculpture

by Jeff Prust,

Hurley.

In the work of some folk artists, the common values of practicality and simplicity are less apparent than are traditional ornamental concerns; nonetheless, even objects which the folk artist decorates are representative of the community, and of common use. The tradition of hunting in northwestern Wisconsin bonds families and friends, and serves as a fundamental and unquestioned basis for community. Sam Rust's work restoring heirloom rifles and carving gunstocks is highly valued within his region. Typical of community artists, Rust works mostly for himself, his friends and his family, employing woodworking skills he learned from his uncles, who in their day also worked on guns in their home shops. Rust uses the same patterns his uncles used, especially checkerings and oak leaf motifs. Rather than relying on pattern books, he scratches animal and floral patterns freehand onto the gun stock before carving. These motifs are traditional, emblems inspired by nature, both regionally and historically familiar. By repeating them, Rust deepens their symbolic connection to the local hunting community.

A slightly different aesthetic is employed by decoy makers. Their primary (and original) concern is to create a replica so life-like that it will effectively entice the prey. The carver is not just concerned with the decoy's shape and detail, its coloring and proportion; he also has to be concerned with durability, accuracy, and balance—properly placed weights in the bottom of the decoy. John Snow, from the Lac du Flambeau Band of the Ojibwa, has used years of experience and observation to assure that his fish decoys will "swim" realistically when they are jigged. Snow uses his decoys to ice fish traditionally, with a spear. Yet many decoy carvers who originally created objects meant purely for utilitarian purposes—the harvesting of fish or fowl—have found that their work is now celebrated by people outside their local communities for very different reasons—as objects of art. Thus Milton Geyer made two types of duck decoys, for hunting and for collecting. Through materials used and through function, Geyer distinguished between these two types. For example, where his working decoys got painted glass eyes, his collector's decoys got glass "taxidermist's eyes," less practical but more lifelike.

Extraordinary Objects Made by Everyday Tools Sometimes things intended for one function end up being used for another. Certainly this is what has happened to decoys, which have proved so popular with collectors. Dennis O'Donnell began making his "junque art" as the result of an experiment. He thought that an old plowshare looked so much like the body of a goose, he used it to make a decoy. He was sure his creation would draw geese to the field. But then O'Donnell considered its weight: "Can you imagine lugging around a sack of those things?" O'Donnell welds together his whimsical creations from old farm machinery parts, using the torches he uses for his own farm equipment repairs in his machine shed. He does most of his artwork in the winter when he has fewer daily chores, providing it isn't too cold to work in his shop.

Jeff Prust, too, uses a tool common in the North—the chainsaw—in order to carve his sculptures. Many of Prust's sculptures capture the animals typical of the North: wolves, eagles, bears. His carvings range from imposing to whimsical. For his bears especially, Prust likes to focus on character, recreating human emotions on their faces and in their stances. He has specialized the chainsaw's use to his purposes—he owns a series of differently sized saws to work on different details. Prust's collection of chainsaws can be seen as the result of his modified use of these tools; for cutting firewood, in contrast, one chainsaw is really all one needs.

Both Jeff Prust, with his chainsaws, and George Ellefson have created art with the tools of traditional occupations. Ellefson, who for many years fished Lake Michigan commercially, found himself after his retirement continuing to work with the tools and with a medium with which all working fishermen are familiar—he began to shape wooden models of the different fishing vessels he had owned or fished in. While whittling is common for sailors, Ellefson's whittlings of miniature boats and other fishing gear are remarkable for their detail—he includes the floats and pike

poles, and even paints the bottoms with the type of copper paint used on real boats. For many traditional occupations, retirement doesn't mean that a craftsperson need be totally cut off from long-nurtured skills and interests. Until his death in 1990, Ellefson continued to participate in his life's work, through memory made concrete. For his neighbors and friends, Ellefson's miniatures act as a symbol for, and inspire discussion and commentary on, their region's way of life.

Miniatures and Mammoths Loggers and farmers as well as fishermen can use their retirement to create miniature versions of their past experiences. But craftspeople can also create giant models of tools or objects they are used to using every day. Where miniatures take what we expect to be big and make it small, mammoths take what we expect to be small and make it big. Both forms of exaggeration increase our attention and scrutiny. We marvel, and examine more closely, and see our preoccupations in new light. The power of both miniatures and mammoths lies in their creation of a fantasy, a new way to view the recognizable elements of our world.

Miniature work scenes and miniature objects can act as memory aids; we look for the details that we remember, or we are surprised to see particular details recreated minutely. John Henkelman, a farmer and teamster who started carving at age 65, has created miniature logging replicas that show typical scenes from an old-time lumber camp. Sharing the impulse of other such re-creators of past work scenes, and following the regional aesthetic, Henkelman carves what he knows, focusing on logging scenes, wildlife and other natural themes. His use of many different woods reveals his continued connection to resources. For example, in his carving of a skidder with a team and crew toploading a logging sleigh, the small logs are maple, the sled hard maple; the men are of butternut—one holds a hickory cant hook; the horses are butternut and sport a buckskin harness. The scene took John most of a winter to complete and he himself is the skidding teamster.

This attention to detail is also important to Carl Vogt, who builds miniature traction engines (following an inch-to-a-foot scale), models of the gas engines formerly used on farms to run such equipment as threshing machines, pumps, and cream separators. All Vogt's engines are in working order and fitted out with a set of batteries. Vogt was born in Buffalo County, where his father did carpenter work and farmed, learning to speak Norwegian so that he could communicate with the other farmers in his threshing ring in "Norwegian Valley." Vogt's father generally bought used equipment which he and his son fixed together. Vogt worked a number of years in a machine shop; he now machines the parts for his miniatures in his basement shop. He takes his miniature engines to engine shows and thresherees, where enthusiasts of farm implements—both full-sized and miniature—gather and reminisce about the old days.

Images of threshing have come to symbolize a type of farming intensely community-based and community-dependent, not viable for today's farmer, certainly not up North where small farms are embattled. Lavern Kammerude's painting of a threshing dinner captures an event that no longer exists in contemporary farming. As such, the painting can serve as a prompt for memory, as old timers who have taken part in threshings can retell their own stories about past harvesting seasons. Such images can also feed nostalgia, reducing the image's ability to educate and increasing its ability to evoke sentiment, a desire for a past no longer possible except as it is recreated by those who long for it. In more than one sense of the word, such details can become precious.

But with mammoths, where the inconsequential can become overpowering, we may find our attention expanded, our view of the significance of the object exhilarated. Such is the case for the giant fishing lures that Jack Swedberg makes. Swedberg began making fishing lures about the same time that he started collecting them. He fished with some of the old lures he had collected, and began making replicas of old Heddon musky lures because he found they were catching fish, and he didn't want to chance losing his originals. He made his first giant lure to advertise his original-size usable replicas at a collector's

Miniature horse-drawn

farm wagon

by Bill Malone,

Cedarburg.

show. The first thing he sold was the giant lure and he went home with orders for more. For awhile, Jack continued to market his "usable lures," but found that people's expectations for them were more appropriate for mass produced lures; they weren't willing to pay the price for hand-worked lures and complained if colors faded or chipped over the years. Jack began exclusively making what he now calls "feelable art," giant lures of the models he first made as usable lures. He goes to many shows, and finds that he has ready customers who believe his work is bound to increase in value. His work is valued among collectors because he carefully replicates the more recognizable old favorites, and perhaps because his lures' exaggerated size speaks to the out-of-bounds enthusiasm of lure collecting lunatics and fishing fanatics.

SELF-RELIANCE

Historically, the northern counties of Wisconsin are the least populated and the poorest. Traditionally, residents have had to participate in a variety of subsistence forms in order to survive: in the earlier part of this century, many lived on small farms, logged in the winter, hunted and fished to put meat on the table, gathered wild berries and foods to preserve for winter, relying on the land for fuel, sustenance and shelter. Today this close relationship and identification with the land continues—and so does the scrambling to survive, as people patch together work and ways to make money in order to stay in an area with few job opportunities but with tremendous natural beauty.

Northerners have always been self-reliant, in that they have always had to depend on their own capabilities and resources to get by. But being self-reliant is not at all the same thing as being self-sufficient, providing for oneself without the help of others. Residents of Northern Wisconsin are not cut off from the rest of the world. As members of a larger society, they are as susceptible as everyone else to current trends and twists in the life of the state and nation. People adorn their homes with cute images of cows but

remove dairy products and beef from their diets. Decoys become high-priced collectibles but hunting finds itself under a disapproving public eye. Chainsaw sculptures sell like hotcakes but loggers feel themselves an "endangered species," misunderstood by protesters who place a higher value on preserving forestland than on preserving the loggers' traditional way of life. Thus, the objects northern artists produce sometimes are influenced by social and economic systems outside the region.

What happens when everyday objects come into contact with larger social forces and have to change? Sometimes the things of every day become items for display rather than for use. They may deliver a muted message, like the decoy which uses glass eyes and isn't painted or prepared to actually be used on the water; or they may provide a good firm nudge to the ribs, like the giant fishing lure, very clearly not for actual use. Quilts sometimes become "wall quilts," decorative hangings more in line with the limited time seamstresses have these days, and less practically useful. Their role in the domestic environment has dramatically changed.

Baskets which in the past were used until they were used up are now also collectible objects and artifacts; fewer people know how to make them, which increases their value and decreases their use. A number of years ago Eino Hakamaa, a Finnish immigrant to the Hurley-Ironwood area, was one of the few people who made cedar baskets, a skill he learned through his work as a logger. This was a skill Hakamaa wanted to pass on to his children, but their work schedules precluded them from having time to learn. The making of baskets is no longer an expected part of one's normal workday; it takes a special and concentrated effort to learn traditional skills out of context.

Ray Steiner makes his willow baskets as a hobby. He makes around 75 or 100 baskets a year, most of them going to neighbors and family. Steiner learned his skill from a neighbor, Ernest Lisser, who used to make willow baskets in Switzerland, and who made baskets as an old man in

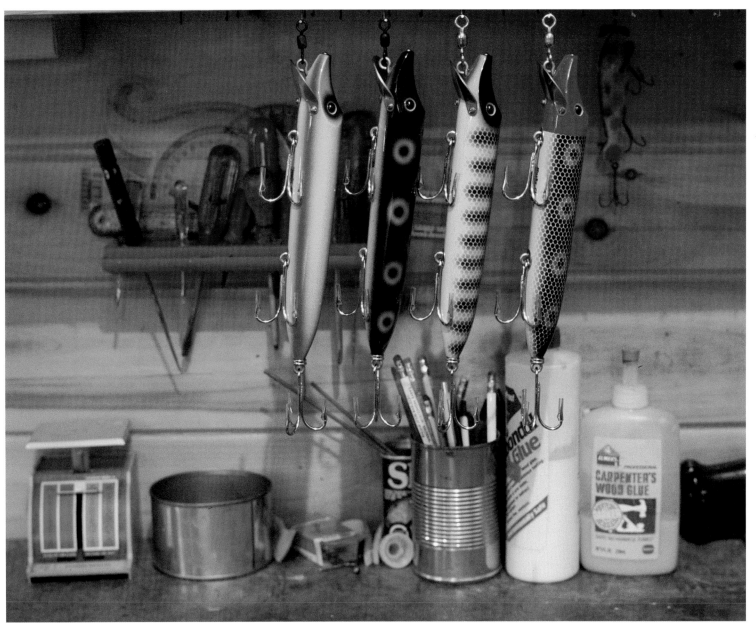

Musky lures

by Jack Swedburg,

Webster.

Wisconsin for extra money. After Steiner offered to cut willow for Lisser in exchange for a few baskets, Lisser insisted that Steiner make his own. Now Steiner uses basketmaking as a way to re-connect with his cultural past as a Swiss-American. Steiner emphasizes that these baskets were originally used for farm work, but he has changed the design that Lisser taught him. Rather than inverting the bottoms of his baskets, as Lisser used to do for added strength, Steiner makes them flat; and rather than making the sides of the baskets straight, he flares them slightly, so that fingers can get inside more easily. These adaptations allow his baskets now to be used to carry casseroles and pies. Steiner's baskets are still useful, but no longer for work on the farm.

CONCLUSION

It's a tumultuous time Up North. Embedded in this region is the place called "the New North." Back-to-the-landers, same-sex couples, alternative cooperative living groups, some who cry out in defense of endangered species, some concerned about the deleterious effects of strip mining, some worried about the effect of overlogging the land—these all number among the new settlers of Northern Wisconsin. Some residents from families who've been Up North for generations feel under attack for the way they've learned to do things. As a result, groups which in the past were characterized as independent and individualistic are tightening up. Many trappers, for example, feel under fire from animal rights activists, and have drawn together to protect themselves and share their knowledge. Unlike past years, older trappers are willing to give younger trappers the benefit of their experience; perhaps they have less reason to protect their secrets; and perhaps pressure from people outside the industry has increased the camaraderie within it.

Some of the new residents, however, re-animate old traditions, sometimes becoming more Northern than the Northerners themselves. New people are taking up wood carving, taxidermy, weaving—and some back-to-the-landers

in the past decade even formed a threshing ring within their community of small farms. Sometimes new residents and old find that what they have in common is ultimately greater than what they differ on—the enjoyment of the natural resources around them, especially in food that is fresh and untainted; the sense of self-reliance that comes from taking care of oneself in a variety of daily chores, as one must to live in the country; or simply the gift of living in a region that allows them to teach their children to love nature, in the many forms that can take.

Wisconsin Folklife Festival
Madison, Wisconsin

SOURCES

Allen, Barbara. "Regional Studies in Folklore Scholarship." In Barbara Allen and Thomas J. Schlereth, ed. *Sense of Place, American Regional Cultures.* Lexington, Kentucky: The University Press of Kentucky.

Bawden, Timothy. 1997. "The Northwoods: Back to Nature?" In Robert C. Ostergren and Thomas R. Vale, ed. *Wisconsin Land and Life.* Madison, Wisconsin: The University of Wisconsin Press.

Mickelson, David M., 1997. "Wisconsin's Glacial Landscapes." In Robert C. Ostergren and Thomas R. Vale, ed. *Wisconsin Land and Life.* Madison, Wisconsin: The University of Wisconsin Press.

Vale, Thomas R. 1997. "From End Moraines and Alfisols to White Pines and Frigid Winters: An Introduction to the Environmental Systems of Wisconsin." In Robert C. Ostergren and Thomas R. Vale, ed. *Wisconsin Land and Life.* Madison, Wisconsin: The University of Wisconsin Press.

Williams, Raymond. 1983. *Keywords: A Vocabulary of Culture and Society.* New York: Oxford University Press.

EXHIBITION CHECKLIST

EXHIBITION CHECKLIST

EXHIBITION CHECKLIST

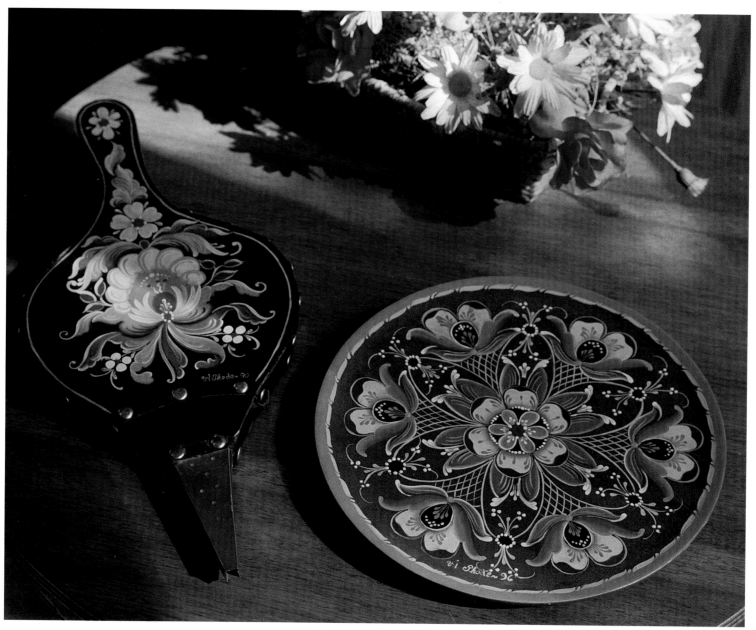

Rosemaling

by Vi Thode,

Stoughton.

WISCONSIN FOLK ART:
A SESQUICENTENNIAL CELEBRATION

EXHIBITION CHECKLIST

I. INTRODUCTION

DAIRY FARM SIGN
Florian and Julie Zajackowski
Milladore
1997
Wood, painted
52" x 52"
Loaned by the Zajackowski Family

II. KEEPING TRADITION

A. Consistency

HO-CHUNK KETTLE BASKETS
By Ruth Greengrass Cloud
Baraboo
1986
Black ash splints, commercial dye, white ash handle
10 x 9" diameter each
From the Wisconsin Folk Museum Collection of the State Historical Society of Wisconsin

HO-CHUNK MARKET BASKET
By Bertha Greengrass Blackdeer
Wisconsin Dells
1995
Black ash splints, commercial dye, white ash handle
14 x 17.75 x 10.5"
From the Wisconsin Folk Museum Collection of the State Historical Society of Wisconsin

CHEESE BOXES
By Dufeck Manufacturing Company
Denmark
1997
Basswood or poplar veneer, nails, staples
5 x 8" diameter to 17.5 x 20" diameter
From the collection of the Cedarburg Cultural Center; donated by Dufeck Manufacturing Company

NORWEGIAN HARDANGER FIDDLE
By Ron Poast
Black Earth
1989-90
Sitka spruce, Gabon ebony, curly maple, mother-of-pearl, abalone
c. 25 x 9 x 4"
Loaned by Ron Poast

B. Continuity

ONEIDA CORNHUSK DOLLS
By Priscilla Jordan Manders (1907 - 1997)
DePere
1993
Cornhusks, natural materials
15 x 6 x 8" and 8 x 5 x 5"
From the collection of the Cedarburg Cultural Center

ONEIDA CORNHUSK DOLLS
By Kim Cornelius Nishimoto
Oneida
1995
Cornhusks, nylon thread, calico, wool, deer hide, glass beads, feathers, ash splints
9 x 4 x 1" and 10 x 4 x 1"
From the Wisconsin Folk Museum Collection of the State Historical Society of Wisconsin

AFRICAN-AMERICAN EIGHT-POINTED STAR LAP QUILT
By Allie Crumble
Milwaukee
1991
Cotton/polyester blends, hand-pieced and hand-quilted, machine-edged
38 x 42"
From the Wisconsin Folk Museum Collection of the State Historical Society of Wisconsin

AFRICAN-AMERICAN EIGHT-POINTED STRING STAR QUILT
By Ivory Pitchford
Milwaukee
1990
Cotton/polyester blends, hand-pieced and hand-quilted
92 x 92"
From the collection of the Cedarburg Cultural Center

LATVIAN MITTENS
By Ieva Lacis (1856 - 1940),
Alma Upesleja, and Anna Vejins
Greenfield
1920, 1969, and 1954
Wool, knitted
9.5 x 4.5", 11 x 4.25", 11.75 x 5.5"
Loaned by Anna Vejins

C. Creativity

WOODEN CHAINS, BALLS-IN-CAGES, AND WOODCARVERS' TESTS OF SKILL
By Adolph Vandertie
Green Bay
c. 1955 - 1988
Basswood, hand-carved
c. 9.5 x 0.5 x 0.5" to 15.5 x 0.5 x 0.5"
From the Wisconsin Folk Museum Collection of the State Historical Society of Wisconsin

SLOVENIAN WHIRLIGIGS:
Butcher Shop, Shoemaker, Pig Roast, Boxing Match, and Dancing Bears
By John Bambic
Milwaukee
Late 1980s - 1990s
Wood, carved and painted; wire
c. 15 x 10 x 10" each
From the collection of the Cedarburg Cultural Center and the Wisconsin Folk Museum Collection of the State Historical Society of Wisconsin

HMONG FLOWER CLOTHS *(PAJ NTAUB)*
By Xao Yang Lee
Sheboygan
1990s
Cotton/polyester blends, appliqued,
cross-stitched, and embroidered
17 x 17" and 18 x 33"
From the collection of the Cedarburg
Cultural Center

HMONG FLOWER CLOTHS *(PAJ NTAUB)*
By Xia Lee and Unknown Hmong Artists
Madison and Thailand
c. 1979
Cotton/polyester blends, appliqued,
cross-stitched, and embroidered
17 x 17", 14 x 14", 12 x 12", 15 x 15"
From the Wisconsin Folk Museum Collection
of the State Historical Society of Wisconsin

**SLOVAK WHEAT WEAVINGS AND
DECORATIVE PAINTING**
By Sidonka Wadina Lee
Lyons
1984 - 1994
Wheat, woven; wood, painted
Wheat Weavings:
 "Harvest Bouquet" 16 x 11 x 2";
 "Blessing Elegante" 15 x 15 x 5";
 "Harvest Medallion" 20 x 20 x 1"
Painted Plate: 14" diameter
From the collection of the Cedarburg
Cultural Center

SLOVAK EASTER EGGS
By Sidonka Wadina Lee
Lyons
1984-1994
Eggs; commercial dyes; straw, split and glued
Eggs: 3.5 x 2.25" diameter to 4.5 x 2.5" diameter
From the collection of the Cedarburg
Cultural Center

III. CELEBRATING COMMUNITY

A. Calendar Celebrations

PUERTO RICAN CARNIVAL MASK
By Emilio Bras
Wauwatosa
1994
Papier mache, painted
18.25 x 21 x 9"
Loaned by Emilio Bras

CROATIAN EASTER EGGS *(PISANICA)*
By Stephanie Lemke
Mazomanie
1991
Eggs, thread
c. 2.25 x 1.5" diameter each
From the Wisconsin Folk Museum Collection
of the State Historical Society of Wisconsin

UKRAINIAN EASTER EGGS *(PYSANKY)*
Betty Piso Christenson
Suring
1993 and 1997
Eggs, dyed using wax-resist technique; shellac
3.5 x 2" diameter to 4.5 x 2.5" diameter
From the collection of the Cedarburg
Cultural Center

DANISH CHRISTMAS BASKETS
By Albert Larsen
Bayview
1993
Wrapping paper, cut and woven
0.75 x 0.50" to 7.5 x 4.75"
From the colection of the Cedarburg
Cultural Center

HOLIDAY DRESSER SCARF
By Inga Hermansen
Racine
1993
Linen, cross-stitched
36 x 14"
From the collection of the Cedarburg
Cultural Center

B. Life Cycle Celebrations

POTAWATOMI CRADLEBOARD
By Ned Daniels
Crandon
1995
Red cedar, black and white ash, maple, deer
rawhide, "Indian glue" (pitch and deer tallow)
27 x 11 x 12"
From the Wisconsin Folk Museum Collection
of the State Historical Society of Wisconsin

HMONG BABY CARRIER
By Xao Yang Lee
Sheboygan
1993
Cotton/polyester blends, appliqued
and cross stitched
23.5 x 17" plus ties
From the collection of the Cedarburg
Cultural Center

NORWEIGIAN MANGLE BOARD *(MANGLETRE)*
By Norman Seamonson
Stoughton
1996-1997
Basswood, carved and glued
c. 5 x 28 x 4"
Loaned by Norman Seamonson

JEWISH MARRIAGE CERTIFICATE *(KETUBAH)*
By Diane Glaser Simmons
Glendale
1997
Paper, ink
c. 20 x 20"
Loaned by Diane Glaser Simmons

POTAWATOMI MOCCASINS
By Josephine Daniels
Crandon
1994
Buckskin, thread, beads
2 x 10 x 4"
From the Wisconsin Folk Museum Collection
of the State Historical Society of Wisconsin

C. Social Symbols

AFRICAN-AMERICAN NECKTIE QUILT
By Allie Crumble
Milwaukee
1982
Cotton/polyester blends, synthetics, polyester batting, hand-pieced, -appliqued, and -quilted, machine-edged
87 x 72"
From the Wisconsin Folk Museum Collection of the State Historical Society of Wisconsin

OJIBWA DANCE DRUM
By Joseph Ackley
Lac du Flambeau and Mole Lake
1990
Wood, buckskin, rawhide, thread, fur
39 x 35 x 36"
From the collection of the Cedarburg Cultural Center

POLISH *KAPLICZKA*
By Andrzej Borzecki
Armstrong Creek
1997
Wood, carved
40 x 17 x 6"
From the collection of the Cedarburg Cultural Center

HOLLANDTOWN *SCHUT* BIRD
By Linus Vander Loop
Kaukauna
1997
Tin, rubber belting, wood, screws
c. 15 x 36 x 36"
Loaned by Linus Vander Loop

PIÑATA
By Berta Mendez
Waukesha
1997
Papier mache, tissue paper
c. 12 x 36" diameter
From the collection of the Cedarburg Cultural Center

IV. EXPRESSING ETHNIC IDENTITY

A. Norwegian Nationalism

HARDANGER COSTUME ADAPTATION
By Oljanna Cunneen (1923 - 1988)
Blue Mounds
1980s
Wool suiting, beaded; cotton apron and blouse with Hardanger embroidery; commercial braid
66 x 47"
Loaned by JoAnn Woods

ROSEMALED TANKARD AND PLATE
By Vi Thode
Stoughton
1980 and 1989
Wood, painted
11 x 8 x 6.5" and 1.5 x 10" diameter
From the Wisconsin Folk Museum Collection of the State Historical Society of Wisconsin

KUBBESTOL and ALE BOWL
By Phillip Odden and Else Bigton
Barronett
1997
Basswood, carved
Kubbestol: c. 38 x 22"diameter;
Ale Bowl: 7 x 14 x 6"
Loaned by Phillip Odden and Else Bigton

ACANTHUS-CARVED BENCH
By Monroe Johnson
Cashton
1989
Butternut and walnut, carved
26 x 35 x 15"
From the Wisconsin Folk Museum Collection of the State Historical Society of Wisconsin

ROSEMALED TRUNK
By Dorothy Peterson
Cashton
1988
Wood, painted
12 x 20 x 15"
From the Wisconsin Folk Museum Collection of the State Historical Society of Wisconsin

ROSEMALED BOWLS
By Ethel Kvalheim
Stoughton
c. 1989
Wood, painted
5 x 16" diameter and 4 x 14" diameter
From the Wisconsin Folk Museum Collection of the State Historical Society of Wisconsin

B. Cross-Cultural Comparisons

POLISH PAPERCUTS (WYCINANKI)
By "Bernie" Jendrzejczak
Hales Corners
1993
Wrapping paper, folded and cut
Leluje or Lily 10 x 5"; *Gwiazdy* or Stars: 11.5 to 14.75" diameter
From the collection of the Cedarburg Cultural Center

SWISS PAPERCUTS (SCHERENSCHNITTE)
By Elda Schiesser
New Glarus
1987 - 1989
Paper, cut
22 x 17", 10 x 17.5", and 13 x 16"
From the Wisconsin Folk Museum Collection of the State Historical Society of Wisconsin

ARMENIAN NEEDLE LACE DOILY
By Elizabeth Keosian
Milwaukee
1960s
DMC embroidery thread
12" diameter
From the collection of the Cedarburg Cultural Center

NORWEGIAN HARDANGER LACE
By Selma Spaanem
Mount Horeb
1970s
Cotton fabric, cut, drawn and embroidered with cotton thread
9.5 x 9.5" each
Loaned by Selma Spaanem

HO-CHUNK FINGER-WOVEN SASH
By Willa Red Cloud
Neillsville
1997
Yarn, hand-woven
100 x 3"
From the collection of the Cedarburg
Cultural Center

LATVIAN WOVEN BELT
By Vita Kakulis
Bayside
1990
Wool and linen, woven
c. 150 x 1.5"
Loaned by Vita Kakulis

WOODLAND COURTING FLUTES
By Louis Webster
Neopit
1989 and 1994
Wood, glue
23.5 x 3 x 1.5" and 31 x 2 x 1"
From the collection of the Cedarburg Cultural
Center and the Wisconsin Folk Museum Collection
of the State Historical Society of Wisconsin

HMONG TWO-STRINGED VIOLIN
By Wang Chou Vang
Menomonie
1989
Wood, gourd, raccoon hide, metal strings,
horsehair bow
36.5 x 5.5 x 4.25"
From the collection of the Cedarburg
Cultural Center

LATVIAN KOKLE
By Konstantins Dravnieks
Thiensville
1964
Basswood, spruce, hickory
c. 3 x 26 x 8"
Loaned by Konstantins Dravnieks

CROATIAN BRAC
By Nick Vukusich (1923 - 1994)
Milwaukee
1982
Maple, spruce, rosewood, ebony, abalone
c. 36" x 12 x 3"
Loaned by Jane Vukusich Zellmer

POMERANIAN BELBUCK TRACHT
By Pommersche Tanzdeel Freistadt
Freistadt
1980
Wool, cotton
c. 60 x 36"
Loaned by Pommersche Tanzdeel Freistadt

IRISH SOLO DANCE DRESSES
By Carroll Gottschlich and Christina Cronin
Shorewood
1995-1996 and 1997
Wool, embroidered and appliqued
28 x 28" and 36 x 36"
Loaned by Carroll Gottschlich and
Christina Cronin

**LATVIAN BOY'S COSTUME,
VIDZEME REGION**
By Vita Kakulis
Bayside
1981-1986
Wool jacket and pants; linen shirt,
embroidered; wool belt, woven; wool mittens
and socks, knitted
58 x 32"
Loaned by Vita Kakulis

C. Creolization

CONCERTINA
By Anton Wolfe
Stevens Point
1987
Basswood boxes, steel reeds, aluminum plates
and action, jute paper bellows, stainless steel
corners and staves
10 x 23 x 11"
From the Wisconsin Folk Museum Collection
of the State Historical Society of Wisconsin

HO-CHUNK RIBBON SKIRT and PAH-KEH
By Elena Greendeer
Oneida
1995
Cotton/polyester, satin, thread; glass beads,
thread, buckskin, satin, brass
34 x 27" and 82 x 1"
From the Wisconsin Folk Museum Collection
of the State Historical Society of Wisconsin

HO-CHUNK GERMAN SILVER JEWELRY
By Kenneth Funmaker, Sr.
Wisconsin Dells
1990s
German silver
Pendant: 2" diameter; Waterbird: 3 x 3"; Claw
brooch: 4 x 2"; Circle brooch: 3" diameter;
Earrings: 1 x 3"
From the Wisconsin Folk Museum Collection
of the State Historical Society of Wisconsin

MENOMINEE MOCCASINS
By Gerald Hawpetoss
Keshena, Wisconsin and Wahpeton, North
Dakota
1995
Deerhide, glass beads, threads, coins
2 x 10 x 4" each
From the Wisconsin Folk Museum Collection
of the State Historical Society of Wisconsin

MENOMINEE VEST
By Gerald Hawpetoss
Keshena, Wisconsin and Wahpeton, North Dakota
1987
Velvet, lined; glass beads
22.5 x 14.75"
From the collection of the John Michael
Kohler Arts Center

OJIBWA DEER TOE JINGLES,
BUCKSKIN DANCE LEGGINGS
By James Razer
Tony
1989
Deer toes, buckskin
16 x 8 x 8"
From the collection of the Cedarburg
Cultural Center

PACK BASKET
By Leo Hoeft
Bruce
1997
White ash splints
18 x 15 x 12"
From the collection of the Cedarburg
Cultural Center

HO-CHUNCK "BINGO BASKET"
By Ruth Cloud
Baraboo
c. 1986
Black ash splints
9 x 10 x 6"
From the Wisconsin Folk Museum Collection
of the State Historical Society of Wisconsin

V. LIVING ON THE LAND,
LIVING OFF THE LAND

A. *Working the Woods*

A LOAD OF LOGS
By John Henkelman
Merrill
1988-1989
Maple, hard maple, butternut, hickory, carved
and finished with tung oil; buckskin harness
20 x 35 x 16"
From the Wisconsin Folk Museum Collection
of the State Historical Society of Wisconsin

LOADING LOGS
By John Henkelman
Merrill
1986
Maple, hard maple, butternut, hickory, carved
and finished with tung oil; buckskin harness
22 x 60 x 16.5"
From the Wisconsin Folk Museum Collection
of the State Historical Society of Wisconsin

BEAR CHAINSAW SCULPTURE
By Jeff Prust
Hurley
1997
Pine, carved with chainsaws
c. 72 x 24" diameter
Loaned by Jeff Prust

B. *Farming*

CZECH CATTLE FEED BASKET
By John Arendt
Luxemburg
1997
Black ash splints
30 x 27" diameter
From the collection of the Cedarburg
Cultural Center

SWISS WILLOW BASKET
By Ray Steiner
Argyle
1990
Willow, woven and peeled
15 x 14" diameter
Loaned by Robert and Heather Teske

FINNISH BASKET
By Eino Hakamaa (1911 - 1997)
Ironwood, Michigan
1985
Cedar, split and woven
8 x 14 x 12"
Loaned by James P. Leary and Janet C. Gilmore

TOBACCO SPEARS AND AXES
By Alvin Stockstad
Stoughton
1980s
Sheet metal, brass, steel, wood
Spears: 8 x 2 x 1" each; Axes: 21 x 5 x 1" each
Loaned by Alvin Stockstad

MINIATURE CASE TRACTION ENGINE
By Carl Vogt
Madison
1973
Copper, steel, brass, enamel paint
10.25 x 22 x 8.5"
Loaned by Carl Vogt

MINIATURE HORSE-DRAWN
FARM VEHICLES
By William Malone
Cedarburg
1996-1997
Wood, carved
Manure Spreader: 6.5 x 26 x 7";
Hay Wagon: 8 x 26 x 9";
Buckboard: 5 x 17 x 6"
Loaned by William Malone

DINNER FOR THE THRESHING CREW
By Lavern Kammerude (1915 - 1989)
Blanchardville
1987
Oil on masonite
16.8 x 35 x 0.8"
From the Wisconsin Folk Museum Collection
of the State Historical Society of Wisconsin

C. *Commercial Fishing*

MODEL OF THE *HOPE*
By George Ellefson (1908 - 1990)
Washington Island
1980s
Solid white pine
5.5 x 11.5 x 4"
Loaned by Janet C. Gilmore

GILL NET, REEL, STAND, TWINE BOX, and
MARKER BUOYS
By George Ellefson (1908 - 1990)
Washington Island
1980s
Wood, twine
Gill Net Reel and Stand: 10.5 x 10.5 x 10.5";
Marker Buoys: 13.25 x 1" and 12.5 x 0.75"
Loaned by Janet C. Gilmore

D. *Hunting*

HUNTING SKIFF
By Patrick Farrell
Green Bay
1997
White pine, mahogany, white cedar, oak, white
ash, fiberglass
18" x 16' 8" x 36"
Loaned by Patrick Farrell

DECOY RIG
By Patrick Farrell
Green Bay
1990s
Cedar, basswood, carved and painted
Loaned by Patrick Farrell

BLUEBILL DECOY PAIR
By Milton Geyer (1912 - 1996)
Green Bay
1989
Cedar and basswood, painted; glass eyes;
lead weights
Male: 6 x 10.75 x 6.75"
Female: 6 x 12 x 7"
From the Wisconsin Folk Museum Collection
of the State Historical Society of Wisconsin

CARVED GUNSTOCK
By Sam Rust
Rice Lake
1990s
Walnut, carved and finished with urethanes;
metal action and barrel
6 x 44 x 2.5"
Loaned by Sam Rust

ANTLER BASKET
By Della Pleski
Foxboro
1990s
Deer antlers, reed, natural materials
13 x 15.5 x 16"
Loaned by Della Pleski

DEER TAG COLLECTION
By Mert Cowley
Chetek
Deer tags, wood frame
c. 15 x 12 x 2"
Loaned by Mert Cowley

E. Sport Fishing

FISHING LURES and GIANT LURES
By Jack Swedburg
Webster
1996-1997
Giant: Basswood, sawn, shaped and laquered;
Usable: Maple
Giant: 8 x 30 x 3.5" each;
Usable: 4 x 11 x 1.25" each
Loaned by Jack Swedburg

F. Winter

MAINE SNOWSHOES
By Tom Nelson
Ashland
1997
Stock frames, spar varnish, rawhide, saddle
skirting
c. 48 x 17"
From the collection of the Cedarburg
Cultural Center

**MUSKELLUNGE DECOY and JIGGING STICK
RAINBOW TROUT DECOY and JIGGING STICK**
By John Snow
Lac Du Flambeau
1995 and 1994
Basswood, lead, glass eyes, acrylic paint, 35-
pound test line, oak stick
8.25 x 3" and 8.5 x 3.25"
From the Wisconsin Folk Museum Collection
of the State Historical Society of Wisconsin

"WORK-IN-THE-COLD SOCKS"
By Ethel Wetterling Soviak (1923-1992)
Ladysmith
1992
Wool, knitted
c. 9 x 12"
From the Wisconsin Folk Museum Collection
of the State Historical Society of Wisconsin

G. Self-Reliance and Subsistence

CORDUROY QUILT
By Lauretta Suhr Neubauer
Sparta
1965
Cotton corduroys, machine-pieced, hand-edged
and -tied; cotton sheet blanket batting
74.5 x 57"
From the Wisconsin Folk Museum Collection
of the State Historical society of Wisconsin

**BRAIDED WOOL RAG RUG and
BRAIDED DENIM RAG RUG**
By Inez Cooper Robertson
Sheldon
1990
Wool, denim
25" diameter and 40.5 x 28.5"
From the Wisconsin Folk Museum Collection
of the State Historical Society of Wisconsin

"JUNQUE ART"
By Dennis O'Donnell
Frederic
1997
Scrap metal, welded
Pig: 29 x 35 x 15";
Chicken: 36 x 20" diameter;
Tractor: 8 x 12 x 8"
Loaned by Dennis O'Donnell

(All dimensions: H x W x D)

ARTISTS' BIOGRAPHIES

ARTISTS' BIOGRAPHIES

ARTISTS' BIOGRAPHIES

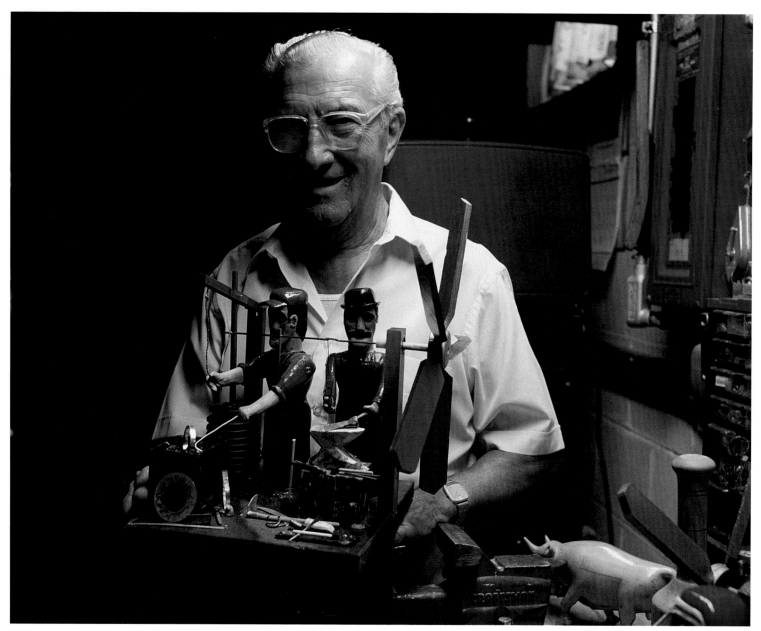

John Bambic displays his

blacksmith shop whirligig.

WISCONSIN FOLK ART:
A SESQUICENTENNIAL CELEBRATION

ARTISTS' BIOGRAPHIES

JOSEPH ACKLEY
Lac du Flambeau, Wisconsin
Ojibwa Dance Drums

Joseph Ackley was born in 1940 at L'Anse, Michigan, and raised in Wisconsin on the Bad River Reservation. Like both his father and grandfather, Joe Ackley is a traditional person with regard to religion and he is a drum-maker.

The drums which Joe Ackley makes are not sacred drums intended for religious ceremonies. Rather, they are social drums for use in intertribal powwows. Despite their secular use, however, Ackley treats his drums in a fashion which stresses their symbolic importance in Ojibwa life. He makes a drum only when one is needed. Once constructed, the drum is the focus of a feast for those who will play it and sing over it. Thereafter, the drum belongs to those people and they must care for it with respect: storing it with its head at right angles to the floor, transporting it wrapped in blankets, and guarding against its handling by those to whom it does not belong.

As a young man, Ackley danced to the drum as others played. Later he began to play and sing, eventually becoming a lead singer with a preference for the low-pitched Ojibwa style. He currently belongs to two drums and cares for the instruments he has made for each. One group is his own Woodland Woodtick Singers. The other is the TRAILS drum of Lac du Flambeau. TRAILS is a youth program run by Ackley which emphasizes the importance of traditional values and points out the damaging effects of drugs and alcohol. One of the group's principal activities is playing, singing over, and caring for its drum.

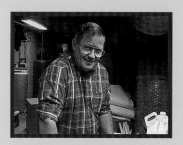

JOHN ARENDT
Luxemburg, Wisconsin
Cattle Feed Baskets

Throughout the first half of this century, there were a number of active basketmakers in eastern Wisconsin's rural Czech settlements. One of the most popular types of basket made by these early craftsmen was the cattle feed basket, which was used by area farmers to haul chopped hay, silage, and other feed from the barn to their cattle. By the second half of the twentieth century, the number of Czech basketmakers had declined significantly. Only Joe Buresh and his neighbor Joe Shefcheck continued to make the various types of woven carry-alls once commonly available in the community. Joe Buresh taught his basketmaking techniques to several younger apprentices. One of these was John Arendt, a German-American neighbor in rural Luxemburg.

When Joe Buresh passed away in 1991, he left John Arendt as the only basketmaker in the area. Arendt was born in Luxemburg, Wisconsin, in 1942, the seventh of ten children in a German-American family. Around 1980, when Joe Buresh was beginning to make baskets in earnest once again after many years away from the craft, John Arendt came to work with him and to learn the process. Since that time John has made twenty-five or thirty baskets from local black ash. Although he knows how, John Arendt only rarely makes the old cattle feed baskets any longer. Rather, he makes laundry baskets, picnic baskets, Easter baskets, and baskets for holding firewood.

JOHN BAMBIC
Milwaukee, Wisconsin
Slovenian Whirligigs

John Bambic was born in the Slovenian region of Yugoslavia in 1922. He was raised on a farm, and as a boy he assisted a neighbor who ran a blacksmith shop. As a young man, Bambic worked as a butcher for a number of years.

For five years following World War II, John Bambic was held in a displaced persons camp in Austria. In 1950, he immigrated to the United States. Bambic and his wife settled in the old Slovenian neighborhood on the southwest side of Milwaukee, and he found work at the Pfister Vogel Tannery. He was employed there for more than thirty years, until his retirement in the mid-1980s.

While visiting his Slovenian Lodge's summer camp one weekend shortly before his retirement, John Bambic came across an old linden tree that had fallen down. The tree reminded him of Old World carvings which were made from linden wood, and this recollection prompted him to attempt some carvings of his own. He started out making wind-powered noisemakers like those he remembered being used to scare the crows away from the vineyards in Slovenia. Later, he turned his hand to fashioning more elaborate ornamental whirligigs.

Since his retirement from Pfister Vogel, Bambic has devoted a good deal of his time and imagination to making whirligigs. Bambic's whirligigs — especially his more autobiographical works — are very popular among his fellow Slovenians who value them as moving images of their homeland.

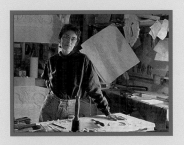

ELSE J. BIGTON
Barronett, Wisconsin
Norwegian Furniture and Woodcarving

Else J. Bigton was born in Aalesund, Norway, in 1956. As a child, Bigton learned a variety of needlework skills both at home and in the public schools. Encouraged by her grandmother who was a weaver, Else decided to study weaving with the ultimate goal of teaching the craft for a living. In order to better prepare herself, Bigton enrolled in one of Norway's schools of traditional artistry, the *Hjerleids Husflid Skole,* in 1977. There she met Phillip Odden, whom she married and accompanied to his native Wisconsin following completion of their courses. Like Odden, Bigton pursued a combined program of carving and furniture making during her first year at the school. During the second year she concentrated only on furniture making.

In 1979, upon their arrival in the United States, the couple founded a business called Norsk Wood Works. Bigton is responsible for the design and construction of such major pieces of furniture as hutches, beds, tables, chairs, and entire living room or dining room sets. The most elaborate decorative carving is done by Odden. Works created in the shop, whether pieces of furniture or individual decorative carvings, are generally made for Norwegian-Americans from the Upper Midwest.

BERTHA GREENGRASS BLACKDEER
Oneida, Wisconsin
Ho-Chunk Baskets

Like her older sister, Ruth Cloud, Bertha Blackdeer was raised outside Black River Falls. When her father, Ed Greengrass, a farmer and builder, died quite young, her mother's basketmaking became essential to the family's Depression-era income. Bertha learned by doing, and eventually made Easter and cheese baskets for sale.

Blackdeer went to Indian schools in Tomah and Neillsville through eighth grade, then attended Black River Falls High School. After marrying Irvin Blackdeer, Bertha did more beadwork than basketmaking from the late 1930s through the mid-1960s as her energies were devoted to raising two children and working three stints in the Baraboo area's Badger Ordnance Plant.

"After the family grew up...my daughter [Elena] and her husband had a business and they hired me....There was a lady friend of mine, her and I were the last ones to live in a wigwam there. It was a nice one that we had. So we used to go see the Indian Ceremonial every night...Dells Park they called it. Out of Wisconsin Dells. They had a place where you can make baskets, so I did that for awhile too....and the tourists come through there." Now she makes baskets mostly at the request of family members. She no sooner makes one than it is sold or given away. "It's funny that I make baskets for other people, but I don't even have a basket of my own."

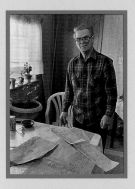

ANDRZEJ BORZECKI
Armstrong Creek, Wisconsin
Polish Kapliczkas

Born sixty-four years ago in the Ludzmierz district of Nowy Targ in the Podhale region of Poland, Andrzej Borzecki is a "Guralski" or highlander. He was raised on a farm and, for the better part of his life, earned his living as a farmer. Woodcarving was a common practice in Borzecki's district, and as a youth he learned to carve on his own, modeling his work after the many older men he observed. At first, Andrzej worked with a jackknife to whittle the wooden pieces used for crucifixes. Later, he mastered more decorative carving, cutting flowers and other patterns out of soft wood.

When Borzecki had serious intestinal surgery at the age of 30, he became frustrated with a lack of things to keep himself occupied. As a result, he began making *kapliczkas,* ornately carved shrines or grottoes for displaying statues of the Madonna. Originally Borzecki made small versions for use indoors, but later he turned to making larger ones for use outside. After producing scores of both types, he developed an impressive reputation for his work, and people traveled from as far away as Warsaw to purchase his altars.

In 1982, Borzecki and his wife emigrated to Chicago, joining his brother and sister who had come to this country decades before. He was also reunited there with his son and daughter. Through them, Borzecki became acquainted with Armstrong Creek, Wisconsin, a popular summer retreat for Guralski Poles from the Chicago area.

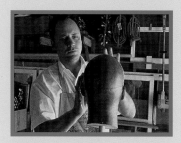

EMILIO BRAS
Wauwatosa, Wisconsin
Puerto Rican Carnival Masks

Emilio Bras was born in Santurce, Puerto Rico, in 1960. He came to the United States in 1979 to attend the University of Wisconsin - Milwaukee. After completing his studies, he worked in the sign shops at Summerfest and Badger Exposition Services before joining the exhibit staff of the Milwaukee Public Museum.

Although Emilio Bras grew up amid the special traditions associated with Carnival, the celebration that marks the beginning of the Lenten season in Puerto Rico, he had never made one of the fantastic, brightly colored masks used for parades and festivities until coming to this country. In August, 1992, the Milwaukee Public Museum presented an exhibition of photographs by Jack Delano entitled "Contrasts: Forty Years of Change and Continuity in Puerto Rico." In conjunction with this presentation, the museum displayed artifacts from the island alongside the artist's images. When Emilio Bras was unable to locate a Carnival mask, he simply turned to his own past experience to create one. Since making that first mask, Bras has had numerous requests for others from members of Milwaukee's Hispanic community. However, a busy schedule has kept him from making more than a few additional pieces.

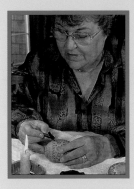

BETTY PISO CHRISTENSON
Suring, Wisconsin
Ukrainian Easter Eggs (Pysanky)

Betty Piso Christenson was one of nine children raised by Stefan Piso and Justina (Stella) Kuzemka Piso on cutover land near Suring in Oconto County. Despite the family's relative isolation, the Pisos continued to practice Ukrainian traditions associated with Orthodox Christianity and with religious holidays.

In the late 1930s when she was about seven years of age, Betty began learning to decorate Easter eggs from her mother. She learned the basic techniques for making *krizanki*, the simple, single-colored eggs which Stella Piso decorated using the family's beeswax and dyes made from bark, flowers, and berries. While her mother made an occasional two-colored egg, she did not have the tools or the knowledge required to make more elaborate Ukrainian Easter eggs, called *pysanky*. She did, however, describe examples of these jewel-like creations for her children.

In 1974, after approximately thirty-five years of making *krizanki*, Betty Christenson finally saw examples of fancier Ukrainian *pysanky* while visiting relatives in Canada. Drawing upon these observations, as well as publications and materials purchased at a Ukrainian specialty shop in Minneapolis - St. Paul, Christenson undertook mastering the creation of the elaborate eggs.

Over the past twenty years, Betty Christenson has gained a high level of accomplishment in her new art form. She has made beautiful *pysanky* for every sibling, child and grandchild in her family. She also received a National Heritage Fellowship from the National Endowment for the Arts. Her eggs have even been transported to relatives in the Ukraine, where the practice of decorating Easter eggs has declined markedly but where the eggs remain a powerful symbol of religious belief and ethnic identity.

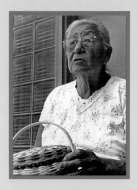

RUTH GREENGRASS CLOUD
Baraboo, Wisconsin
Ho-Chunk Baskets

Born in 1912, Ruth Cloud grew up along the Black River where her mother, Jenny Blackhawk Greengrass, would take the children to cut ash for baskets. Her mother cut the pounded ash strips into splints to weave sturdy baskets for home use and for sale. Ruth learned basket weaving by watching her mother and experimenting.

Like many other Ho-Chunks, the Greengrass family sold their baskets to stores in Millston and Black River Falls. They also sold their wares from a roadside stand on Highway 12. Ruth continued to make baskets after her marriage to Edward Cloud, thanks to his help in finding suitable trees, pounding them, and carving basket handles. Today, their sons continue this work.

Ruth Cloud's repertoire of forms includes rectangular market baskets, round sewing baskets, cylindrical kettle baskets, and even purse-like "bingo baskets." Her skill and experience as a basketmaker have made her an important teacher of younger Ho-Chunks.

MERT COWLEY
Chetek, Wisconsin
Hunter, Fisher and Trapper

Mert Cowley was born in Rice Lake, Wisconsin, in 1941. His father worked as a Grainbelt Beer distributor in and around Barron for twenty-eight years. When he wasn't busy with work, Cowley's dad would spend time trapping, ice fishing, and pheasant and partridge hunting. Mert began hunting in 1955. He attended college in Eau Claire, and he has been employed as a teacher in Chetek for thirty-two years. Married in 1963, Cowley and his wife have two sons, the older of whom outshines even his father as a hunter.

Cowley owns a 100-year-old log cabin near Danbury which he uses mainly as a deer camp. An accomplished hunter who has taken over a thousand bucks in his career, Cowley also treasures the fellowship deer hunting affords and regards himself as a "steward of the land." An amateur archeologist and historian, Mert Cowley has amassed a collection of antique guns and hunting equipment, some of which he uses in the field each year. Since 1990, Cowley has authored three books, entitled *The Ultimate Stand, In Camps of Orange, and 100 Hunts Ago,* which bring together his hunting poems and the history of hunting in northern Wisconsin.

ALLIE M. CRUMBLE
Milwaukee, Wisconsin
African-American Quilts

Allie Crumble was born in 1911 in Newton County, Mississippi, and, raised in Sardis. In 1944 she moved to Milwaukee with her second husband who had relatives in the city. He found work first at Milwaukee Boiler and then at A.O. Smith, but later went into business on his own as a carpenter. Allie never worked outside the home, choosing instead to be a housewife and to raise ten children. Her husband passed away in 1983, and since that time Allie's mother, Minnie Lofton, and, more recently, her daughter, Ivory Pitchford, have shared her home.

Allie Crumble first learned to piece quilts from her mother at the age of seven. At about the age of nine or ten, Allie was allowed to move on from merely "piecing" quilts to actually "quilting," sewing the quilt top to the batting and backing with a variety of decorative stitches. By the time she was twelve, Allie was sufficiently accomplished to help her mother with her quilts.

Allie Crumble has continued quilting on a regular basis throughout her entire life. Prior to her husband's death about fifteen years ago, Crumble produced roughly one quilt per month. Since then, Allie has produced only a small number of quilts for her own use, for her grandchildren, and for sale. She refuses to make quilts to order, preferring instead to sew favorite traditional patterns or to create new ones of her own. On some, she makes use of the string quilting technique characteristic of many African-American quilt makers.

OLJANNA CUNNEEN (1923-1988)
Blue Mounds, Wisconsin
Norwegian Traditional Costumes

B orn in Dane County in 1923, Oljanna Cunneen was taught by her mother to keep her hands busy. Cunneen supplemented her mother's early instruction in handwork by taking classes, attending workshops, and exchanging information with friends on Norwegian embroidery, costumes, and *rosemaling*. Cunneen's first marriage took her to California where she worked as a photographer for the air command service during World War II. Following her return to Dane County, she married a second time and "retired" to housework.

In 1961, Cunneen began working during the summers as a guide at an outdoor ethnic museum near Mount Horeb called Little Norway. In order to have the appropriate attire for her tour duties, Cunneen created several different Norwegian regional costumes. At the museum, she also gained a reputation as a great storyteller. This exposure led to numerous speaking engagements in which she regaled her audiences with Norwegian dialect stories from the Ole and Lena cycle. She also created troll dolls which she incorporated in her storytelling performances.

JOSEPHINE JOHNSON DANIELS (1929-1997)
Crandon, Wisconsin
Potawatomi Moccasins

W hen Josephine Daniels was a girl, agents of the Bureau of Indian Affairs hauled her off to a Catholic boarding school at Keshena on the Menominee Reservation. "I had an awful hard time because I couldn't speak English." Years later, when she returned home, she had trouble readjusting to Potawatomi culture until she sat down with her grandmother. "I watched her make moccasins and I remembered." Josephine's grandmother, *Natnoke* (Coming Wind), was the "boss of the family," earning vital income by selling her handwork. She also oversaw her granddaughter's acquisition of traditional knowledge: "She used to tell me to sit down and learn how to do things because later on in life I would find it very useful to keep up moccasin making and beadwork." In the last twenty years before her recent death, Josephine Daniels not only taught her children traditional skills, but she was instrumental in forming a cooperative of handworkers at the Potawatomi Tribal Center.

NED DANIELS
Crandon, Wisconsin
Potawatomi Cradleboards

KONSTANTINS DRAVNIEKS
Thiensville, Wisconsin
Latvian Kokles

Ned Daniels was born in 1916 in a logging camp in northeastern Wisconsin where his father, Young George, was "a foreman in the cedar swamp." Educated at Indian schools in Tomah, Wisconsin, and the Haskell Institute in Lawrence, Kansas, Ned learned the trades of a pressman and a welder. He worked in shipyards during World War II, and subsequently with the Ironworkers Union on construction sites. In the 1970s he studied linguistics and counseling at several universities, and eventually served as tribal chair of the Forest County Potawatomis.

Throughout his life, Ned Daniels has been a steadfast traditionalist. He grew up with the old ways, "the language, the religion." Initiated into the Grand Medicine Lodge when he was "about five," Ned Daniels learned "how to hunt, track, and trapping...the ways of language, song, and building wigwams, building traps, all those things." A cradleboard baby himself, Daniels "used to look at cradleboards from way back" and, in keeping with a grandfather's duties, has been making them for his children's children.

Konstantins Dravnieks was born of Latvian parents in Petrograd on May 21, 1914. Following World War I, his family returned to Latvia where Dravnieks studied mechanical engineering and graduated from the University of Riga. In 1949, after the Soviet Union forcibly incorporated Latvia and its neighboring Baltic states, Dravnieks came to the United States, one of nearly 100,000 Latvians who emigrated during the era following World War II. He settled first in Chicago, then in Fort Atkinson, Wisconsin, and thereafter in Madison. For the last seventeen years, Dravnieks has resided in Thiensville.

Like his fellow Latvians, Konstantins Dravnieks was attracted to the *kokle* as a vehicle for expressing his ethnic identity. His interest in the instrument, however, has taken him farther than most other Latvian-Americans. In the course of his travels as an engineer, Dravnieks has visited numerous museums and documented *kokles* in their collections with the precision of a design professional. He has also mapped the distribution of the whole family of related Baltic instruments. Through his studies and research, Dravnieks eventually came in contact with Leonids Linauts of Reading, Pennsylvania, who showed him how *kokles* are made. Inspired by Linauts, Dravnieks attempted to make a *kokle* in 1961. His first efforts proved successful and he has continued making the instruments to the present. Dravnieks has made over eighty *kokles* in all and frequently exhibits his work at *kokle* festivals and other Latvian events.

DUFECK MANUFACTURING COMPANY
Denmark, Wisconsin
Cheese Boxes

Dufeck Manufacturing Company was established during the late nineteenth century by Albert Dufeck, Sr. and several of his siblings. Following their father's death, Albert and his brothers were apprenticed to various tradesmen in the area. Albert, Sr. learned blacksmithing, while his brothers learned carpentry and lumbering. The three came to the realization that they could all put their complementary skills to good use in manufacturing the cheese boxes used to age cheddar by dairies throughout the region. With the help of their sister who ran the boarding house for the workers, the Dufecks launched their woodworking business. The company's first factory was in Black Creek, near Stangelville, in Kewaunee County. Shortly after the turn of the century, the plant was moved to its current location in Denmark. During the course of time, the company was passed along to Albert's son, Albert Dufeck, Jr., and eventually to his son Paul and his wife Jeanette who currently operate the facility.

Throughout its history, Dufeck Manufacturing has made cheese boxes for use by the dairy industry in Wisconsin. Today, it remains one of only two companies still manufacturing these containers. Recently, the Dufeck family has expanded the line of specialized wood containers it produces, diversifying to serve customers in the packaging industry and craftspeople who decorate the cheese boxes, crates, and other articles they produce. This strategy seems to be making up for a decline in demand from cheesemakers and keeping the company strong into its third generation.

GEORGE ELLEFSON (1908 - 1990)
Washington Island, Wisconsin
Model Fish Tugs

George Ellefson was born on Washington Island off the tip of Wisconsin's Door County peninsula in 1908. His mother and father, John and Martha Ellefson, were natives of Norway. John was an ocean sailor who also worked on the Great Lakes until settling on Washington Island just after the turn of the century. There he fished and built boats until 1924, when he moved his family to Chicago due to slack fishing.

George fished some with his father while he was growing up. Although he moved to Chicago with his parents, he did not like the city and the work available there. As a result, in 1927 when his brother needed help fishing back on Washington Island, George returned home for two years. Thereafter, from 1928 until 1952, he fished out of ports at the southern end of Lake Michigan, including South Haven and Muskegon, Michigan, Waukegan, Illinois, and Kenosha, Wisconsin. Following a hospital stay for severe rheumatism in the early 1950s, Ellefson went to work for Johnson Motors in Waukegan, a division of Outboard Marine. In 1970 he retired and moved back to Washington Island with his wife, where he lived until his death in 1990.

From 1979 through 1990, George Ellefson carved over two dozen models of commercial fishing tugs and related work boats, representing mainly boats of friends and relatives, boats his father built, and those on which he worked earlier in life. In this way, he celebrated the importance of commercial fishing to him and other island residents.

PATRICK FARRELL
Green Bay, Wisconsin
Woodworking and Waterfowling

Among the youngest of Green Bay's "old breed" of woodworkers and waterfowlers, Patrick Farrell was born into an Irish working class family in 1942. He chummed with the sons of boatbuilders, commercial fishers, and hunters of Belgian, German and Scandinavian extraction. He played in boats with duck decoys and saw old men carve them with hatchets and coping saws. By the age of ten or eleven, Farrell became interested in hunting and began making his own decoys from scrap wood.

As he grew older, Pat Farrell served an unofficial apprenticeship with John Basteyns and Ted Thyrion, two local hunters who also built hunting skiffs, carved working decoys, and made paddles and other waterfowling accouterments. Farrell began learning the basics from them around 1962. By 1982, he had long since surpassed his teachers and had begun building hunting skiffs nearly full time. He also makes snowshoes and builds wooden canoes.

While Green Bay has changed a great deal over the years, Pat Farrell continues to make hunting skiffs and an occasional decoy in the old way — not for money, not for hunting, but out of his commitment to the work itself and to the old-timers from whom he learned.

KENNETH FUNMAKER, SR.
Wisconsin Dells, Wisconsin
Ho-Chunk German Silver Jewelry

Ken Funmaker is among the last generation of Ho-Chunks to grow up speaking their language on a daily basis. Born in La Crosse in 1933, Funmaker was given the Bear Clan name *Wamaniga* or "Walks on Snow." He attended Haskell Institute in Lawrence, Kansas, for three years of high school before graduating from Wisconsin Dells in 1951.

By then the Funmakers lived amidst many Ho-Chunks working for the Badger Ordnance Works near Baraboo. Among them were fine traditional singers and craftspeople like Winslow White Eagle, whose vocal power and jewelry-making inspired Ken. Although he has been a traditional singer for decades, Funmaker's artistic pursuits were deferred. He joined the Ironworkers Union to labor with structural steel. While working in Chicago, he met and married Ruby Keahana, a Mesquakie from Tama, Iowa. The Mesquakie settlement was home to such fine Woodland jewelers as Julius Caesar, Horace White Breast, and Pete Morgan. Funmaker admired their work and, after a disabling injury, decided to seek further education.

Funmaker attended the Institute of American Indian Art in Santa Fe and the University of Wisconsin from 1979 to 1981. Working primarily in German silver, he mastered traditional Ho-Chunk earrings, bracelets, and brooches. Drawing upon the flora and fauna of his Woodland home, he also fashions contemporary jewelry. Now, however, he has largely put his tools aside for the important task of directing his nation's Language and Culture Preservation Committee.

MILTON R. GEYER (1912-1996)
Green Bay, Wisconsin
Duck Decoys

Milton R. Geyer was born in Green Bay, Wisconsin, in 1912. When he was a boy, the east side of town was largely marshland and sloughs where prairie chickens and ducks abounded. Geyer's father and four older brothers hunted and trapped the marshes, and young Milt was fascinated by the form and color of the ducks which they brought home. At the age of sixteen, Geyer began to hunt and trap. Prompted by the rising cost of store-bought decoys during the Depression, Geyer began making his own. He emulated the examples set by other bird carvers in the Green Bay area. These included his father as well as Jack Van Caughenburgh and Jack Kearney.

Geyer made his first decoys for himself and his brothers. Over the last fifty years, he made approximately 250-300 decoys, including both nonfunctional "decorator" decoys as well as working birds. Geyer worked for thirty-nine years for the Bay West Papermill making paper towels and related products. Retired in 1976, he remained an avid hunter and active supporter of organizations such as Ducks Unlimited until his death.

DIANE GLASER SIMMONS
Glendale, Wisconsin
Jewish Marriage Certificates (Ketubahs)

Diane Glaser Simmons made her first *ketubah* about twenty years ago. Already an accomplished calligrapher at the time, Glaser Simmons was commissioned by a customer to create the traditional Jewish marriage certificate which records the groom's promises to his bride. Though she had never created a *ketubah* before, Glaser Simmons took courses in Hebrew to better prepare herself for her commission, and she asked a rabbi to review the completed text to insure its acceptability.

Since making her first *ketubah,* Diane Glaser Simmons has made many more and is widely recognized for her skills within the southeastern Wisconsin Jewish community. In addition to the standard *ketubah* which is regarded as a legal document among orthodox and traditional Jews, Glaser Simmons has developed more "egalitarian" versions in cooperation with her customers. Some of these include pledges from both the bride and the groom, and others feature an English translation alongside the Hebrew text.

CARROLL GOTTSCHLICH AND CHRISTINA CRONIN
Shorewood, Wisconsin
Irish Solo Dance Dresses

Carroll Gottschlich and Christina Cronin first became involved in the making of traditional Irish dance dresses when their daughters began step dancing about thirteen years ago. A seamstress all of her life, Carroll assembled dance costumes for the Cashel-Dennehy dance school during the 1980s. From assembling the component parts which were embroidered in Ireland and shipped to the United States, Gottschlich and Cronin progressed to making the solo dance dresses themselves — first using hand embroidery and, later, machine embroidery techniques. The elaborately embroidered dance dresses signify the Irish dancer's attainment of solo performer status. Each dress requires from sixty to eighty hours to complete, and the individual dancers negotiate their design and color preferences with Gottschlich and Cronin or other dressmakers.

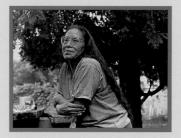

ELENA BLACKDEER GREENDEER
Oneida, Wisconsin
Ho-Chunk Beadwork and Ribbonwork

When Elena Greendeer was born in 1948, an American Indian tourist industry was well established at Wisconsin Dells. A Ho-Chunk gathering place for centuries, the Dells became an important stopover for timber craftsmen in the mid-nineteenth century and tourists in the post-Civil War era. In 1929 Ho-Chunk traditional singers, dancers, and artists camped in what was called the "Indian Village" and began nightly performances from mid-June through Labor Day.

Elena Greendeer grew up in this atmosphere. "That was the thing to do: to demonstrate your crafts and sell to the public, and at night perform at the Stand Rock Indian Ceremonial. This was always a summer pastime. Although it was income, it was also one [way] of living the way your people do and enjoying it." From her mother, Bertha Blackdeer, and an elder, Flora Bearheart, Elena learned the intricacies of beadwork and ribbon appliqué. In addition to being marketable, these skills also enabled her to fashion her own dance regalia.

In the 1960s, Elena worked at Dells Park with George Greendeer, who became her first husband. Like a Ho-Chunk artist's cooperative, Dells Park was the area's "first to be Indian owned and operated." Beyond the Park's summer operation, the Greendeers traveled "east of the Mississippi...to schools, to performances, and then we got into going to the malls to sell our crafts." Over the past twenty years, Elena Greendeer's growing family has kept her closer to home where she has had the satisfaction of seeing her daughters progress as bead- and ribbonworkers.

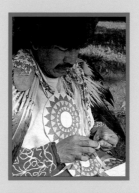

EINO HAKAMAA (1911-1997)
Ironwood, Michigan
Finnish Baskets

Eino Hakamaa was born in Kauhajoki, Finland in 1911, and he was raised on a farm. Hakamaa learned the making of simple functional baskets from an elderly neighbor at the age of fourteen or fifteen, and he continued to make containers all his life. Although he never sold any of his baskets, preferring to give them away to family and friends, he was widely known and appreciated for his skills in northern Wisconsin's Finnish community.

Hakamaa married his wife Edith in 1939, and together they raised dairy cattle and small grain on their farm in Finland. He also worked during the summers as a house carpenter. In 1960 the Hakamaas immigrated to the United States, joining relatives who had earlier come to Wisconsin. They settled on a farm in Iron County's Oma Township, south of Hurley. In 1966, following several instances of bad luck on the farm, the Hakamaas moved to Ironwood, Michigan, just across the state line, and Eino Hakamaa took a job with a sawmill. He worked at the mill until his retirement.

Until his recent death, Eino Hakamaa was an active member of the Finnish-American community which straddles the Wisconsin and Michigan segments of the Gogebic Iron Range. He was a frequent participant in ethnic programs held at "Little Finland" in Kimball, Wisconsin. Eino Hakamaa also demonstrated basket making at ethnic events in urban areas including Milwaukee.

GERALD HAWPETOSS
Keshena, Wisconsin, and Wahpeton, North Dakota
Menominee Beadwork and Moccasins

Gerald Hawpetoss was born in 1952 and spent his early years in Milwaukee where his parents had found work. Stricken with rheumatic fever at eight, he was given to his paternal aunt and uncle, Ernest and Jane Neconish. "The doctor said I couldn't survive in Milwaukee. I had to be in a clean environment. I didn't want to go. I ran back to my father. He told me, 'These are your parents now. You learn to serve them. You haul them water, you carry them to the outhouse, you bury them, and then you'll be free.'...This was on the Menominee Reservation, just outside of what they call Zoar."

From his Neconish "grandparents," Hawpetoss learned moccasin-making, an art practiced within the extended family from the time of his great-grandmother Osakapun Fish. "It isn't right for some other Menominees to just pick [a moccasin] up and make it. Because when we make moccasins for the dead, and then they [the spirits] ask them, 'Who made your moccasins, how'd you get over here?'...They'll tell them...'the Fish family,' and this was inherited." Besides making moccasins, Hawpetoss is adept at brain-tanning hides, beadwork, and the fashioning of traditional regalia. In 1992, he was awarded a National Heritage Fellowship by the Folk Arts Program of the National Endowment for the Arts.

JOHN HENKELMAN
Merrill, Wisconsin
Woodcarving

John Henkelman was born in Hewitt, Wisconsin, in 1905. He worked as a logger until the age of twenty-four. For thirty years afterwards, he farmed and did occasional stone, brick and block masonry. Following his retirement in 1970, Henkelman took up woodcarving in order to keep himself occupied. Adhering to a regional and occupational aesthetic, he concentrates on natural motifs, wildlife, and logging scenes. Henkelman keeps most of his pieces for himself and gives others away to relatives. At the same time, he has acquired a local reputation as a woodcarver over the last sixteen years and has sold a number of pieces of his work to community members who value the lifestyle and occupations characteristic of the region.

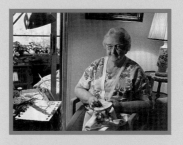

INGA HERMANSEN
Racine, Wisconsin
Danish Needlework

Inga Hermansen of Racine learned traditional counted cross-stitch embroidery from her mother. As a child in Denmark, Inga watched her mother, a seamstress by trade, making various decorative items for family and friends. Inga was also exposed to needlework in school, where she and other Danish girls began doing cross-stitch at the age of seven.

In 1955, Inga Hermansen left Copenhagen with her husband and three daughters and followed a path other Danes had trod for over one hundred years. They settled in Racine where her husband Axel's aunt and uncle lived and where there was a small Danish community. Axel, a trained engineer, found work with the Oster Manufacturing Company. Inga turned her sewing skills to work in a bridal shop and to her own drapery business.

Since coming to Wisconsin, Inga has continued to create the elaborate and intricate counted cross-stitch designs she first learned as a girl in Denmark. Working ten to twelve hours per day, Inga still fashions table runners, bell pulls, and dresser scarves adorned with national symbols and a variety of regional motifs. She uses only materials obtained from Denmark to create the traditional designs taken from color-coded, printed patterns which have been passed down through the years. Through her personal commitment and creativity -- and through her patient instruction of two of her daughters and four of her granddaughters in the tradition — Inga Hermansen has assured the continuation of Danish needlework in Wisconsin for years to come.

LEO HOEFT
Bruce, Wisconsin
Ash Pack Baskets

Leo Hoeft was born in 1923 on the family farm north of Bruce where he still resides. His parents came from Kashubia on the Baltic Sea, an area which is now part of Poland but which was then the German province of Pomerania. His mother and father, John and Martha, immigrated to Philadelphia, then to Chicago where they worked in the meat packing plants of Swift and Armour. In 1910, when cutover land became available in Rusk County, they joined other Slavs in moving to northern Wisconsin. After a brief stay in Ladysmith, they settled on a farm north of Bruce where they kept a few cows, raised feed, and grew potatoes.

Leo grew up as a farm boy, working in the fields and with animals, but also hunting, fishing and trapping. His father had made oak baskets in the Old Country for gathering potatoes, and he continued to do so in America. While Leo recalled watching his dad make a basket around 1930, he did not become involved in the practice until much later.

In the late 1940s, Hoeft purchased an ash pack basket from the A.J. Daley Company, whose catalogue indicated it was made by Indians in northern New York State. Some ten years later, Hoeft began making his own pack baskets, modeled after the one he had purchased, from stands of white and black ash on his farm. These he sold to fishermen, hikers and trappers through Sam Parker's fur company in Rice Lake. Although he no longer has a commercial outlet for his work, Hoeft continues to make pack baskets for an established clientele and to make a living as a trapper.

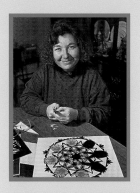

"BERNIE" JENDRZEJCZAK
Hales Corners, Wisconsin
Polish Paper Cutting (Wycinanki)

Bernie Jendrzejczak is a third-generation Polish-American, born and raised in Milwaukee. Her mother and father were also born in Milwaukee of parents who had immigrated from Poznan and Bydgoszcz, respectively. Like many other Polish-Americans, the Jendrzejczaks have always observed a variety of traditional holiday customs in their home.

Taught by her family to value the customs of her ethnic community, Bernie Jendrzejczak joined Polonki, a Polish women's cultural club, after she graduated from high school in the early 1970s. At the time she became a member of the organization, Bernie became actively involved in teaching and demonstrating Polish folk arts as part of Polonki's cultural conservation program.

Bernie Jendrzejczak drew upon a variety of sources as she began to learn *wycinanki,* or Polish paper cutting. She gleaned some things from the senior members of Polonki, others from Ryszarda Klim, a Milwaukee artist, and still others from Mrs. Wladsyslawa Muras, a professional folk artist from Poland. Eventually Bernie Jendrzejczak mastered not only the well-known styles of Polish paper cutting from the regions of Kurpie and Lowicz, but also some less familiar forms like those from Opoczno.

Now a research technologist at the Medical College of Wisconsin and president of Polonki, Bernie Jendrzejczak continues to make *wycinanki* and to teach the art form.

MONROE JOHNSON
Cashton, Wisconsin
Norwegian Woodcarving

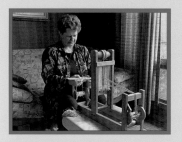

VITA V. KAKULIS
Bayside, Wisconsin
Traditional Latvian Costumes and Belts

Monroe Johnson's family came to the area around Coon Valley, Wisconsin, between 1870 and 1890. His grandfather was one of the last to arrive, following other relatives to the area. Like many immigrants, Johnson's grandfather changed his name from Hovren to Johnson. A carpenter by trade, Torger Johnson built houses and, with a friend, constructed the Middle Coon Valley Norwegian Lutheran Church. Monroe Johnson's parents were dairy and tobacco farmers, and he has farmed most of his life as well. Johnson used to raise registered Holsteins, but now grows primarily hay and a little corn on his 160 acres. He and his wife raised a family of six children on their farm near Cashton.

Monroe Johnson discovered acanthus carving on a trip to Norway about twelve years ago. He was especially fascinated by *kubbestols,* or log chairs, adorned with this elaborate style of carving. Several years later, Johnson returned to Norway to purchase tools and patterns, and he began to teach himself the various carving techniques. Shortly thereafter, he became part of a network of Norwegian folk artists in the Coon Valley/LaCrosse area and started taking yearly classes at Vesterheim, The Norwegian-American Museum in Decorah, Iowa. Johnson prefers to make furniture pieces decorated with acanthus carving, and he creates a lot of shelves, mirrors and boxes, as well as *kubbestols,* chests and three-legged chairs. In addition to his carving, Monroe Johnson is also on the board of Norskedalen Nature and Heritage Center.

Vita V. Kakulis was born in Valmiera, Latvia, in 1936. In 1944 at the age of eight, she left Latvia aboard a refugee train led by her father. In the spring of 1945, after arriving in Germany by ship and moving from one displaced persons camp to another, the Kakulis family settled in a camp in the American Zone. Following the war, Vita came to the United States with her family. They lived first in Massachusetts and thereafter in Ohio, New Mexico, and Washington, D.C. In 1961 Kakulis married a Milwaukee man whom she had met while visiting her sister. The recipient of a degree in business administration from the University of New Mexico, she worked periodically as a computer business analyst while raising her family.

Kakulis learned knitting, embroidery, belt weaving, and costume making in the displaced persons camps in Germany, attending classes offered by people who had studied in the Latvian folk art institutes. However, she did not return to belt weaving and costume making until her sons began attending Latvian school and needed costumes for festive events. Since then, she has made approximately four costumes for each son. In 1978, when the Latvians were the featured ethnic group at the Holiday Folk Fair, Kakulis began making her own costume. For several years in the early 1980s, she studied belt weaving on larger looms with Erma Jamsons of Milwaukee. Since then, Kakulis has shown her work at Latvian conventions and occasionally taught belt weaving at her children's Latvian summer camp near Three Rivers, Michigan.

LAVERN KAMMERUDE (1915-1989)
Blanchardville, Wisconsin
Farm Paintings

Born in 1915 on the family farm south of Blanchardville, Lafayette County, Wisconsin, Lavern Kammerude was of Norwegian, Irish, and Austrian stock. His family and most neighbors, who included people of English and Swiss backgrounds, practiced small-scale, diversified farming which relied on horse power and local markets. For nearly thirty years, Kammerude practiced this same type of "plain old-fashioned farming" using draft horses and milking a score of Holsteins by hand. In 1967 he turned to rebuilding automotive parts in Argyle, but remained on the farm, raising horses and entering them in sulky races in county fairs.

Before he quit farming, Kammerude had begun to paint, inspired by his mother's present of oils one Christmas. In his youth he had "always loved to draw horses." Largely self-taught, Kammerude found an enthusiastic local response to his farming scenes that recalled an earlier time. Farmers and businesses serving a rural clientele purchased many of his paintings. Then Surge dairy equipment supply executive and former farmboy, Gerald Regan, commissioned Kammerude to paint a series of scenes over a dozen years that expressed Kammerude's attention to detail in representing a broad range of seasonal rural activities. Regan's sales of originals and prints brought Kammerude's work to the attention of a broader public, regional and national galleries, buyers, dairy farming and country living publications, and cultural institutions. In 1990, the Wisconsin Folk Museum published *Threshing Days,* which couples prints of many Kammerude paintings with retired farmer Chester Garthwaite's recollections.

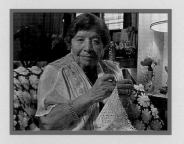

ELIZABETH KEOSIAN
Milwaukee, Wisconsin
Armenian Needle Lace

Elizabeth Keosian was born on September 25, 1909, in Adana, Turkey — then Cilician Armenia. When she was only three months old, her father, grandfather and other male relatives were "purged" by the Turks for refusing to deny Christianity. Shortly thereafter, Elizabeth's mother lost her eyesight, possibly as a result of the emotional stress. Elizabeth remained in Turkey with her mother until the age of ten, at which time they fled to a refugee camp in Lebanon. After nine years in Beirut, she came to Milwaukee in 1929 as the "mail-order bride" of a friend of her sister, an Armenian who had immigrated to the United States in 1912.

Elizabeth Keosian began learning Armenian lace-making from her older sister at about the age of five or six. She started by fashioning lace borders for handkerchiefs and later graduated to making doilies. By the time she was nineteen years old, just before she was to marry, she had prepared an entire hope chest full of needle-lace doilies and trims for wedding garments and underclothes.

Since coming to the United States, Elizabeth Keosian has continued to practice her traditional needlework. Although her eyesight is not as good as it once was, at the age of eighty-eight Keosian still makes gifts of her needlework for her many nieces and grandnieces. Keosian also remains an active participant in the southeastern Wisconsin Armenian community, participating in the Holiday Folk Fair in Milwaukee and other ethnic events.

ETHEL KVALHEIM
Stoughton, Wisconsin
Norwegian Rosemaling

Ethel Kvalheim was born in Pleasant Springs, Dane County, Wisconsin in 1912. She was raised on a farm near Stoughton. From 1957 until 1975, while raising two sons, Kvalheim worked as a housemother at the Oregon School for Girls in Oregon, Wisconsin.

When she was first married, Kvalheim lived only one block from famed Stoughton *rosemaler* Per Lysne. Inspired by his work, Kvalheim took up *rosemaling* in 1942, modeling her work after that of her famous neighbor. Her search for models for her work later led her to Vesterheim, The Norwegian-American Museum, in Decorah, Iowa, about 1947. She was a participant in the museum's second *rosemaling* workshop, taught by Sigmund Aarseth, and this experience marked a turning point in her work.

Today, Kvalheim paints mostly for her own enjoyment, avoiding commission work and selling her work by word-of-mouth. She regularly paints a trunk for the Wisconsin Rosemaling Association which the group raffles during its annual exhibit in conjunction with Stoughton's *Syttende Mai* celebration.

One of this country's foremost *rosemalers,* in 1969 Kvalheim received the National Exhibition's first Gold Medal. Two years later, she was awarded the St. Olav's Medal from the King of Norway. And, as recently as 1989, Ethel Kvalheim was honored with a prestigious National Heritage Fellowship from the National Endowment for the Arts.

ALBERT LARSEN
Bayview, Wisconsin
Danish Christmas Baskets

Albert Larsen learned the tradition of making heart baskets from his father, who settled in Kenosha's already established Danish community in 1909 after coming to America from Olberg, in Jutland, Denmark. He taught Albert how the woven paper baskets were used to decorate the Christmas tree and sometimes displayed in household windows during the holiday season. Albert also learned that it was an old Danish custom to take the empty baskets from the tree, fill them with candy, and give them to visitors and guests during the holiday season to take home with them. While other Scandinavian groups made heart-shaped baskets in their traditional colors, Albert's father taught him that only the Danes made theirs of red and white paper.

A stickler for detail and precision like his father, Albert Larsen continues to make Danish heart baskets in essentially the same manner he was taught. Using only a pencil and scissors, Larsen transfers patterns from detailed measurements or cardboard templates to one white and one red sheet of glossy wrapping paper. Slits are then cut part way up the folded strips of paper, and the resulting loops or "members" are woven through one another. Once the body of the basket is completed, a handle is added. While Albert once affixed the handles with paste, he now prefers Scotch tape for its appearance and durability.

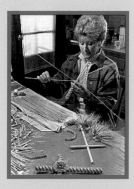

SIDONKA WADINA LEE
Lyons, Wisconsin
Slovak Wheat Weaving, Egg Decorating, and
Decorative Painting

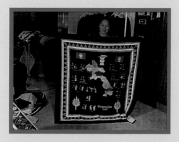

XAO YANG LEE
Sheboygan, Wisconsin
Hmong Needlework (Paj Ntaub)

Sidonka Wadina Lee was born in Milwaukee in 1947 to second-generation Slovak-American parents. Both of her grandmothers, Johanna Biksadsky and Anna Wadina, lived nearby. When Sidonka was only two, she began visiting her Grandmother Biksadsky regularly. Later, her grandmother introduced her to such traditional arts as cookery, egg decoration, and fancy embroidery.

Today, Sidonka Wadina Lee continues to practice three forms of Slovak folk art: egg decoration, painting on woodenware, and her specialty — straw work. Sidonka learned to paint Easter eggs from Johanna Biksadsky at an early age. She did not become acquainted with straw work until her visit to Czechoslovakia as a teenager. With the help of her grandmother who had practiced the art form as a youngster, Sidonka disassembled and reassembled wheat weavings in order to learn how to create traditional house blessings and harvest crosses.

Sidonka Wadina Lee has not been satisfied simply to reproduce the forms which were handed down to her, however. Like any accomplished artist, she has not only mastered the skills and techniques of her predecessors, but has also attempted to bring new life to the tradition through her own creative experimentation. In recent years, Sidonka has added such forms as swans to her repertoire of straw work. In addition, almost twenty years ago, Sidonka began hand painting a collectors series of wooden plates decorated with representations of customs of Slovakia.

Through her dedication to tradition, her exceptional artistry, and her exciting creativity, Sidonka Wadina Lee has accomplished the mission her Grandmother Biksadsky began so many years ago — preserving the folk culture of people of Slovak heritage in Wisconsin and sharing it with others.

Xao Yang Lee was born in an agricultural village in northern Laos in 1943. Her mother, Kai Yang Lee, began to teach her to sew and to create the intricate needlework characteristic of the White Hmong tribe when she was only six. When she married, Xao Yang Lee applied her needlework skills to making her own clothing, as well as clothing for her husband and children.

During the mid-1970s, following the war in Southeast Asia, Xao Yang Lee and her five children escaped from Laos across the Mekong River to a refugee camp in Thailand. There she and many other Hmong women were introduced to new ways to put their needlework skills to use while they awaited relocation. They learned how to employ traditional motifs and sewing techniques to fashion new items that would sell on the American market, and they learned how to modify their color schemes and select types of fabric better suited to their new clientele.

Xao Yang Lee came to the United States in 1979 after two years in Thai refugee camps. She settled for a short time in California before moving to Wisconsin in April, 1980, to join her cousin. Now fully resettled in Sheboygan with her immediate family and many members of her extended family, Xao Yang Lee is employed as a second-shift factory worker in the local Wigwam Mills plant. She continues to make traditional clothing for members of her family and to fashion a wide range of inexpensive needlework items, much like those she learned to produce in the refugee camps, for sale to an American audience.

STEPHANIE LEMKE
Mazomamie, Wisconsin
Croatian Easter Eggs (Pisanica)

Stephanie Lemke was born in Podbrezje, Yugoslavia, in 1948. She was brought up on a small farm in the hilly inland area of Ozal. At the age of fifteen, she left home to study motel management on the Adriatic Coast. She was offered a job in a West German motel, and in 1966, at the age of seventeen, she left Yugoslavia for West Germany. Lemke lived there for six years and, during that time, met her husband, an American in the military. She came to the United States with him in 1972. In 1974, they moved to Cross Plains, Wisconsin. Late in 1977 they moved to the house in Mazomanie where Lemke and her son still live.

Although familiar with the practice of egg decorating since childhood, Stephanie Lemke did not begin making thread-decorated eggs until she married and moved to this country. Encouraged by a woman who wished to sell the eggs in her gift shop, she began making the eggs regularly. They were very popular in the local community. Over several years she was able to raise the price for each egg substantially and move the sales from the gift shop to her home. Despite this demand, Lemke is no longer able to produce her eggs on a large scale due to surgery for rheumatoid arthritis. Now she makes the eggs only on an individual basis for very special people. She also hopes to teach the technique and symbolism of Croatian egg decorating to the daughters of friends.

WILLIAM MALONE
Cedarburg, Wisconsin
Miniature Farm Wagons

In 1855, Thomas Malone purchased eighty acres of land about one mile north of Cedarburg. One of the early Irish immigrants to the area, Malone cleared his land and began growing wheat, corn and vegetables, as well as raising pigs, dairy cows and chickens. Thomas Malone passed his farm along to his son John, and John in turn handed it down to his son William. Bill Malone and his wife Anita still live in the Cream City brick farmhouse his grandfather built in 1874, and they have recently marked the 140th year the Malone family has lived on this property.

When Bill Malone was growing up on his family's farm, horse power was still the primary source of energy for farm work and transportation. The various types of horse-drawn vehicles used on the farm during Bill's youth have always remained fresh in his mind's eye, and over the last few years he has begun recreating them in miniature out of wood. Malone has now completed about eight such wagons and sleds, including a manure-spreader, hay wagon, dump wagon, and several carriages. He attempts to fashion each miniature vehicle in a manner as close as possible to the full-sized version used on his family's farm.

PRISCILLA MANDERS (1907 - 1997)
Oneida, Wisconsin
Oneida Cornhusk Dolls

Priscilla Jordan Manders was born at Oneida in 1907. Blind throughout much of her early childhood, she grew up in the care of her paternal grandfather who lived with her family until she was six years old. Her grandfather spoke only Oneida, and from him Priscilla learned the language and many traditional stories about the corn and other plants. He also taught Priscilla to make cornhusk dolls, a task which she first had to accomplish entirely by feel as a result of her blindness.

Priscilla recovered her sight around the age of four and began attending school at seven or eight. She went to boarding school in Tomah in fourth grade, and later attended a Bureau of Indian Affairs boarding school in Pipestone, Minnesota. After leaving school, Priscilla moved to Milwaukee where she did housework and cared for children. Eventually, she married and had a family of her own. By the 1950s, Priscilla and her family returned to live in Oneida where she became a trained nurse and hospital worker. From the time of her childhood until sometime in the 1940s, Priscilla Manders made cornhusk dolls regularly. However, when she returned to work full time, she set aside the craft. Only in the late 1970s, when she began working for the Oneida tribe, did Priscilla return to dollmaking. At first she made upright dolls in the old style, but from the late 1980s until her recent death, Manders made dolls "doing something" to teach children about Oneida culture.

BERTA MENDEZ
Waukesha, Wisconsin
Mexican Piñatas

Born in 1934 in El Paso, Texas, Berta Mendez watched her mother, Berta Ramirez, make paper flowers. She followed suit, making and exchanging the brightly colored flowers with a circle of girlfriends on birthdays and other special occasions. However, it was not until the early 1950s, when she married, moved to Milwaukee, and began to raise a family, that Berta Mendez became really active in paper artistry. No longer able to cross the border to Juarez to buy piñatas, she quickly realized that she would have to make them herself if they were to be a part of a child's birthday celebration. Soon Berta was not only making piñatas for her children's birthdays and for Christmas, but also for her children's school, for the Baptist church her husband pastored, and by the mid-1970s for community events celebrating ethnic heritage.

In pursuing her folk art form, Berta Mendez has continued to make piñatas in traditional forms like the star. However, she has also fashioned a number of innovative new designs, including piñatas in the shape of birds, snowmen, hearts, and even Santa Claus and his elves. For Waukesha's Latino Days, Mendez created a series of giant piñatas symbolic of Mexican-American culture. These included piñatas in the shape of a sombrero, a taco, a jalopena pepper, and a guitar. Berta Mendez has also passed along the tradition of paper artistry to her nine children.

TOM NELSON
Ashland, Wisconsin
Snowshoes

Tom Nelson was born in Hancock, Michigan, in 1919, of a Danish father and Cornish mother. His father worked for a power company, and the family moved frequently, relocating to Ishpeming in 1923, to Munising in 1926, and to Glidden, Wisconsin, in 1937. While a youngster in Munising, Nelson would watch the father of some of his friends make snowshoes. Fascinated, he picked up some scraps and, at the age of twelve or thirteen, constructed his own miniature pair of snowshoes.

After such youthful experimentation, Nelson did not actively pursue snowshoe making for some twenty years. Following a lengthy period in military service during World War II, Nelson returned to northern Wisconsin where he returned to his job with the power company, married, and began correspondence courses in surveying and engineering on the G.I. Bill. Eventually he formed his own surveying company, which called for a good deal of outdoor work that sometimes necessitated snowshoes.

Bit by bit, Nelson became involved with making snowshoes once again during the early 1950s. However, he did not get serious about the craft until after his retirement in 1982. Since that time, he has built a solid clientele of trappers, loggers, and surveyors. In addition, he serves a growing number of customers who use his shoes for recreational purposes.

LAURETTA SUHR NEUBAUER
Sparta, Wisconsin
Quilts

Lauretta Suhr Neubauer was born near Cashton, Wisconsin, in 1904, in Pine Hollow Valley, an area settled primarily by Germans. A third-generation German-American, she was raised on a farm there. When she married, Neubauer moved just five miles away, to the farm where her husband had been born.

Lauretta Neubauer learned quilting from her mother, and she has practiced the art continuously ever since. Over the years, she has furnished her four children and many grandchildren with fancy quilts as well as practical tied comforters. According to her daughter, Leonilda Kelly, "She's still making both kinds of quilts. She makes pretty quilts (of new material) for gifts if she wants to make a gift, and for quilts to use, she uses materials that were used but still real nice and cuts them up and makes quilts of them."

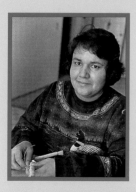

KIM CORNELIUS NISHIMOTO
Oneida, Wisconsin
Oneida Cornhusk Dolls

The mother of three young children, Kim Cornelius Nishimoto holds a mathematics degree from St. Norbert College, De Pere. She learned to make cornhusk dolls in 1987 from her mother, Amelia Cornelius, who had learned from her grandmother, Amelia Wheelock Jordan.

Corn, along with beans and squash, are the "three sisters," traditional staples for the Oneida people. Members of the League of Iroquois, the Oneidas were forced from New York State to Wisconsin where they occupied their current reservation west of Green Bay in 1838. Here generations of Oneida women have continued to grow white corn from heirloom seeds.

After an early September harvest, Kim explains, "My mom puts a big pile in her garage. As people have time, they just go and help [husk]." Dried until ready for use, the husks are dampened slightly for shaping into dolls. Like her elder relatives, Kim makes an occasional plain doll as a child's plaything, but her major efforts are devoted to clothing the dolls in the traditional regalia of nineteenth-century Oneidas. The Oneida tribe, her best customer, asks her for: "Something that's Oneida, made by an Oneida, given out as a gift from the Oneida tribe."

JULIA ECKERBERG NYHOLM
Crystal Falls, Michigan
Ojibwa Beadwork and Rabbit Blankets

Julia Nyholm was born in Caspian, Michigan, in 1913. When she was five, the family moved to nearby Crystal Falls. Her father, Gustav Eckerberg, was a Swedish immigrant and railroad section foreman. Her mother, Charlotte Bennett, was an Ojibwa from the Baraga Band on the shores of Lake Superior. While in her teens, Charlotte Bennett was "shipped down to lower Michigan, to Mount Pleasant, to the Indian School" until age twenty-one. She and her classmates were not allowed to speak their language, "or to do any customs, or do any Indian crafts. It was just like they were brainwashed."

Thereafter Julia's mother never practiced her cultural traditions, but she did take her family on frequent visits to Odanah, Wisconsin, on the Bad River Ojibwa Reservation where her brother Joe and his wife Julia lived. Known as *Zhiibayaash* (The Wind Sails Through), Julia Bennett was highly respected as an *ogichidaakwe* or head woman. From her aunt, young Julia Eckerberg learned beadwork, the weaving of bags, and moccasin-making. She also watched her cure rabbit pelts and loop them into warm blankets. After graduating from high school in 1932, Julia Eckerberg married Rudy Nyholm. "When my boys were small, we didn't have much money, so I used to make moccasins for them to wear....After they grew up, I kind of let that stuff go until later on."

Besides raising three sons, Julia did housework, baked in the Crystal Hotel, and toiled in the local hospital laundry. Evenings found her practicing the knitting, crocheting, tatting, and quilting she had learned from her mother and a neighbor lady. In the mid-1950s, her sons grown, Julia began twining yarn bags in the manner learned from her aunt. And in the late 1980s, at the request of her son, Earl, she revived the art of fashioning rabbit pelt blankets.

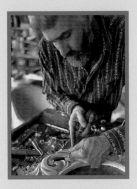

PHILLIP ODDEN
Barronett, Wisconsin
Norwegian Woodcarving

Phillip Odden was born in Shell Lake, Wisconsin, in 1952. After attending college in River Falls, Odden worked in Montana for a period of six or seven years. He did hunting, trapping, fishing, and surveying for the forest service. During the summers, he fought forest fires in Alaska. Inspired by the Eskimo and other Native American carving he observed there, Odden began carving bone, horn, and soapstone. Then, during the winter of 1976 while visiting relatives in Norway, Odden learned of the hundred-year-old *Hjerleids Husflid Skole,* one of the two trade schools in the country where a small number of students could learn traditional cabinetry and carving from a master carver. With the assistance of his relatives, Odden was admitted to the program and spent two years at the school. There he learned both carving and furniture making. Later he focused exclusively on carving.

Following completion of the program, Odden and his wife, classmate Else Bigton, returned to Wisconsin where they established Norsk Wood Works in Barronett. Odden generally creates the most elaborate decorative carvings sold by the wood shop and is responsible for the more complicated carvings on the furniture which Bigton designs and builds. The majority of their work is made to order for the Norwegian-American community in the Upper Midwest.

DENNIS O'DONNELL
Frederic, Wisconsin
"Junque Art"

Dennis O'Donnell was born in Frederic in 1952 of Irish and German ancestry. His father was a dairy farmer, and Dennis and his wife Linda now own and operate the 340 acre farm, milking fifty-eight registered Jerseys.

A while ago, O'Donnell began making what he calls "junque art" from scrap materials. He got his start one day when he noticed that a particular piece of equipment looked like a goose. He welded a few pieces together using equipment from his farm shop and created what he felt was a very nice goose. He continued by creating bugs, birds, cowboys, and eventually all manner of things.

O'Donnell regards his work mainly as a hobby, and he enjoys making pieces as yard decorations and as personalized gifts for friends. However, several years ago a shop owner from Luck saw his sculpture while attending his birthday party and offered to sell it through her store. His work sold so well that a second store has also picked it up. O'Donnell believes that most of the people who buy his pieces are from the Twin Cities, and that eventually the interest in his work will pass. In the meantime, he continues to enjoy recycling materials into whimsical objects of "junque art" that are appreciated by friends and neighbors in his community.

DOROTHY PETERSON
Cashton, Wisconsin
Norwegian Rosemaling

Dorothy Peterson lives near Cashton, Wisconsin, in the farmhouse where she was raised. Peterson took her first *rosemaling* lesson from instructor Pat Virch when she lived in the Upper Peninsula of Michigan. Eventually she went to a weeklong workshop at Vesterheim, The Norwegian-American Museum in Decorah, Iowa, when her husband offered to watch their children.

Like many other novices, Peterson began *rosemaling* by tracing patterns and following established models. Norwegian painter Nils Ellingsgard encouraged her and others to discard these set patterns and paint more individually. Peterson has followed this advice and has become a widely recognized American designer of Hallingdal style *rosemaling*. She won a Gold Medal at the national competition in Decorah in 1975.

IVORY PITCHFORD
Milwaukee, Wisconsin
African-American Quilts

Just as Allie Crumble learned to quilt from her mother many years ago in Mississippi, so too did Allie's daughter, Ivory Pitchford, learn the craft from her. Born in Sardis, Mississippi, in 1930, Ivory moved to Milwaukee with her parents at the age of thirteen. After attending school in Milwaukee, she married in 1949 and moved to Los Angeles three years later. Ivory lived in California for thirty years, working at Northrop Aircraft and at the Beverly Hills Hotel. In the early 1980s, she moved to Mississippi with her husband, a minister. After his death in 1987, she moved back to Milwaukee to live with her mother.

Ivory Pitchford's first quilt was a string quilt that her mother taught her to make. She started it at about the age of 16, constructing blocks about the size of a napkin from "strings" of fabric. She quilted it herself, in "shares" or sections, just as her mother did. Over the years, Pitchford has made quite a few string quilts, including one for each of her five boys. While she is rather pessimistic about the next generation carrying on the quilting tradition in the manner she has, Ivory would like to start a quilting club in order to share her knowledge with others. And, just as her mother started her out on a string quilt, she would use the same pattern to introduce her students to the African-American quilting tradition.

DELLA PLESKI
Foxboro, Wisconsin
Antler Baskets

Della Pleski was born in Superior, Wisconsin, in 1950. One of her grandmothers was Finnish, the other was Welsh; one of her grandfathers was Swedish, the other was a mixture of German, Scottish and a few other nationalities. Consequently, Della considers herself to be truly multi-ethnic. She was raised in Superior by her mother, a teacher, and her father, a railroad policeman. After she married, Della and her husband built a home in Foxboro, where they had a cabin previously.

For many years Della Pleski enjoyed doing needlework, especially crocheting. However, about fifteen years ago, her sister gave her a basketmaking kit for Christmas, and she has pursued this craft more actively than any other ever since. Most of her baskets are a variation on a basic market basket, made of reed and decorated with local materials, intended for use but nicely decorative as well.

Pleski has long experimented with different styles of baskets and different materials for their construction. Some years ago, after experimenting with driftwood for handles, she tried incorporating antlers her husband had hanging in the garage. Eventually, she developed a method of drilling holes in the antlers and weaving them into the basket. She has sold many of her antler baskets to hunters who value them as remembrances of a kill, and to other customers at craft shows and festivals who find them unusual and interesting.

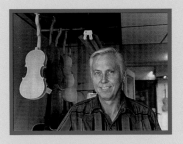

RON POAST
Black Earth, Wisconsin
Norwegian Hardanger Fiddles

Ron Poast was born in Dodgeville, Wisconsin, in 1940 of Norwegian heritage. He grew up on a farm in the Blue Mounds area of Dane County. Both of Ron's grandfathers were old-time fiddlers. Ron's dad also played music, and he himself took up the guitar. As a boy, Ron Poast occasionally heard his relatives speak of a peculiar, very ornate, multi-stringed fiddle which they had seen and heard years before. The instrument Poast's family referred to was a *hardingfela,* or Hardanger fiddle, the national folk instrument of Norway. While very popular in the Upper Midwest around the turn of the century following the massive influx of Scandinavian immigrants to the region, the Hardanger fiddle declined considerably in popularity by the time of World War II.

It was not until years after first hearing of these unusual instruments that Ron Poast finally encountered a Hardanger fiddle, on display in a shop window in Mount Horeb, Wisconsin. By that time, Poast had already been building guitars and banjos for C.C. Richelieu in Oregon, Wisconsin. He began immediately to study the making of Hardanger fiddles. Poast visited Vesterheim, The Norwegian-American Museum, in Decorah, Iowa, to examine old instruments. He procured an instruction manual from Norway, and he talked to some of the again-growing number of fiddlers playing the instrument. Since the chance encounter with his first Hardanger fiddle, Ron Poast has built a number of the instruments and has gained a national reputation as one of only five Hardanger makers in the country.

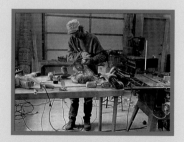

JEFF PRUST
Hurley, Wisconsin
Chainsaw Carvings

Originally from Jefferson, Wisconsin, Jeff Prust and his wife Sheila moved to Manitowish Waters a few years ago and then, more recently, to Hurley. There they opened a shop, called Hawk Hollow. About this time, roughly 1991, Jeff began experimenting — "fooling around," to use his phrase — with chainsaw carving as a way to relax. His results were so impressive that, after only three months, people began offering to buy his work. Now Prust considers himself to be a full-time sculptor, and his work makes up a significant portion of the merchandise sold through Hawk Hollow.

Jeff Prust usually carves red or white pine which he obtains from loggers or log home builders. His pieces vary in size from one to twenty feet. Unlike some chainsaw carvers, Prust does not use chisels or other tools to finish his carvings. He relies solely upon chainsaws, though he employs ten or twelve different saws in as many different sizes. While he often accepts commissions, Prust specializes in subjects like bears, eagles, gnomes and totem poles. He is known nationally for his bears which the sculptor endows with an almost human quality or character.

JAMES RAZER
Tony, Wisconsin
Ojibwa Ceremonial Regalia

James Razer was born in Minnesota in 1928. He is an enrolled member of the Fond du Lac Band of Ojibwa. At the age of five months, Razer was placed in a school operated by the State of Minnesota. The only Indian in the school, Razer was not allowed to communicate with his relatives. He was cut off from his cultural heritage and made to feel ashamed of it. The negative stereotype of Indians which Razer confronted during his fourteen years in the state school prompted him to undertake a lifelong search for his own roots. It also led him to attempt to prove that "the old stuff could be beautiful."

Razer began reading and researching his background, and he began talking to tribal elders. He became involved in dancing in an effort to recover a sense of his cultural past, and he was an active participant in powwows for many years. In the early 1980s, Razer began presenting public programs to explain and interpret Ojibwa dance, crafts and dress.

At about the age of thirty-five, in conjunction with his dancing, Razer started fashioning traditional garments and accouterments of the type made by Woodland peoples prior to contact with whites. Among the articles Razer creates are a number of musical instruments. These include deer toe jingles to adorn buckskin dance leggings, turtle shell rattles used for curing ceremonies, warrior's whistles made from the wingbone of an eagle, small hand drums to accompany moccasin games, and larger social drums fashioned from hollowed-out cottonwood stumps.

WILLA RED CLOUD
Neillsville, Wisconsin
Ho-Chunk Finger-Woven Sashes

Willa Red Cloud was born in 1953. Her mother, Priscilla Mike, was well known for her finger-weaving. An only child, Mike may have learned her art form from Helen Russell who traveled widely teaching the basic techniques. Willa Red Cloud remembers her mother working on her weaving all of the time, and she recalls her taking orders for her work at powwows.

When Willa Red Cloud was very young, she began playing with yarn and making dolls with long skirts. Her mother taught her the basics of finger-weaving and told her that, if she learned to weave an arrowhead belt, she would be able to make anything. Red Cloud remembers mastering the arrowhead and lightning designs, and then teaching herself the rest. Now a long-time weaver herself, Willa Red Cloud has never seen another tribe use the weave, unless they traded with or bought from a Winnebago.

INEZ COOPER ROBERTSON
Sheldon, Wisconsin
Braided Rag Rugs

Born in Barron County, Wisconsin, in 1933, Inez Cooper Robertson grew up near Sheldon in Taylor County and has lived most of her life in nearby Rusk County, farming and working in the woods while raising eight children. She remembers her mother braiding rag rugs from flannel salvaged from her father's worn out shirts. She also recalls rescuing small scraps from her mother's weaving which she used in childlike imitation of her parent's braiding.

Robertson completed her first rug on May 1, 1964 as a wedding gift. Since that time, she has crafted well over 2,000 rugs, giving away most of them to family and friends. An accomplished artist, it now takes her only a single day to braid a circular rug roughly two feet in diameter.

SAMUEL RUST
Rice Lake, Wisconsin
Carved Gunstocks

Samuel Rust was born in Rice Lake, Wisconsin in 1934. When he was a boy, Rust spent a great deal of time in the garage and basement workshops of his uncles, Lee and Pat Scherz. The two brothers were accomplished woodworkers who made, modified, and decorated gunstocks. Sam helped his uncles with sanding and other basic tasks. From them, he learned how to fit a gun's metal "action" into a wooden stock. He also learned a range of decorative patterns, including checkering and oak leaf motifs.

Rust carved his first gunstock at the age of nine and has been steadily involved in the craft ever since. He works on his guns primarily in the evenings and on weekends. While he carves mainly for himself, he has made numerous gunstocks for his children, relatives, and friends. Rust estimates that he has carved between 100 and 150 stocks over the years and has worked on many others. Although most of his customers hear of his work by word-of-mouth, Rust has made guns for sportsmen and collectors "from Maine to California." Still, his largest audience remains the hunters within the region who value his reasonable prices and willingness to repair or rebuild heirloom guns for them.

ELDA SCHIESSER
New Glarus, Wisconsin
Swiss Paper Cutting (Scherenschnitte)

Elda Schiesser was born on a farm near New Glarus. Her Swiss heritage has been a strong influence throughout her life, and it may have prompted her interest in *Scherenschnitte,* or "scissor cutting." Schiesser's first contact with the traditional art of paper cutting came in 1962 when she purchased a Walter Von Guten cutting. After viewing many old examples of the art in museums during a 1985 visit to Switzerland, her interest peaked once again, and she began to apply herself to mastering the practice.

Schiesser first exhibited her work during the 1985 Wilhelm Tell Art Fair in New Glarus. Since that time, she has expanded her repertoire and increased her expertise. Her subjects include not only scenes from daily life in Switzerland, but also immigration to the United States, and a variety of religious topics. In addition to taking part in a number of exhibitions throughout Wisconsin, Elda Schiesser contributed works to exhibitions at the Swiss National Museum in Zurich in 1994 and the Thomas Legler Haus Museum in Diesbach, Glarus, Switzerland in 1995.

NORMAN SEAMONSON
Stoughton, Wisconsin
Norwegian Woodcarving

Norman Seamonson was born in 1919. His grandfather came to the United States from Femrite, on the Sognafjord, in Norway. According to Seamonson, the family name was originally Femrite as well, but his grandfather began using his father's name, which was Simon, calling himself Simonson. When Norman's father went to school, the spelling was Anglicized and Seamonson resulted.

In 1944, Seamonson married a girl he'd met in high school through friends of the family. He worked on a farm for about seven years after they were married, then began working for a contractor and cabinet maker in Stoughton. Eventually, he went into business on his own, building houses and making cabinets. From about 1966 through his retirement in 1982, Seamonson worked for Sullivan Bros. in Madison as a jack-of-all-trades.

After his retirement, Norman Seamonson began making woodenware for his wife who was an avid *rosemaler*. He purchased a lathe, a tool he had never used before despite his many years in construction and cabinet-making. As he became more proficient, he developed a small catalogue advertising the plates, bowls, trays and other items he made for *rosemalers*. Seamonson stopped producing this type of woodenware when his wife passed away in 1989. At that time he turned to chip carving at the suggestion of *rosemaler* Ethel Kvalheim. While he has created boxes and other forms, Norman Seamonson has come to specialize in mangle boards, winning a gold medal in 1996 at the annual competition at Vesterheim, The Norwegian-American Museum in Decorah, Iowa.

JOHN SNOW
Lac du Flambeau, Wisconsin
Ojibwa Fish Decoys

"I was born right back here in a little red shack, right on the reservation [in 1932]. They had an Indian hospital, but it was way over in Hayward. All the kids in our family were born right here on Flambeau."

The French named Lac du Flambeau for the flaming torches fixed to canoes by Ojibwas who, spears in hand, scanned the spring waters for muskellunge and walleye. Months before, however, when lakes were frozen, the spearers had lain in dark tipis peering through holes in the ice and hoping to attract a fish by jigging a wooden decoy. The "dark house," spear, and fish decoy complex extends back at least 1,000 years among the Upper Midwest's Woodland peoples.

John Snow learned carving and fishing skills by watching and experimenting. His father-in-law, Earl Cross, Sr., and his brother-in-law, Ross Allen, "were two guys that really knew what they were doing....I'd take my fish [decoys] over there and they would show me theirs." As a young man, Snow worked in the woods and did some guiding. He served in the KoreanWar, then worked for twenty years in a Chicago machine shop before returning to Lac du Flambeau in 1975. Back home, when Snow began carving and fishing regularly, he discovered that duck decoy and woodcarving collectors were seeking fish decoys. "So I started going to shows...decoy shows." Soon his fish decoys attracted customers as easily as they lured muskies. Nowadays John Snow not only carves, but offers classes and kits introducing novices to the art of the fish decoy.

ETHEL WETTERLING SOVIAK (1923 - 1992)
Ladysmith, Wisconsin
Knitting and Needlework

A "duke's mix" of Swedish, German, French, Dutch, and English, Ethel Wetterling Soviak was born in Ladysmith, Wisconsin, in 1923. Except for a single year spent in Milwaukee during the 1940s, she lived in the area all of her life. Her parents farmed, but Ethel always held a housekeeping, restaurant, or factory job while raising her six children. An expert needleworker, Soviak learned to crochet, knit, and sew from her mother.

When she was growing up in Wisconsin's Northwoods, Ethel Soviak helped her mother make wool comforters, coverlets and quilts for family use. Later, she continued the practice for her own family, making mainly cotton bed coverings and an occasional one of wool. In addition, Soviak was known for her extra warm "work-in-the-cold socks," prized by family members who worked outdoors and risked the dangers of wet feet.

SELMA SPAANEM
Mount Horeb, Wisconsin
Hardanger Needlework

Selma Spaanem was born in the Mount Horeb, Wisconsin area in 1912. Like many young girls of her generation, Selma Spaanem learned various forms of needlework as a child in the home. She cross-stitched flour sacks, learned to knit and crochet, and did some tatting with a small shuttle. Through the years, she has continued to do various types of needlework for her own entertainment.

While both Selma Spaanem's mother and aunt made Hardanger lace, she did not learn this particular style of needlework directly from them. Instead, her teacher was Marie Jenson, a Mount Horeb expert. Since learning this traditional Norwegian form of needlework, Spaanem has practiced it continuously and has experimented with various complex decorative stitches to "spice up" the openwork. Spaanem has also taught knitting and crocheting at the vocational school in Mount Horeb and served as the instructor for Hardanger lace-making classes at crafts shops in Verona and Madison.

RAY STEINER
Argyle, Wisconsin
Willow Baskets

Ray Steiner was born in Argyle, Wisconsin, in 1914. He learned to make willow baskets from his neighbor Ernest Lisser, a farmer in the area near Woodford. Lisser had made willow utility baskets in his native Switzerland, earning twenty-five cents per day for his efforts. After his wife passed away, Lisser turned to making baskets for laundry, gardening, and feeding cattle in order to earn extra money. Steiner offered to cut willow for Lisser and asked the older man to make a few baskets for him. However, Lisser insisted that Steiner learn basketmaking himself and taught him the basics of his craft.

Over the past twenty years, Steiner has made hundreds of willow baskets of his own. While he makes baskets primarily for his family, many local people buy his work. His daughter also sells some of his baskets for him at craft fairs and bazaars. A Swiss-American himself, Steiner regards his making of Swiss willow baskets as a means of preserving his cultural heritage. As a result, he is passing along the craft to his grandson.

ALVIN STOCKSTAD
Stoughton, Wisconsin
Tobacco Spears

Alvin Stockstad was born in Stoughton, Wisconsin, in 1922. When Stocktad was a boy, his father Oscar raised tobacco in Dane County. When some tobacco spears he used in the 1920s fit too tightly, he refashioned them. Eventually, Oscar Stockstad turned from refitting these specialized tools to making his own. These he sold to neighbors and to stores in Wisconsin's tobacco belt, from Vernon and Crawford Counties down into Dane County. Alvin Stockstad began to help his father as a young boy in the late 1920s and has continued to create tobacco spears and axes up to the present.

The making of tobacco axes and spears is seasonal. Stockstad begins work each year in late spring and completes his stock of wares by early July. The tools are built to last for several seasons, but Stockstad sells approximately 200 annually. These sales are a valued source of income now that Alvin is retired after thirty years as an employee of General Motors in Janesville.

JACK SWEDBURG
Webster, Wisconsin
Fishing Lures

Jack Swedburg was born in Frederic, Wisconsin, in 1941, the son of John Raymond Swedburg, Sr. and Lucille Doetsch Swedburg. Jack's mother was Dutch and German, and his father was Swedish. A mortician and owner of the Swedburg Funeral Home in Webster, John Swedburg, Sr. also worked at a garage and fixed outboard motors to supplement the family income. After graduating from the University of Minnesota in 1962, young Jack returned home to work with his father. He bought the family business from his dad in 1970 and worked there until his retirement in 1993.

As a boy, Swedburg did a lot of hunting and fishing. He learned most of his skills from Russell Connor, a next door neighbor. Jack's love of fishing led him to join a fishing lure collector's club, and his collecting in turn prompted him to begin making his own fishing lures. Unable to compete with commercial sources of usable lures, Swedburg later turned to making giant lures, which he calls "feelable art." Despite the primarily decorative function of these lures, Swedburg employs the same quality materials and painstaking craftsmanship in the fabrication of these larger-than-life creations as he did in making their usable counterparts.

VI THODE
Stoughton, Wisconsin
Norwegian Rosemaling

Vi Thode has played several important roles in the Stoughton *rosemaling* community, serving as a teacher, artist, show judge, and publisher of *rosemaling* patterns. She is, however, best known as the pioneer of an "American" variation on the Norwegian Rogaland style of *rosemaling*. After taking workshops with instructor Bergljot Lunde in the traditional Rogaland style, Thode developed it a bit further, adding greater geometric complexity and strong shadings which yielded a three-dimensional effect. Thode's extensive use of the "American Rogaland" style in her publications and instructional workshops were instrumental in establishing it within the Midwestern *rosemaling* community. Her accomplishments as an artist were also recognized with a Gold Medal from the National Rosemaling Exhibition in Decorah, Iowa.

ALMA UPESLEJA
Milwaukee, Wisconsin
Latvian Mittens

Alma Upesleja was born and raised on a farm in Laudona County, Latvia, in 1906. In 1931, she married and went to live with her husband's family about twenty-eight miles away. There Alma's daughter Anna was born in 1932. In 1944, the family fled Latvia by horse and buggy, traveling 124 miles to the Baltic Sea where they crossed into Germany. They spent five years in displaced persons camps before immigrating to the United States in 1949. The Upeslejas worked on a farm in Virginia for two years. In 1951, they moved to Milwaukee where Alma's brother-in-law was earning a better living doing factory work. While in Latvia and Virginia, Upesleja did farm work including tending dairy cows. In Milwaukee she worked in a factory, a bank, and at St. Mary's Hospital before retiring.

In Latvia during her childhood, Upesleja learned the intricacies of knitting from her maternal grandmother, Ieva Lacis, with whom she often spent several weeks each summer. Upesleja continues to knit Latvian mittens today, exchanging them with friends for other artwork, giving them as gifts, and selling them at church bazaars and benefits. A tireless handworker, she also weaves rugs, pillow covers, and wall hangings, crochets afghans, and sews clothing for her grandchildren. She has passed along all of her skills as a needleworker to her daughter Anna Vejins.

LINUS VANDER LOOP
Kaukauna, Wisconsin
Schut Birds

Linus Vander Loop was born in Hollandtown, Wisconsin, on October 26, 1929, just a few days before the crash of the Stock Market which marked the beginning of the Depression. He has lived within five miles of Hollandtown most of his life. A farmer for much of that period, Vander Loop once kept cows but now concentrates primarily on raising hay which he sells to race tracks and other businesses.

Like many of his neighbors, Linus Vander Loop has taken an active part in perpetuating an important Dutch tradition in his community, the annual Hollandtown *schut.* Begun in 1849, the *schut,* or "shoot," is a local re-enactment of a medieval tradition still practiced in Germany, Belgium, and the Netherlands. Members of the Hollandtown St. Francis Society and others display their marksmanship by firing at a replica of a parrot mounted atop a pole some 65 feet above the ground The shooter who brings down the bird — usually after 450 to 700 shots — is declared the king.

In the old days, the king was required to make the bird for the next year's event. However, in more recent times, other members of the community have taken responsibility for its construction. During the past thirty years, Linus Vander Loop helped two of his brothers fashion the *schut* bird on several occasions. Over the last five or six years, he has been solely responsible for constructing the bird, making use of his previous experience.

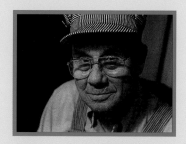

ADOLPH VANDERTIE
Green Bay, Wisconsin
Woodcarving

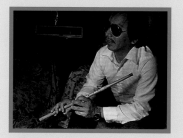

WANG CHOU VANG
Menomonie, Wisconsin
Bamboo Flutes, Hmong Violins

Adolph Vandertie was born in Lena, Oconto County, in 1911. When he was eight years old, his uncle Jules bought him a jackknife. Like all the other boys, Vandertie whittled slingshots, willow whistles, toys, and boats. He and his friends also cut designs into willow sticks and then peeled off the bark to make a pattern.

A few years later, the Vandertie family moved from Lena to Green Bay, then a busy railhead. The town boasted three hobo jungles at the time, and Vandertie visited these frequently without his parents' knowledge. There he saw the hobos carving wooden chains, ball-in-cages, and pliers from single pieces of wood. Vandertie carved his first caged ball when he was about twelve-years-old and continued carving during his teenage years. He set aside his whittling throughout most of his adult life, returning to it only in 1955 when, having given up smoking, he had to do something with his hands.

Over the past forty years, Vandertie has carved approximately 2,400 pieces. He never sold any of his work, though he has given away some small items. Instead, Vandertie has kept most of his woodcarvings in his home, which has now become a veritable museum. Vandertie's family members all enjoy his work, and one of his sons, David, also carves, whittles, and sketches.

Born in Laos in 1952, Wang Chou Vang came to the United States in 1980, settling first in Elk Mound and then in Eau Claire. As a boy, Vang learned to play the *nkauj nrog ncas,* or two-stringed violin, and the bamboo flute. Both instruments were used in courting and in the traditional Hmong New Year's celebrations. In addition, Vang recalled that he would use the flute and violin to play music upon entering a village during wartime. The songs he played indicated who he was and that he came in peace.

In Laos, Vang made two-stringed violins for sale to other musicians. Since coming to the United States, he has made only a few for his own use. In constructing these, Vang has had to find suitable substitutes for various unavailable materials. He has, for example, been forced to use metal cylinders and gourds for the soundboxes of the violins. He has also come to cover the resonators with the hides of raccoon or deer he has hunted. Though it has sometimes been difficult to obtain, Vang has usually been able to get horsehair for the bow of his two-stringed violins, and he has also continued to carve an Asian bird, an *aum vaag,* at the end of the instrument's neck. Thus, despite considerable obstacles, Wang Chou Vang has successfully contributed to the preservation of Hmong music in Wisconsin and the United States through dedication to his traditionally male craft of instrument making.

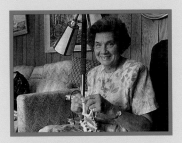

ANNA VEJINS
Greenfield, Wisconsin
Latvian Mittens

Anna Vejins was born in Kraukli County, Latvia, in 1932. In 1944, at the age of twelve, Anna fled from Latvia with her parents, going by horse and buggy to the Baltic Sea where they crossed into Germany. Following five years spent in displaced persons camps, the family came to the United States. For several years, they worked on a farm in Virginia. When Vejins' parents moved to Milwaukee in 1951 to pursue better wages, she remained in Virginia to complete high school and work as a nurse's aide. During a visit to Milwaukee in 1955, she met the man she would marry. Later that year, she moved to Milwaukee and the couple were wed. When Vejins' second child went off to college, she returned to school to take drafting courses and took a position as a draftperson at Harnischfeger, where she designed and wrote specifications for the company's hoists.

In Latvia, Vejins knitted at home before entering grade school. She learned to knit and embroider fancier pieces in a second-grade home economics class. During her family's confinement in displaced persons camps, she learned more handwork techniques from her mother, including fancywork. When her own children were born, Vejins sewed their clothing and knit mittens for them. Today, she continues to create mittens off and on while watching television or talking on the phone. Vejins often displays her mittens at Milwaukee's Holiday Folk Fair. She and Vita Kakulis have organized the fair's Latvian exhibits for many years.

CARL D. VOGT
Madison, Wisconsin
Miniature Farm Machines

Carl D. Vogt was born in Nelson, Wisconsin, in 1919. Vogt's father was both a farmer and carpenter. As a young man, Carl frequently helped him fix used equipment for work on the farm. The skills Vogt developed during his youth on the farm served him well when he reached adulthood. He worked for Gisholt Machine Company in Madison between 1940 and 1948. Thereafter, he worked in a cabinet shop for twenty-five years before buying the business and running it himself until his retirement.

Over the last twenty-five years, Vogt has crafted miniature engines of exceptional detail and quality. He specializes in engines once used on farms to power threshing machines, pumps, cream separators, and the like. These he displays and demonstrates at engine shows and thresherees throughout the summer, where his work is frequently recognized with ribbons and other awards.

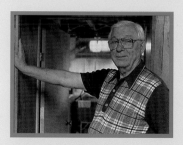

NICK VUKUSICH (1923-1994)
Milwaukee, Wisconsin
Croatian Tamburitzas

A s a boy in the Croatian community of Ironwood, Michigan, Nick Vukusich heard a great deal of tamburitza music. Like many others of his generation, Vukusich learned to play the instrument and to perform the music which had become something of a national symbol for Croatians since the arrival of the first Yugoslav immigrants in the United States in the 1880s. Tamburitza music later became a Vukusich family tradition as well. Nick and his wife Mary Ann, also a tamburitza player, raised three daughters. All of the girls also took up the instrument and learned to play the Croatian folk tunes handed down in their family and the Milwaukee Croatian community.

Nick Vukusich made his first tamburitza just over twenty years ago. Using some of the woodworking skills he had learned as a youngster while summering with his grandfather in Mellen, Wisconsin, Vukusich took apart an old instrument to see how it was constructed, then built a new one using it as a pattern. Over the years, he crafted more than 25 tamburitzas for members of his family and for musicians in Milwaukee's Croatian-American community. So highly valued was his craftsmanship that Vukusich tamburitzas were coveted prizes in raffles sponsored by Croatian music groups in the area.

LOUIS WEBSTER
Neopit, Wisconsin
Woodland Flutes

B orn in Green Bay in 1949 of Menominee, Oneida, Ojibwa, Stockbridge, Munsee and Potawatomi ancestry, Louis Webster was adopted by his grandparents at the age of eight months. He was raised on the Menominee Reservation at Neopit. In the early 1960s, Webster began playing rock music and progressed rapidly through various styles. During the late 1960s, he roamed throughout the country, spending several years in San Francisco. By the time of his return to Wisconsin around 1970, the highly political American Indian Movement had grown strong, and Webster became actively involved in Indian politics and culture.

While attending classes at the University of Wisconsin-Milwaukee in the early 1970s, Louis Webster was introduced to a variety of Native American musical instruments by an ethnomusicology instructor. Among these was a Sioux flute. Webster was fascinated by the instrument and decided to make one for himself. This first attempt at instrument making proved highly successful, and Webster began working flute tunes into his musical compositions. These he performed while traveling the emerging Midwestern powwow circuit. Webster soon encountered other flute players, young and old, at the powwows he attended, and he began making more instruments for barter and sale to this clientele and to other interested parties. Through the efforts of Louis Webster over the past fifteen to twenty years, the Woodland flute has experienced a marked revival, regaining something of the popularity it enjoyed early in this century

ANTON WOLFE
Stevens Point, Wisconsin
Concertinas

Anton Wolfe was born in 1922 near Moquah, in Bayfield County, Wisconsin. He began tinkering with concertinas in the early 1940s when his own instrument broke and replacement parts from Germany were not available due to the war. Over the next twenty-five years, he began to construct his own instruments. In 1967, Wolfe gave up farming in Bayfield County and moved to Stevens Point. There he purchased equipment and parts from Rudy Patek, who had made concertinas in Chicago, and began making the instruments part-time. In 1980, Wolfe began to devote all of his time to making concertinas. He now owns and operates a shop which occupies a former grocery store.

Wolfe produces instruments in a variety of standard keys but generally avoids custom work because it is too time consuming. He works on the production of individual concertina parts for much of the year. When he has built up an adequate stock, he works steadily to assemble the instruments. Because the sound of Wolfe's instruments follows the old German standard rather than approximating that of a piano accordion, his concertinas are sought after by German-American or "Dutchman" style polka bands.

FLORIAN ZAJACKOWSKI
Milladore, Wisconsin
Dairy Farm Signs

Florian Zajackowski was born in 1926 in the Town of Norrie in Marathon County, a farming community several miles northeast of Hatley. His parents were Polish immigrants from the rural area around Posen who immigrated to the United States independently about 1901 and met while living in Milwaukee's south side Polish neighborhood. Florian's father worked for Allis Chalmers before the family bought land, put up a log cabin, and started a farm in Marathon County in 1916. There they raised twelve children, the youngest of whom was Florian.

Florian Zajackowski has farmed all of his life, except for a period of military service during the Korean War. He and his wife Alice married in 1954. They farmed on his parents' farm for six years before moving to their present farm in Milladore, Portage County, in 1960. The Zajackowski farm has always been a dairy farm. Florian started with Guernseys but eventually switched to Holsteins, and currently he and his son Mark milk eighty head.

The Zajackowski homeplace in Marathon County was called the Pine Grove Dairy Farm, and that name was proclaimed in cut-out letters on the side of the barn flanked by diamonds. When Florian and Alice settled on their own farm in Portage County, they continued the family tradition of naming their farm and fashioning a sign for it. Since 1960, two of Florian's daughters, Julie and Maria, have helped to redo the family's farm sign and to continue the tradition.

CONTRIBUTORS

ROBERT T. TESKE —

Robert Teske holds a B.A. in Folklore and Mythology from Harvard University and an M.A. and Ph.D. in Folklore and Folklife from the University of Pennsylvania. Following five years of teaching on the undergraduate and graduate levels at Wayne State University and Western Kentucky University, Teske served as Senior Arts Specialist for the Folk Arts Program of the National Endowments for the Arts from 1979 through 1985. At that time, he returned to his native Wisconsin to become Associate Curator of Exhibitions at the John Michael Kohler Arts Center from 1985 through 1988. Since 1988, Teske has served as the Executive Director of the Cedarburg Cultural Center. During the last 10 years, Robert Teske has curated over 85 exhibitions, including three major traveling exhibitions focusing on Wisconsin folk art. In 1987, Teske curated "From Hardanger to Harleys: A Survey Of Wisconsin Folk Art" which was presented at the Kohler Arts Center, the State Historical Museum and the Milwaukee Public Museum. In 1990, he organized "In Tune With Tradition: Wisconsin Folk Musical Instruments" for the Cedarburg Cultural Center, an exhibition which toured to four other venues throughout the state. Most recently, in 1994, Teske curated "Passed to the Present: Folk Arts Along Wisconsin's Ethnic Settlement Trail," which traveled to a total of eight sites in eastern Wisconsin over a two year period.

RUTH OLSON —

Raised on a dairy farm in northwestern Wisconsin, Ruth Olson has done extensive fieldwork in the northern part of the state. She studies the occupational, recreational, and ethnic life of rural communities, and most particularly, issues of land use and agriculture. Olson holds an M.A. in Writing from Washington University in St. Louis, and a Ph.D. in Folklore and Folklife from the University of Pennsylvania. She taught folklore at the University of Pennsylvania, Harvard University and the University of Wisconsin, Madison. Olson is also on the staff of the Wisconsin Folklife Festival and is helping to arrange the presentation of Wisconsin's traditional life at the 1998 Festival of American Folklife sponsored by the Smithsonian Institution.

JAMES P. LEARY —

James Leary hold a B.A. in English Literature from the University of Notre Dame, an M.A. in Folklore from the University of North Carolina, and a Ph.D. in Folklore and American Studies from Indiana University. Currently a member of the faculty of the Folklore Program at the University of Wisconsin-Madison, Leary has conducted extensive fieldwork throughout his native Wisconsin and has published numerous books and articles on Midwestern folk humor, European-American traditional music and material folk culture. James Leary has served as the principal field researcher for several major Wisconsin folk art exhibitions, including "From Hardanger to Harleys," "In Tune With Tradition," "Passed to the Present," and "Folk Arts of the Chippewa Valley." He has also recently completed researching and organizing an exhibition called "We Chose to Go That Way: Words and Works by Master Woodland Traditional Artists of the Upper Midwest" for the Wisconsin Folk Museum. Leary co-hosts the Wisconsin Public Radio program "Downhome Dairyland" with Richard March of the Wisconsin Arts Board, and he has consulted on a variety of recordings and films.

JANET C. GILMORE —

Janet Gilmore holds a B.A. in English from Reed College, and an M.A. and Ph.D. in Folklore from Indiana University. A self-employed folklorist, Gilmore worked closely with the Wisconsin Folk Museum over the last eight years on the development of exhibitions focusing on the traditional arts of the state, including presentations on Norwegian traditional costume and *rosemaling*. A specialist in occupational folklore, Gilmore has also conducted extensive research on the commercial fishing industry in Wisconsin, Minnesota, the Mississippi Valley, and the Pacific Northwest. Janet Gilmore has also served as a consultant for the National Endowment for the Arts, the Wisconsin Maritime Museum, the Florida Folklife Program, the Wisconsin Arts Board, Artreach Milwaukee, and other organizations. She has also served as a presenter for the Smithsonian Institution's Festival of American Folklife and the Michigan Folklife Festival.

LEWIS KOCH —

Lewis Koch holds a B.A. in History from Beloit College, and studied photography on the graduate level at Kobenhavns University in Copenhagen, Denmark, and at New York University. He has exhibited his work nationally and internationally since 1973 at museums and galleries including the Madison Art Center; the Charles Allis Art Museum, Milwaukee; the Everson Museum of Art, Syracuse; Camerawork, London, England; the American Cultural Center, Brussels, Belgium; and the Munchner Stadtmuseum/ Fotomuseum, Munich, Germany. Koch served as the field photographer for the Cedarburg Cultural Center's traveling exhibitions "In Tune With Tradition" and "Passed to the Present," and his ethnographic photographs of Wisconsin traditional artists were featured both in the exhibitions and in the accompanying catalogues.

VICTOR DI CRISTO —

Trained at the Layton School of Art in Milwaukee, Victor Di Cristo has been active as a design professional in southeastern Wisconsin since 1965. As owner of Victor Di Cristo Design and a full partner in Di Cristo Slagle Design, he developed corporate designs, packaging, signage and annual reports for such major corporations as Johnson Controls, Kohler Corporation, and the Hearst Corporation. Past President of the Illustrators and Designers of Milwaukee, Victor Di Cristo is also affiliated with the American Institute of Graphic Arts and the American Center for Design. Di Cristo has designed four recent publications for the Cedarburg Cultural Center, including both exhibition catalogues for "In Tune With Tradition: Wisconsin Folk Musical Instruments" and "Passed to the Present: Folk Arts Along Wisconsin's Ethnic Settlement Trail."

PHOTOGRAPHIC CREDITS

LEWIS KOCH —
Cedarburg Cultural Center:

"Wisconsin Folk Art:
A Sesquicentennial Celebration," 1997
pg. 16, 18a, 21, 48, 60, 64, 72, 75, 77, 80, 91,
92a, 92b, 94, 100a, 104a, 104b, 108a, 108b,
112a, 112b, 114, 115, 117, 118a, 121a, 121b,
122, 123a, 124

"Passed to the Present: Folk Arts Along
Wisconsin's Ethnic Settlement Trail," 1994
Cover, Pg. 10, 26, 28, 33, 36, 52, 55, 56, 71,
88, 90, 93a, 96b, 98a, 102, 103, 105, 106, 107a,
107b, 109a, 109b

"In Tune With Tradition: Wisconsin Folk
Musical Instruments" 1990
Pg. 89, 123b, 125a, 125b

Wisconsin Folk Museum:

"Traditional Woodland Indian Master Artist
Project," 1994
Pg. 14a, 25, 41, 45, 95b, 96a, 98b, 100b, 101,
111, 118b

"Quilt Exhibition," 1992 — Pg. 4, 42

"Rosemaling Exhibition," 1989 — Pg. 58

JAMES P. LEARY—
Cedarburg Cultural Center:

"Wisconsin Folk Art: A Sesquicentennial
Celebration," 1997 — Pg. 49

Wisconsin Folk Museum:

"Traditional Woodland Indian Master Artist
Project," 1994
Pg. 22, 93b, 126

"Fall Festival," 1989 — Pg. 113

Chippewa Valley Museum:

"Hmong in America Project," 1992 — Pg. 39

JANET C. GILMORE — Pg. 34, 95a

ANDREW LUBANSKY — Pg. 40

MAURICE THALER —
Courtesy of the Dane County Cultural Affairs
Commission — Pg. 31

MERT COWLEY COLLECTION —
Pg. 67, 69

LYLE OBERWISE COLLECTION —
Pg. 37

**DUFECK MANUFACTURING
COMPANY** — Pg. 19

COURTESY OF WILL VAN ABEL —
Pg. 38

**STATE HISTORICAL SOCIETY OF
WISCONSIN** — Pg. 14b, 30

**UNIVERSITY OF WISCONSIN-
MADISON, CARTOGRAPHY
LABORATORY, GEOGRAPHY
DEPARTMENT and UNIVERSITY
OF WISCONSIN PRESS** — Pg. 51, 57

WISCONSIN FOLK MUSEUM —
Pg. 18b

WISCONSIN SESQUICENTENNIAL FUNDING

Wisconsin Folk Art: A Sesquicentennial Celebration has been funded in part by the Wisconsin Sesquicentennial Commission with funds from the State of Wisconsin and other individuals, organizations and the following corporate contributors:

Trailblazer contributors:
AT&T; S.C. Johnson Wax; The Credit Union of Wisconsin

Voyageur contributors:
Firstar; Harley-Davidson, Inc.; Marshall & Ilsley Corporation; and Wisconsin Manufacturers & Commerce

Founder contributors:
3M; ANR Pipeline Company; Blue Cross/Blue Shield United Wisconsin; General Casualty; Home Savings; John Deere Horicon Works; Johnson Controls; Kikkoman Foods, Inc.; Michael, Best & Friedrich; Miller Brewing Company; Northwestern Mutual Life Foundation; Robert W. Baird & Co., Inc.; Snap-on Incorporated; Time Insurance; Wisconsin Power & Light Foundation

Badger contributors:
Oscar J. Boldt Construction Co.; Marcus Corporation; Badger Mining Corporation; Case Corporation; Fort Howard; Jorgensen Conveyors Inc.; Kimberly-Clark Corporation; Kraft Food/Oscar Mayer Foods Corp.; Mann Bros., Inc.; Modine Manufacturing Company; National Business Furniture, Inc.; Rust Environment & Infrastructure; Twin Disc, Inc.; and Virchow Krause & Company, LLP.